3/08

D1270496

Arts, Sciences, and Economics

Tönu Puu

Arts, Sciences, and Economics

A Historical Safari

With 54 Figures

Springer

Professor Dr. Tönu Puu
CERUM
Umeå University
90187 Umeå
Sweden
tonu.puu@econ.umu.se

ISBN-10 3-540-34423-3 Springer Berlin Heidelberg New York
ISBN-13 978-3-540-34423-0 Springer Berlin Heidelberg New York

Cataloging-in-Publication Data
Library of Congress Control Number: 2006927038

Springer is a part of Springer Science+Business Media

springeronline.com

© Springer Berlin · Heidelberg 2006
Printed in Germany

Hardcover-Design: Erich Kirchner, Heidelberg

SPIN 11759300 88/3153-5 4 3 2 1 0 – Printed on acid-free paper

Preface

This book has a rather long-winding history. It is not like anything else the present author ever wrote, as all the rest is theoretical economics in a distinctively mathematical dress.

For the emergence of the following pages, there are several people, except the author, who are to have the credit, or perhaps the blame. Around 1985, the department of economics at Umeå University in the North of Sweden was visited by *Professor William Hendon*, Editor of the *Journal of Cultural Economics*. In my capacity of chairman of the department I invited him to a social lunch. We soon realized that we did not have much in terms of common research interests to talk about. However, somebody at the department later informed him that I also used to make copies of historical musical instruments during my free hours, so, once back in the US, he asked me to write an article for his journal, comparing the making of mathematical models to the making musical instruments. I thought the idea was absolutely crazy, but could not help start thinking about it now and then, so five years later I actually contributed a paper called "*On the unity of the arts, crafts, and sciences*".

By that time I met *Professor Gianfranco Mossetto* from the University Venice, who was about to start his institute for the study of the economics of "beni culturali" (ICARE), and he asked me to join in the scientific council for the institute. For a few years I attended their regular meetings and had the chance to meet a number of interesting cultural economists, though I never became one myself. From that period dates an article "*On progress and perfection in the arts and sciences*" published in *Ricerche Economiche*.

Meanwhile, my very good friend and former colleague, *Professor Åke E. Andersson* became director of the *Institute for Futures Studies* in Stockholm, and developed it into an interdisciplinary international melting pot

that nobody would have expected from its, to say the least, humble prehistory. He convinced me to start writing this book.

I also tried my hands on the practical production of culture through founding the "*Nordic Baroque Music Festival*", whose director I remained for the period 1987-2001. From that experience I also learned about the precarious existence for all such enterprise.

My interest in the philosophy of science has a different background. When I finished my thesis in 1964, I felt a need to think a little about what I was doing when I did "research", so I asked the department of philosophy at Uppsala University to give me an outright course reading list. I then wrote a few papers in this field, and, fortunately, came in touch with *Sir Karl Popper*, then at the London School of Economics. He was most supportive, and also used some of my papers in his teaching. As economics was not yet as quantitative then as it is now, back in Sweden I was accused of dissipating a "physicalistic" science ideal among my fellow economists. Ever since I retained an interest in these issues.

The first drafts of the present essay were circulated among a few colleagues, and I am very much indebted to *Professors Åke E. Andersson, Martin J. Beckmann,* and *Karl-Gustaf Löfgren*, for valuable comment. I also delivered a preliminary draft, but by then my good friend Åke had left the institute, and his successor was not interested, so I put the manuscript in the drawer. The institute, by the way, dropped back to its humble original state very soon after Åke left.

Then I found the manuscript a few years later, and, upon rereading, thought that perhaps it after all was worth finishing. To have an independent opinion, I sent a copy to *Professor Ian Stewart*, author of some of the best popular science books I know of. I am grateful for his reading and for being most supportive. So in 2000, I was invited by *Professor Yuij Aruka* to deliver a plenary lecture "*Economic Development in the Arts, Crafts, and Sciences*" at the yearly conference of JAFEE, the *Japan Association for Evolutionary Economics*. The outcome can be retrieved in Professor Aruka's "*Evolutionary Controversies in Economics - A New Transdisciplinary Approach*" (Springer Tokyo 2001). Some formal analyses, grown out from my occupation with these issues, concerning public utility location, and evolution seen in terms of catastrophe theory, also found their way into my own books "*Mathematical Location and Land Use Theory*" (Springer-Verlag 1997, 2003), and "*Attractors, Bifurcations, and Chaos - Nonlinear Phenomena in Economics*" (Springer-Verlag 2000, 2003).

So, as Åke entered a new large scale project on the economics of culture at the *Swedish Institute for Studies in Education and Research* (SISTER),

and asked me to finish the manuscript for this project, I did no longer hesitate.

I was most honoured when some time ago *Professor Mohammad El Naschie*, Editor-in-Chief of one of the most exciting and successful journal publishing ventures (Elsevier) I have ever been involved in, suggested to publish this essay in parts in the shape of articles, though I naturally prefer the present connected publication form. I am also most grateful to the staff of Springer-Verlag for invaluable help with foremost the copyright issues in which I am completely inexperienced.

Umeå, May 2006
Tönu Puu

Contents

1	**Culture and Civilization**	**1**
1.1	Current Threats	1
1.2	Reversed Perspective	2
1.3	Civilization: Frazer	4
4.4	Embodiment	5
1.5	Specialization: Castiglione	5
1.6	Development	6
1.7	Circularity	7
1.8	Layout of the Book	7
2	**Public Goods**	**9**
2.1	The Concept	9
2.2	Embodied Ideas	10
2.3	Vivaldi's Oevre	10
2.4	Attitudes to Culture	13
2.5	Protection of Originals	17
2.6	The Marais	18
2.7	Paris and Vienna	19
2.8	Piazza San Pietro	20
2.9	Performing Arts	21
2.10	Property Rights	22
2.11	Trade Secrets	23
2.12	The Stock of Knowledge	25
2.13	Knowledge and Capital	26
2.14	Embodied Knowledge	27
2.15	Storage	28
2.16	Accessibility	29
2.17	Compactification	30
2.18	University Cultures	31

3 Patronage.. **33**
3.1 Introduction... 33
3.2 Diversity of Institutions... 34
3.3 Uncertainty in Production.. 35
3.4 Risk and Insurance.. 36
3.5 Patronage in Culture.. 39

4 Changing Attitudes.. **45**
4.1 Background.. 45
4.2 Dissipation of Culture.. 45
4.3 Leisure.. 48
4.4 Addiction... 50
4.5 Dilettantism... 52
4.6 Schliemann, Fermat, and Galois.................................. 53
4.7 Specialization.. 57
4.8 The Ultimate Purpose.. 57
4.9 Florence and Vienna.. 60
4.10 The Fin-de-Siècle.. 66
4.11 Nonlinearities.. 68
4.12 Superstars... 69
4.13 Removing Constraints.. 70
4.14 Historical Monuments.. 71
4.15 Standardization... 72
4.16 Concentration.. 73

5 Evolution in Science.. **77**
5.1 Logical Empiricism.. 77
5.2 Newton, Kepler, and Galileo....................................... 78
5.3 Refutation.. 78
5.4 Approximate Truth... 80
5.5 Ad Hoc Explanation... 81
5.6 Normal Science.. 81
5.7 Supertheories... 83
5.8 Schumpeter.. 83
5.9 Reductionism... 84
5.10 Generalization.. 85
5.11 Hilbert's Programme.. 86
5.12 Gödel.. 87
5.13 Chaos and Predictability... 87

5.14 Laplace.. 88
5.15 The Weather Factory... 88
5.16 Social Engineering... 89
5.17 Poincaré.. 90
5.18 Linearity.. 92
5.19 Lorenz... 93
5.20 Aesthetic Principles... 95
5.21 Maupertuis.. 95
5.22 Leibnitz... 98
5.23 Metaphysics.. 98
5.24 Aesthetics.. 99
5.25 Computers and Visuality.. 103
5.26 Ethics.. 107
5.27 Pioneers.. 108
5.28 Pseudoscience... 112
5.29 Female Scientists.. 114

6 Perfection in Art.. **117**
6.1 The Role of Art in the Society....................................... 117
6.2 A Unique Opportunity.. 118
6.3 The Baroque Transition.. 119
6.4 To Romanticism.. 120
6.5 Musical Instruments.. 122
6.6 A Fast Transition... 125
6.7 Discovery in Art.. 126
6.8 Rediscovery in Music.. 133
6.9 Tuning and Temperament.. 139
6.10 The Modern Harpsichord.. 141
6.11 Back to Originals.. 145
6.12 The Early Music Revival.. 148
6.13 Meaning and Beauty... 150
6.14 Harnoncourt.. 150
6.15 Rhetoric in Music... 152
6.16 Art and Science... 152
6.17 Art as Sedative... 155

7 Economic Principles.. **157**
7.1 Introduction... 157
7.2 Böhm-Bawerk and Smith.. 158
7.3 Increasing Complexity.. 159

7.4 The Development Tree.. 160
7.5 Continuous Evolution.. 163
7.6 Diversification... 166
7.7 Property Space... 167
7.8 Paretian Ordering... 168
7.9 Prices and Progress.. 169
7.10 Branching Points.. 170
7.11 Music Automata... 173
7.12 Bifurcations... 174
7.13 Synergetics.. 176
7.14 Viable Alternatives... 177
7.15 A "Genesis" of Musical Instruments... 178
7.16 Summary.. 182

References.. **185**

Illustrations... **189**

1 Culture and Civilization

This book has no claims on being a work in the field called "the economics of culture", the main reason being that its author has no expertise in that particular area. The economics of culture is nowadays a well defined research area in economics, with its proper specialists, publications, journals, conferences, and university courses. For an authoritative recent book on the topic see Bruno Frey, *Arts & Economics*.

The main issue for the economics of culture seems to be to prove that culture is good and should be favoured. The message is directed to the political establishment, and it is implicit that this can be influenced to the favour of culture only if it can be established that culture promotes economic development, either on the local, the regional or the national stage.

This implicitly defines a supreme goal for all economic activity to produce material welfare. If culture in its function of a recreation for a hard working population can contribute to enhance productivity in the material sense, it is good. Nobody says that it otherwise is not, but it lies in the air.

1.1 Current Threats

The social mission of cultural economics is therefore beneficial, even necessary, for defending culture. First, there is nowadays very little room for such conspicuous consumption that historically provided some room for culture. Second, the production of culture, thus having to rely on the public sector for support, tends to be politically caught between a pair of pincers, provided by a populist socialism on one hand and an extreme neo-liberalism on the other.

The former suspect culture of any other provenance than the popular to be a harmful manifestation of bourgeois mentality and therefore a threat. The splendid social settings that continue to go with many cultural events are hardly suited to remove such prejudice.

The latter would like to dismantle all public services and relegate production to the free market. This, of course, is negative for culture, because its bulwarks, in terms of public libraries, museums, theatres, opera houses, concert halls, and festivals, normally benefit from substantial public subsidies. Anyhow, both political sides currently collaborate against culture.

Therefore it is essential to point out, as specialists in cultural economics in fact do, that, for instance, markets do not work in the case of public goods. Market solutions also fail in the case of art and science because the production period is very long, taking in account the training of artist/scientist, and because the future benefits cannot be foreseen at all by any informed critics or peer groups, as historical experience tells us. They may even accrue over periods much longer than a lifetime.

It, moreover, is a pity to subscribe to the market ideals of the worshippers of the "Temple of the Invisible Hand", be they left- or right-handed, who refuse to distinguish between good and bad taste, and who prefer to concede consumer preferences supremacy, no matter how good or bad taste they reflect.

1.2 Reversed Perspective

Why not simply regard things the other way? Material living standard as an indirect benefit, a means of producing culture as an ultimate end? Such a view may seem to be absurd and arbitrary, but it is no more arbitrary than the opposite perspective from which we use to see things.

There is even an argument for such a perspective shift, in terms of very long run "productivity": From that very tiny fraction of resources, allotted over the history of humankind to the production of culture, there remain such things as: monuments, literature, scientific theory, music, paintings, and sculptures.

So, what are the long run remains of the daily material consumption, to which an overwhelming part of the resources were always assigned? The answer is: just skeletons and potsherds. It must be emphasized that a skel-

eton has to be at least 20,000 years old to be as interesting to posterity as an average poem or theorem.

Anyhow, by accepting to have to prove that culture is beneficial for the production of material wellbeing, for instance to prove that concerts are useful through providing jobs for cloak room attendants and promoting the sales of hot dogs, the economics of culture agrees to reduce the value of culture.

It is as if we evaluated good health in terms of postponed fees to physicians and funeral undertakers. There is admittedly something in such an economistic perspective, but probably so little as to make one wonder whether it is worthwhile to name it at all. It is outright ridiculous to make it the core of an analysis.

This brings us to the fact that the tools normally used to prove the usefulness of culture are those of cost benefit analysis, just as in the economics of natural resources. This is another reason why the author is not very enthusiastic about the economics of culture, as it is his firm belief that, if there ever was a really shaky field of economics, it is welfare economics and all its spiritual children.

The reason for this is the extensive use these fields make of cardinal and additive utilities, things which were once successfully discarded to the favour of weak rationality as represented by revealed preference. It is itself an interesting story how cardinal utility re-entered economics through its first recycled use in the "expected utility doctrine". That theory, however, had an axiomatic basis. Today nobody is any longer the least concerned with justifying any kind of social utility functions. Utilities for different time periods and even for different people are added, so that one might ask whether economists again, like Bentham once, think of utility as some mysterious substance composed of "utils" which can be counted, measured, and weighted. Under the cloak of scientific objectivity economists again even make "scientific" recommendations on such necessarily controversial issues as progressivity in taxation.

There is, of course, nothing wrong with benefit cost analysis, if we accept that it, with all its weaknesses, is just a heuristic tool devised to complement the debits and credits of a private firm with the damages and benefices they cause to a third party.

It is when we start thinking that consumer's surpluses, social discount factors, and benefit cost ratios have any objective scientific sense above such heuristic tools, that we really enter the marsh-land. This is a personal belief which definitely is not shared by the majority of the economics profession today.

Nevertheless, given the prejudices by the author, there still exist several perspectives for economics to be applied to cultural activities, and some concepts from the standard repertory become quite useful for understanding what is going on in that sector of the economy.

1.3 Civilization: Frazer

As for a general starting point, I think there is a much better argument for the case of culture than the promotion of material welfare, provided we at all need an argument for one of the things that make life worth living. That is the obvious link between culture and civilization. Of course, I cannot tell why civilization is important either, I just think it is. Even Euclid could not do without some axioms to start from!

Few single books have had a greater impact on the author's mind than Sir James Frazer's *"The Golden Bough"*, published in the years 1907-1915. It can be read in many different ways. I read it as a history of civilization.

The terrible thing is that Frazer demonstrates, by overwhelming historical evidence and beyond any doubt, that civilization is a very thin varnish, just pertaining to very late periods of history, and to limited patches of the Earth.

According to Frazer civilization arose once forces, such as religion and science, managed to damp out some of the most barbarian habits of mankind. This verdict is perfectly echoed by that imputed to Siegmund Freud in Stefan Zweig's autobiography *"Die Welt von Gestern"*, published posthumously in 1944, two years after the latter's suicide: *"Freud was right when he saw our culture and civilization as only a thin layer, which in any moment could be broken through by the destructive forces of the underworld"*.

Frazer completely kills the idea of the "good savage", by an overwhelming supply of counter-examples, and, in that perspective, the concentration camp attendants of Nazi Germany prove to have a long ancestry.

It even does not surprise that such a relapse into barbarity could happen in our time in a country where Bach, Dürer, and Gauss once lived and worked.

If a varnish is very thin it can become brittle and let through the dark undercurrents of human nature again and again.

There is of course no perfect linkage between culture and civilization. The Aztecs used their marvellous edifices for human sacrifice, and the Romans watched cruel slaughters in their splendid amphitheatres. Hitler and his staff were amused to attend the Bayreuth and Salzburg Festivals. This

being admitted, there is still no doubt that the correlation between culture and civilization over history has been strong, and that culture in general tends to mitigate the habits.

What exactly is culture? There are anthropological definitions, which are both very precise and very broad, including the ways we dress or use knife and fork. In the present context there is, however, no need for such sophistication.

A rather trivial and relatively narrow definition will do. We take culture as just art and science. We might add some of the crafts, and maybe subtract some applied science, but there is no point in such hair splitting.

The book is exactly what the title claims. It is an essay, addressed to economic perspectives on the production and consumption of culture. But there is no claim whatever on a well defined topic, or on an exhaustive treatment of anything, as indeed indicated by the descriptive subtitle "safari".

1.4 Embodiment

There are, however, a few topics which are discussed at some length. One is the issue of embodiment versus disembodiment of public goods in the cultural sphere. It seems that the distinction is useful, because the problems arising are very different, we may even say contrary, for the two categories.

For embodied goods, such as the historical monuments, protection against erosion through crowding by tourists and other visitors is the most essential aspect today. For disembodied "goods", such as scientific, literary, or musical work, it is the protection of the "property rights" for the originators that becomes the crucial issue.

It is in these sections that the essay comes closest to the topics in traditional economics of culture.

1.5 Specialization: Castiglione

Another issue to which some space is devoted is specialization. The conviction that we should all specialize, like Adam Smith's pin-makers, everybody

in one tiny little work operation, sharing the total activities of the economy among us according to comparative advantages, and profiting from multilateral exchange of goods and services, is one of the best selling ideas economics ever had. The belief in the benefits of specialization is now as firmly established among the general public as is the belief that material welfare is the ultimate end of all human activity. In fact it is its perfect companion.

In this context it can be noted that, for the active involvement in culture, amateurism, the very opposite of specialization, was historically extremely important. Our professionalistic ideal, which even makes us go to concerts to listen to professionals playing chamber music that was never intended as concert repertoire, now calls all such amateurism in doubt. The words "amateur" and "dilettante", once, according to the respective French and Italian origins of the words, laudatory distinctions of those who made something for "love" and not for money, have now become unambiguously disparaging.

The professionalistic ideal also is in bright contrast to Baldassare Castiglione's ideal of educated humanity, which for centuries provided the very basis for our entire education system.

Several examples of productivity enhancement through non-specialization and multiple occupation from the history of culture, actually contradict the professionalistic ideal. In particular Florence of 1500, and Vienna of 1900 provide exemplary counterexamples.

For these reasons one issue focused is whether the linear structure underlying the assumption of frozen comparative advantages holds at all as a reasonable theoretical assumption. No doubt the monotony at the endless conveyor belt is tiresome, and the pleasant alternation between very different operations in the workshop of the traditional artisan productivity enhancing. Nobody would deny that, but few realize that this actually blows up part of the Smithian specialization ideal.

1.6 Development

The third main topic of the book is that of development and progress. Some pains are taken to model such development, which takes the character of increasing diversity, rather than of increasing numbers; and change of structure, rather than growth within a given structure.

A most striking fact is that much development in the economy, not only restricted to the field of culture, quite like the development of living organisms, has taken the remarkable road towards constantly increasing complexity of organization, i.e. decreasing entropy - quite contrary to the second law of thermodynamics. We definitely would need some rudimentary explanation for this astounding phenomenon, and one is offered in the last chapter.

1.7 Circularity

Other striking facts in this context are the obvious changes over time of the appreciation of different styles in culture, even to the extent that previously scrapped ideals occasionally become fully up to date again.

Development in culture in hindsight often appears to be circular, though the contemporary development is usually always reported as being one of constant progress. No doubt, preferences, pricing, and index theory would have to say something about all this.

Such circular development and other shifts of taste are illustrated by some detailed historical examples from various arts and sciences. The author fully realises that some readers may even think that these examples break the thread of reasoning. However, it seems appropriate to write something substantial about culture in a book on economics and culture.

1.8 Layout of the Book

The following essay is written on different levels. There is the main text, containing numerous very short "case studies" from the history of culture which the author feels are relevant for the story told.

However, the numerous illustrations are provided with rather elaborate comments which largely focus information not contained in the main text. The reader inclined to just browsing the book may hopefully enjoy just following this suite of pictures and their legends.

2 Public Goods

2.1 The Concept

The concept of a public good, in contrast to that of a private good, is used to designate commodities that by their very nature can be consumed simultaneously by any number of consumers, without any interference, such as the services of a landscape or a historical monument to the watchers.

Such a concept naturally is idealized. In reality, the presence of a moderate number of other consumers usually increases the amenity of the site, by providing for service and social intercourse, whereas increasing the number of consumers beyond some threshold always is bound to cause pure nuisance.

In terms of basic economics, it is implicit that if somebody were to produce a landscape or a historical monument, he could not expect to recover the production costs by selling it to any individual consumer, though all the interested consumers collectively might want to buy it. Implicit is also that nobody could invest in such a product and retail its consumption in bits at a charge to all the interested consumers.

The very nature of the public good makes it almost impossible to exclude those who have not paid the fee from watching the scenery. Even if it were not entirely impossible, such an exclusion system might have to be so costly to run as to become impracticable. As a consequence, normal markets cannot provide for new production of such public goods, nor can they secure the maintenance of existing ones, and collective action becomes mandatory for their protection.

The examples of public goods that first come to mind, after the classics: provision of defence and law and order, belong either to the sphere of natural resources or to that of cultural objects. The reader may want to object

that historical monuments were once produced; but they were produced in a different social setting as private goods for those who were then able to afford them.

2.2 Embodied Ideas

We should note that the degree to which cultural goods can be regarded as idealized public goods is related to the degree to which they are embodied in physical commodities.

Apart from specific embodiments, some cultural goods have the character of pure non-material ideas. Examples are: a scientific theorem, a poem, a novel, a drama, a symphony, an opera. Essentially, all culture, as something that gives nourishment for the mind, has this character.

Depending on the nature of the commodity, it will be easier or more diffi-cult to separate the spiritual good from its material embodiment. For ana-lytical purposes, it may be useful to distinguish between the specific embodiments and the ideas embodied. The former are often private goods, whereas the latter belong to the domain of public goods.

There is, however, a tie between them. Even when an idea, in principle, can be disembodied, it may still be a delicate operation to initially free it from its physical embodiment.

2.3 Vivaldi's Oevre

The following story illustrates a particularly spectacular example. Few com-posers from the Baroque era are now better known than Antonio Vivaldi.

In his lifetime, however, no more than five sets of sonatas and nine sets of concertos, such as *"L'Estro Armonico"*, *"La Starvaganza"*, and *"Il Cimento dell'Armonia et dell'Invenzione"*, the last containing *"The Four Seasons"*, had been published and so become available for posterity.

One collection of chamber music, *"Il Pastor Fido"*, which had actually been composed by Nicolas Chédeville, had even misleadingly been printed in Vivaldi's name in the 18th Century, maybe to the end of promoting sales by the attribution to a famous master.

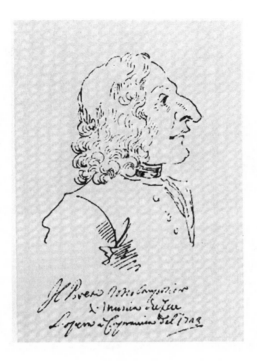

Fig. 2.1: *This caricature is the only existent authentic picture of Antonio Vivaldi, one of the most famous composers of the 18th Century. His oevre was known to posterity through a few contemporary publications of chamber music and through Bach's transcriptions, The whole wealth of his music was, however, not recovered until 1930.*

Vivaldi was also known to posterity through the six transcriptions of violin concertos by Bach for solo harpsichord. This only represented a fraction of his total oevre known today.

The story of how most of it was rediscovered as late as in 1926-30 by a zealous librarian in Turin would almost provide stuff for a novel.

During the Napoleonic Wars, the Chapel Royal of the Piemontese court had stopped for a few nights in a small abbey on its refuge from Turin to Sardinia, hiding some of the music they had carried with them in its library.

It had been so well hidden, that it was not retrieved until 1926, when the monks needed some money for the restoration of the abbey, and therefore considered selling some of the manuscripts in their possession. There were in all 95 sensational volumes of music, among them 14 with music by Vivaldi.

This music could be traced back to a Count Durazzo, who had been Imperial Ambassador of the Habsburg Monarchy in Venice, and probably taken

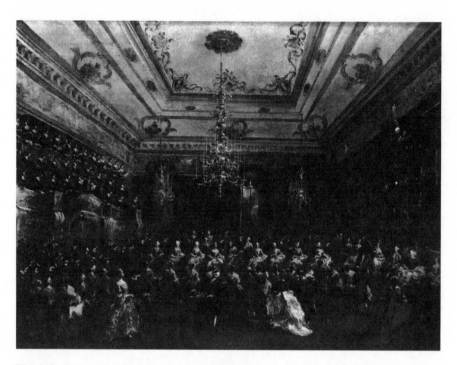

Fig. 2.2: *Concert with the orchestra of the ladies by Francesco Guardi (1712-93). This famous painting, currently in the Alte Pinakothek in Munich, displays a "reception for the Counts of the North" with an orchestra of young ladies entertaining from the balcony. Antonio Vivaldi, priest by profession and successful opera impresario, was also music teacher in "Ospedale della Pietà"; a school for orphans, and he trained the girls of the school to a virtuoso orchestra. This was famous in all Europe, and is known to posterity through the diaries of famous 18th Century travellers to Venice.*

care of some of the music in Ospedale della Pietà, the home for orphans, where the late Vivaldi had been music teacher, and trained his girls to a virtuoso orchestra famous in all Europe.

Fortunately, the volumes found in the monastery were systematically organised, and it was not difficult to establish that about half the collection was missing.

After some detective work it was suspected that the rest of it was in the possession of the last Durazzo, a somewhat feeble-minded marchese, who on one hand did not care what exactly he had in his library, on the other guarded his personal patrimony with jealousy, refusing everybody, even his servants, to come near the chaotic library.

It literally took three years of negotiations before, finally, the old marquess's confessor was able to arbitrate sale of the music. The marquess was

infuriated when he learned that the monastery had sold their half of the collection, and this did not exactly facilitate the negotiations.

One of the absurd conditions for the marchese's consent was that the music should never be published nor performed. In this way 300 concertos, 14 entire operas, and a lot of vocal and instrumental chamber music were retrieved.

The negotiations had to be conducted in secret in order to keep private curiosity hunters away until such substantial sponsorship had been secured that the Turin library could outbid everybody else.

Fortunately, two wealthy Italian industrialists wanted to commemorate their sons who had both died in childhood, so they contributed half the necessary funding each.

2.4 Attitudes to Culture

Social attitudes to which part of the cultural heritage can be regarded as private property and which cannot shift over time. Pictures, statues, and even architectural objects are generally regarded as legitimate private possessions, though most countries put constraints on their disposal. For instance, exportation of antiquities of a certain age is usually forbidden, and the reconstruction of historical buildings for modern use is subjected to severe control by antiquarian authorities.

Manuscripts too are regarded as legitimate private property, though keeping for oneself an original proof of Fermat's last theorem, or a seventh Brandenburg Concerto by Bach, modelled on his viol sonata in g-minor, the existence of which has been conjectured by some musicologists, would most likely be regarded as highly asocial behaviour, much more now than it was in 1926.

Once an idea has been initially liberated from its original embodiment it can live an independent life, but mostly the original is needed as a kind of "backup file" without which the public good may ultimately perish.

Those who very much dislike Platonic ideas, might be reluctant to concede reality to anything except the physically embodied cultural objects on one hand, and the individual experiences of beholding them on the other.

It is, however, undeniable that there is something in common in the individual experiences of, say, a drama or a scientific theory, having an objec-

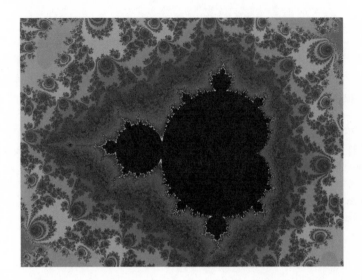

Fig. 2.3: *The Mandelbrot set; invented or discovered? Penrose claims that its discovery in no essential sense is different from the discovery of Mount Everest. This mathematical object was discovered by Benoit B. Mandelbrot, and it shows if and how fast the iterated process of squaring a complex number with a complex constant added diverges to infinity. The picture is an example of the set of geometrical objects introduced by Mandelbrot and called "fractals". Those pictures are characterized by fractional dimension measures and display amazing detail at every new level of magnification, among other an infinite number of miniature copies of the whole set itself Modern computer software makes it possible to explore the pictures to such detail that the original complete set becomes as large as the orbit of the planet Pluto.*

tive existence quite apart from the paper and the ink of the original manuscript.

Roger Penrose in his suggestive book *"The Emperor's New Mind"*, manages to convince even the most incredulous reader that mathematical concepts, such as the Laplacian Operator or the Mandelbrot Set, are discovered rather than invented, in exactly the same way as is Mount Everest or a new Elementary Particle.

A scientific theory, a literary work, or a piece of music can be used without touching the original, resting undisturbed in a library or an archive. In fact, it will only be necessary to return to the original manuscript on those relatively rare occasions when it is realised that its circulating contents have been distorted by too much editing to the purpose of filling in "missing" parts and correcting real or imagined "mistakes".

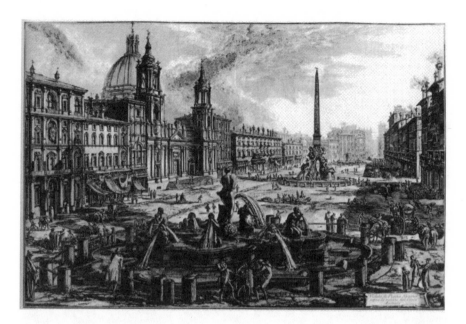

Fig. 2.4: *Piranesi's engraving of Piazza Navona, located on the ancient racecourse Circo Agonale in Rome. In 1745 Giovanni Battista Piranesi published the 135 etchings in his famous work "Vedute di Roma" (Pictures of Rome), where the picturesque antique ruins of Rome in decay amidst the splendour of the new Baroque edifices were romanticized. Besides the engravings of the Fontana di Trevi and the Forum Romanum this is probably the most well known of the etchings. The work spread through Europe and became an appetizer for the "grand tour" to Italy. The dramatic touch with an extreme contrast between light and shade was even more pronounced in Piranesi's later almost science fiction like series of imaginary prison vaults, the "Carcere d'Invenzione".*

Likewise, printed reproductions of paintings in an art history book can nowadays transmit an even better impression of the original than the original itself hung on the wall of some museum amidst crowds and photo flashes. Note how fast things have changed in this respect. The crowding in museums is a recent effect of mass tourism, and modern reproduction technique too is of so recent a date that Bernard Berenson in his monumental picture books on Italian renaissance painting still refused to use illustrations in colour due to their inferior quality, though this was as late as in the years 1957-1963.

A solid copy of an antique statue, of the type the aristocracy used to adorn their houses and gardens with in times past, already, has a much stronger flavour of fake, and a miniature imitation of Piazza San Marco in some

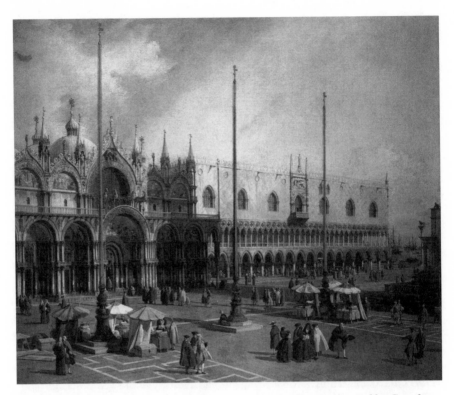

Fig. 2.5: *Picture of 18th Century Piazza San Marco in Venice painted by Canaletto, Antonio Canal (1698-1768). Canaletto was the most productive of the "vedutisti", with an almost photographic style very different from the more "impressionistic" painting by his contemporary Guardi. The Venetian townscape and civic life has been amply documented in pictures from Gentile Bellini and Vittore Carpaccio of the 15th Century to the 18th Century vedutisti. In this picture the visitors are few as compared to any tourist snapshot of today and the stress and strain put on the city very different. In the 18th Century the authorities of the aging aristocratic republic encouraged tourist income, though they were extremely watchful on citizens having any intercourse with the visiting foreigners. Many a noble senator made his way across the "ponte dei sospiri" or to the lead chambers on the slightest suspicion of such contacts. This ambiguity resembles that of today, though the motives were different, above all concerns of public security in a state whose secret waterways had protected it against invasion for centuries.*

Disneyland borders on the verge of the ridiculous, in particular if put side by side with the Taj Mahal and Neuschwanstein.

Nevertheless in a certain sense there even exists a disembodied idea of Venice, communicated in the numerous "veduti" by Canaletto, Guardi, Tiepolo and others, and in literary work by, for instance, Casanova, Ruskin, and Thomas Mann.

2.5 Protection of Originals

In the 18th Century, antique Roman culture penetrated throughout Europe. All those more or less accomplished marble copies of statues, and all the numerous prints, of which Piranesi's *"Vedute di Roma"* were the most successful, served as substitutes for the "grand tour" of actually visiting the classical sites.

As substitutes they protected the originals, though the effect was not unambiguous. The replicas could eventually also make people want to see the real thing, becoming preparations for a real tour, or, in terms of economics, complements rather than substitutes for it. Literary work too, such as Goethe's *"Mignon"* or Mme de Staël's *"Corinne",* served to invoke a passion for the meridional.

More specific in purpose were all the "Baedeckers" of those days, travel diaries by mostly famous authors: Brosses (1739), *"Voyage en Italie",* Goethe (1786), *"Italienische Reise",* Stendhal (1827), *"Promenades dans Rome",* Taine (1864), *"Voyage en Italie".*

In the days of the grand tours of the wealthy the practical consequences, however, were negligible, in sharp contrast to those of mass tourism today.

To the extent that the artistic ideas have to be physically embodied, crowding around the originals is impossible to avoid. This is relevant in particular in the case of historical monuments. Embodied cultural commodities become similar to exhaustible natural resources, and special measures have to be taken to preserve them from being actually exhausted by consumption.

The unregulated market does not pay any attention to the ideas of Bruges or Venice, embodied in the physical cities, which can be literally worn down by unregulated consumption in tourism.

In addition to physical deterioration, a historical town can also be economically damaged by tourism, through increasing living costs, and through diversion of the economic activities from what is useful for the permanent inhabitants, as demonstrated by the research of Gianfranco Mossetto.

Venice is a particularly good example, where butcher's and baker's shops have literally been replaced by shops for glass and jewellery. As a consequence we notice such drastic decrease to about half of the permanent population, as was in fact witnessed the last decades, almost closing the city down between tourist seasons.

Despite this Venice is in a unique and favourable position due to its location in the middle of its lagoon. Not only did this protect the city against foreign invasions for many centuries, until it was finally conquered by Na-

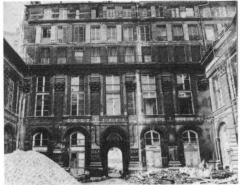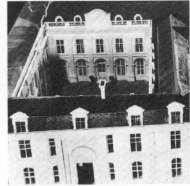

Fig. 2.6: *Hotel de Saint Aignan in the Marais district in Paris, built as residence for the Duke of Saint Aignan, currently the site for the archives of the city of Paris. On the left in a state of unrecognisable destitution, on the right as restored to its previous splendour. In the time of Richelieu the Marais (literally the swamp), located around the Place des Vosges was the part of town where the nobility had built its city palaces, and the Place de Vosges itself had been the obvious location for splendid Royal festivities, as illustrated in contemporary engravings. In the 19th Century the whole area became a slum, the palaces being rebuilt so that they were no longer recognizable for anybody but the experts. In the 1970's a large scale reconstruction of the whole area took place, and it can now be seen in its former splendour Of course, as always in such cases, the original inhabitants could no longer afford to stay in the area.*

poleon. Still today its unique dual transportation system, by winding canals, and by narrow corridors for walking, interrupted every few steps by bridges, make it totally impossible for adaptation to any modern transportation system. Like no other city it is therefore effectively protected from cars.

2.6 The Marais

What can otherwise happen to historical townscapes is illustrated by the case of the Marais district in Paris, located around the Place des Vosges, once in the 17th Century the centre for all Royal festivities, such as processions, carrousels, and tournaments, all surrounded by the palaces of the aristocracy.

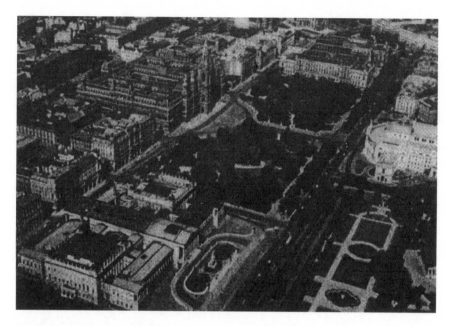

Fig. 2.7: *Part of Ringstrasse in Vienna, completed in the 1880's on the former city walls and moats. The Parliament, the City Hall, the University and the Burgtheater are seen on the picture. The ambiance also contains such showpieces as the twin Museums of Fine Arts and of Natural History, and the Staatsoper. The splendour of all these neo-gothic, and neoclassical edifices are tokens of the pride of a rising wealthy bourgeoisie, and reduce the impact of the more modest palaces of the nobility in nearby Herrengasse, and even of Hofburg itself.*

In mid 20th Century the whole area had become a slum in decay, where it was literally impossible to see for anybody but the specialists what had once been magnificent palaces. In the past decades a thorough restoration of the entire area has taken place, so it can again be seen in all its original splendour. It is even good to have ample photographic documentation of its period of decay so that it is now possible to see what the area looked like.

2.7 Paris and Vienna

It is, of course, not possible to restore everything. The transformation of Paris during the Second Empire by means of all the wide and straight boul-

evards, allegedly constructed to the end of keeping riotous masses of people under control by the use of artillery, can definitely not be undone.

The same transformation occurred in other cities, for instance Vienna, where the earlier city walls and moats provided room for magnificent ringroads along which splendid 19th Century showpieces for the housing of parliament, town hall, museums, and theatres were located.

Even those transformations, which were once criticised for utterly bad taste, are now history, and uncompromising historicism would be an untenable idea. What would we otherwise do with all the Cathedrals which may have been started in the 13th, 14th, or 15th Centuries and not been finished until the 19th?

John Ruskin who in his book *"Stones of Venice"*, only accepted the Gothic as genuine, would no doubt gladly have torn down all the Palladian Churches, and all the Baroque Palaces in Venice, but his opinion definitely was a very extreme one.

2.8 Piazza San Pietro

To take another example, consider San Pietro in Rome. Is only the centre of the building with Michelangelo's dome genuine, or should we accept the transept facade adorned with Maderna's contemporarily nicknamed "ass ears" of towers as well? And what about Bernini's colonnade around the huge Piazza. After all the church used to tower over a maze of narrow streets and tiny houses, which of course increased the overwhelming effect of the basilica.

Later exactly the same complaints were given against the construction of Via del Conciliazione. The broad avenue, leading up to the Bernini colonnade, would destroy the overwhelming impression of the Basilica, whose magnificence was now regarded as being enhanced by the colonnade.

We obviously have to consider that a townscape can only survive provided it is continuously used for normal economic activity, and then we have to accept some compromises.

Only traffic and transportation is a real danger, not only to historical environments, but to civilized city life at all. This problem is, however, not new. In ancient Rome of the first Caesars people used to complain that it was not possible to sleep at night due to the constant noise of goods transport which, according to imperial command, had to be done during the nights when the

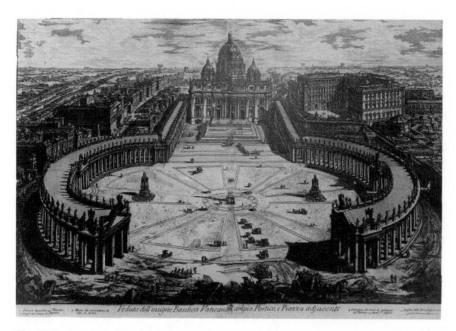

Fig. 2.8: *Another Piranesi engraving representing Piazza san Pietro in Rome, including the Bernini colonnade.*

streets were empty, as this was the only practical possibility of providing this huge city with the necessary provisions, and of removing the wastes. See Carcopino, "*La vie quotidienne a Rome à l'apogée de l'empire*".

Fortunately, historical monuments are in this respect unique. Other cultural objects, such as scientific, literary or musical works, are not in the same danger of being worn out. Wear and exhaustion only apply to the original manuscripts, which, as we noted, can be left untouched despite ongoing consumption.

2.9 Performing Arts

It is true that scarcity and crowding can also occur when culture cannot be consumed without an intervening performance. Even though a play can be read by anyone, and a score for a symphony by trained people, the experience of reading is rather imperfect as compared to a live performance.

Such performances have limited audience capacity and thus become subject to the effects of crowding, unless they are broadcast, televised, video-taped, or recorded.

The difference, in comparison to historical monuments, is that music or drama is never eroded by crowding. Temporarily, a piece of music or drama can, of course, seem to become eroded as an idea, by too frequent and too vulgar repetition, but this is a quite different operation, working on peoples minds rather than on the cultural objects themselves.

Moreover, the exclusion principle is quite easy to apply at most performances. Whenever pricing, without recourse to some kind of rationing, does not establish equilibrium of supply and demand, this is due to the fact that music and drama are treated as merit wants and therefore subsidized.

2.10 Property Rights

The cultural goods which are not embodied in concrete physical objects present different problems, which actually increase with the ease with which the spiritual ideas can be disembodied from the original sources.

This stems from the fact that they are difficult to produce but easy to reproduce. It applies in particular for scientific achievements. A mathematical theorem, once needing the genius of an Euler or a Gauss for discovery and proof, can later be reproved by every college student.

As we will see, there has been a lot of theft of ideas over the ages, and a tendency to keep disembodied ideas in secrecy. In the 17th and 18th Centuries musical ideas were reused not only by the proper composers themselves, but by colleagues as well, sometimes without any indication of origin. Below we will see how difficult it was for Mersenne in the 17th Century to found an academy of sciences to the end of creating a platform for safe dissipation of ideas so as to speed up development.

True copyright laws were rather late to appear, and applied to the publisher rather than to the originator. This still holds for literature, including science. As for music, copyright for published music included the right to perform! It was as late as in 1898 that Richard Strauss founded the association of composers in Germany, and with great difficulty managed to make legislators differentiate the rights of the publisher, proper copyright, ("Verlegerrechte") from the rights of the composer, including performance rights, ("Urheberrechte"). See Deppisch, "*Richard Strauss*". It was these entrepre-

neurial talents which made Goebbels offer Strauss to become president of the "Reichsmusikkammer" of Nazi Germany, an honour the great composer, unfortunately for his later reputation, accepted, until he was later disposed of for collaboration with Jewish librettists.

2.11 Trade Secrets

A change of attitude should be noted. The ethos of science now demands prompt and costless disclosure of discoveries. In times past mathematicians usually communicated only the new theorems to their colleagues, keeping the proofs to themselves.

In the arts things were similar. Composers borrowed without scruples from themselves and others. In most cases the music was processed, but there exist instances of pure theft, such as the sonata by Andreas Anton Schmelzer (not to be confounded with his father Johann Heinrich Schmelzer) to celebrate the escape of Vienna from the siege by the Turks, where he just "borrowed" one of Biber's "Mystery Sonatas", spoken of elsewhere, "The Crucifixion", transposing the piece a semitone up, adding one tiny little movement, and giving the movements fancy names referring to the battle. The hammer blows from driving the nails into the body of Christ being reinterpreted as artillery fire on the walls of Vienna.

A similar instance from the same Century is the case of Cardano, to whom Tartaglia in confidence disclosed a method of solving cubic equations, and who published the result as his own work. It is not to wonder that artists and scientists became jealous of their secrets.

According to Titon du Tillet's *"Le Parnasse Francois"* from 1732, the young violist Marin Marais had to practice qualified "industrial espionage" against his teacher de Sainte Colombe in order to find out the more subtle mysteries of bowing. Du Tillet writes:

"Sainte Colombe was the teacher of Marais, but, having realized after six months that his pupil might surpass himself, he told him that he had nothing more to show him.

Marais, who loved the viol passionately, however, wanted to learn more from his master in order to perfection himself in playing that instrument; and, as he had some access to the house, he chose a time in the summer when Sainte Colombe was in his garden hidden in a little plank cabinet that

he had built on the branches of a mulberry tree, to the end of being able to play his viol more at ease and with greater delicacy

Marais slipped under this cabinet; he listened to his master and profited from some special passages and some special bowings which his master wished to keep to himself. But this did not last for long. Sainte Colombe became aware of the facts and took precautions not to being heard by his pupil again". This feather of an anecdote was, by the way, some years ago used in the successful movie *"Tous les matins du monde"* to reconstruct an entire poultry farm.

We could also cite from Mozart's letters: Concerning his piano concerto in E-flat (KV 449), lent to his father Leopold, which he wanted back, he writes in May 1784: "*I will be pleased to have patience until I get it back - provided it does not come in the hands of anybody. - I could have had 24 Ducats for it today; - however I find it can be more profitable for me to keep it a few years and then make it known only in engraving (*print*)."* And, two years earlier to his sister Nannerl concerning a fugue: "*Please do keep your word not to show the music to anybody. - Learn it by heart and play it so, it is not so easy to imitate a fugue.*"

Today all such novelties would immediately be regarded as common property. It also becomes increasingly difficult technically to protect property rights to scientific or artistic innovations in our age of easy mass-communication and mass-reproduction.

These technological improvements on one hand help to protect physically embodied originals in the case they are old and delicate, on the other hand they impede protection of the property rights to the ideas. The public good character of ideas, in various ways, makes it almost impossible to secure the originators their merited rewards.

It is interesting to note that it was in France, about the time Marais spied on Sainte Colombe, that a remarkable attempt was made to lift the inclination to secrecy among the scientists, by Marin Mersenne founding an embryo to the French Academy. Mersenne clearly realized that every scientist would profit from knowing the results achieved and the methods used by others, so as to build their research on a fundament of common knowledge. Mersenne obviously inspired trust among his colleagues, though the success was only partial. Though Mersenne was one of the few people that Pierre de Fermat at all corresponded with, he could not be convinced to disclose his proofs. Had Mersenne only been a little bit more successful, the three Centuries of vain hunting for the proof of "Fermat's Last Theorem" might not have been necessary. Mersenne is of interest in the present context also because he in 1634 published his *"Harmonie Universelle"*, which

today provides one of the best sources of knowledge concerning historical musical instruments.

We should admit that trade secret has been kept for scientific discovery even in modern times as soon as there is a relation to military aims. Research concerning nuclear physics was quite recently kept highly secret, as is still anything having to do with biological and chemical warfare agents.

The same holds true for the purely mathematical discipline of cryptography. Attitudes vary between periods of war and peace, but a certain degree of secrecy is always there.

The same, of course, holds for industrial procedures that may be patented, but here we deal with applied results of little significance for basic science.

On the whole it, however, still holds that attitudes have shifted to much more openness. Perhaps we should not be too boastful over this progress as the changing attitudes may in fact have something to do with the increasing difficulty of keeping secrets in modern society.

2.12 The Stock of Knowledge

Once we decide to consider a substantial part of the cultural goods as embodied ideas, it is natural to ask whether it would be fruitful to define a stock of ideas, information, knowledge, or whatever we wish to call it, as a non-material companion to the stock of capital.

Along with capital, labour, and land, it could then be regarded as an input in production.

We could also consider the evolution of the stock in terms of the formation of new ideas and the depreciation of obsolete ones.

Using modern computer jargon we might even coin a unit of measurement for knowledge: Bytes, Kilobytes, Megabytes, and Gigabytes. Note in this connection that not only text, but also pictures, and music, are now stored in the same way. Most music notation programs (such as Finale) provide automatic facilities for converting the scores to sound, even to attribute different instruments to the different parts.

We should be watchful, because a page by Shakespeare or Newton may take the same number of Bytes to record as a page of randomly scrambled words from a dictionary!

However, in computer memory too, the high-level instructions of very sophisticated programs are coded like simple data or shear nonsense, so the difference may not be that big after all.

We may also take note of Gödel's demonstration that every mathematical theorem, no matter how deep, and every proof, no matter how ingenious, can be coded as one single number.

In his book *"Gödel, Escher, Bach: an Eternal Golden Braid"* Douglas Hofstaedter discusses whether a gramophone record containing some message, launched into outer space could be considered to contain any information at all.

For an affirmative answer, the addressee must be supposed to possess a gramophone, have access to electricity, understand how to operate these things, and know the language in which the message was recorded.

2.13 Knowledge and Capital

But, again, the situation for ideas is no worse than for modern specialized machinery, where an obsolete piece, fitting no operating system, is completely worthless. This becomes increasingly true with increasing specialisation.

A pair of dentist's pincers could still be used in woodworking, whereas a program module for a modern dishwasher cannot be used for any other purpose than in a dishwasher of exactly that brand for which it was produced.

Ideas becoming obsolete are scrapped, just like machines. A seeming difference is that machines wear out from use, whereas ideas wear out from non-use. Looking closer we, however, find that, though machines wear out from fatigue when in operation, they also wear out from corrosion and lack of attention when left idle.

Ideas and machinery both also wear out from becoming obsolete, which is an attribute derived from the macro environment, when the idea or the machine does not fit in any longer.

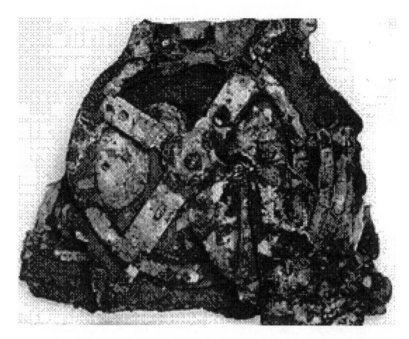

Fig. 2.9: *The mysterious Antikythera gearbox. It was found by some Greek fishermen and sponge divers in 1900 in a shipwreck close to the tiny island of Antikythera where the fishermen took shelter during a storm. It could be dated from the first Century B.C. The perishable metal wheels had of course decayed but when the gadget dried it showed a complex system of dials and gearwheels. In 1972 Derek Price, using X-ray, found out the entire complex system of 32 gear wheels moving together when a protruding central axis was rotated By the ratios of the gears he was able to establish that it had been used as a complex analog computer for calculating the positions of the sun and moon in relation to those of the fixed stars. Nobody suspected that antique technology had achieved such a level of sophistication, the whole thing more resembling some 18th Century clockwork. Notably it took 70 years to decipher the use of the gadget.*

2.14 Embodied Knowledge

There is just one reason why it is of doubtful value to introduce the stock of knowledge into economic theory as a companion to the stock of capital:

It is hardly ever possible to distinguish a pure input of knowledge in the production process as distinct from the inputs of labour and capital!

A new idea is always incorporated either in a new design of some capital equipment, or else embodied in some workman doing his job in a new way.

In the old guild system, apprentices were allowed to own a small well defined set of simple hand tools. Thus, some capital could be regarded as embodied in labour. Likewise a serfdom economy, such as Imperial Russia or the pre civil war America, would embody labour in land.

Except for the obvious case of capital embodied in cultivated land, we therefore have to look very carefully, only to find very particular examples of little significance, such as those above, where there are any problems at all in discriminating between capital, labour, and land.

In attempts to isolate knowledge from capital and labour, the problems are, on the contrary, always prevalent.

2.15 Storage

There are peculiarities pertaining to the nature of the stock of knowledge. Before the advent of the printed word, knowledge was communicated exclusively by oral tradition, from individual to individual, often within a family or a local community.

Procedures such as the making of steel, known to the Hittites, or silk and porcelain, known to the Chinese, could be kept secret over long time periods. The stock of knowledge indeed was made of the ethereal stuff carried in the minds of people. Still in 1710, Elector Augustus the Strong, could imprison alchemist Johann Friedrich Böttger, discoverer of the composition of chinaware, and director of the Meissen newly founded porcelain factory, upon lifetime in order to keep the secret to the "white gold" of Saxony.

Since books, libraries, and computer files have heaped increasingly huge accumulations of information, there exists an enormous backup made of solid matter. We should, however, regard only that portion of knowledge as operative that is also carried in the minds of people. Every piece of knowledge is a link in a giant network, and can be accessed only through its adjacent links. Once too many adjacent links have decayed, the piece itself becomes inaccessible.

The most common reason for such decay is neglect of that particular part of the network of knowledge. Eventually the genius of a Champollion may be needed to recover how to decipher the hieroglyphics. Like Hofstaedter's record, stored information in itself has no value, except as a potential.

2.16 Accessibility

We should mention here that access to knowledge is more complex than the parable of a network seems to suggest. It may be the case that multiple adjacent links of distinct layers are needed for the access.

The process of recovery of lost knowledge is complex in its interdependence. Later we will comment on the recovery of music from the Baroque and Classical periods. The access became difficult because both the original instruments and the knowledge of performance practice were gone. There is no point in trying out various practices on the wrong kind of instrument, nor is there in setting a standard of quality for the instruments when nobody qualified to judge them is around.

Scientific measurement instruments in museums, such as mechanical integration machines, provide another example. For relatively recent instruments there still exist some written instructions.

However, in the case of the mysterious very complex gadget of 32 gear wheels, rescued from an ancient Greek shipwreck at Antikythera in 1900, it was not understood until 1972 that it must have been used in ancient times to calculate the positions of the sun and the moon, given the positions of the fixed stars.

Suppose something such as a scarcity of electric power, making digital computation impossible would force us to develop mechanical integration machines once again. The task would be formidable, because their working was based on a combined use of advanced mechanical clockwork engineering and differential geometry, two fields that have both been neglected during the triumph of the digital revolution.

It cannot be overestimated how much a device such as the computer actually contributes to shape the structure of knowledge. The whole field of calculus, based on the elementary trigonometric and hyperbolic functions, would probably be nonexistent today, had computers and algorithms been available in the 18th Century.

Why bother with all the intricate interrelations between those functions, which themselves are nothing but solutions to specific differential equations, if we could numerically solve any other differential equation we needed to consider?

2.17 Compactification

Recent developments in computer technology and adjacent areas may be regarded as responses to storage problems for the perpetually accumulating quantity of information. Replacing books by microfiches, microfiches by magnetic records, and magnetic records by optical laser tracks, reflects an aim at compactification.

In his brilliant book *"Does God Play Dice?"* Ian Stewart estimated the current yearly output of scientific periodicals to a number around one thousand with at average one thousand pages each. Accessing this accumulating knowledge is bound to become an ever more tricky problem, despite the fragmentation of intellectual work in many specialized compartments, which itself is a consequence of the access problem.

Davis and Hersh in *"The Mathematical Experience"* report that, whereas a mathematics student in 1915 was supposed to be prepared to cover the whole field at examination, in 1940 according to John von Neumann an average mathematician would know about ten percent of the field. Comparing the reading list of a graduate student around 1985 with the contents of a normal reference library Davis and Hersh come to the depressing ratio of 60 to 60,000, i.e., one pro mille.

According to classification lists of specialities from 1868 to 1979 they further note an increase from about 40 to 3,400 items, and also report Stanislaw Ulam's desperation at the fact that by the latter time there were an estimated number of 200,000 new mathematical theorems proved each year. The term scientific pollution lies in the air. Through the discussion perspires a slight desperation at the prospect of anybody being able to discern between what is important and what is not, and hence being in the position of giving reasonable advice for the funding of scientific activities.

The whole situation is, of course, much worse in empirical sciences, such as Physics, Chemistry, or Economics.

Shortening memory in science, and repetitive duplications of "discoveries", are evidence of difficulties to control the access to existent knowledge. The increasing utilisation of computerised data bases, using keywords from titles and abstracts, might not be sufficient to cope with access to the accumulating volume of information. Ian Stewart cites the remarkable fact that Lorenz's seminal contribution to chaos theory was overlooked for ten years because the mathematicians did not have the habit of looking into journals

on meteorology, whereas meteorologists were lacking in the mathematical sophistication necessary to understand the contribution, thus creating a delay of decades in the development of the whole field.

The state of fragmentation also is a bit alarming for the perspective of scientific creativity. As nobody can have any control over his entire discipline it is a safe strategy to play to just continue from any of the tiny riverlets of science, working out from a history of articles over the past five years in the few very specialized journals of exactly that branch.

Unfortunately, the more theorems there are proved about more and more particular issues, the less likely is it that they contain anything really significant. In that respect the scientists may have been in a better position once the theorems were not that many but on average more general and more significant.

Truly new ideas highly depend on cross-fertilization, but that becomes constantly more difficult to achieve the more specialized the sciences become.

2.18 University Cultures

European university culture, until the 1960's, heavily depended on seminars, where various members of the staff, working with entirely different topics, communicated their results. For that reason the staff members had to keep a broad perspective on their disciplines. Relatively little was regarded as being worth publishing, and national and local "schools" were established, which made visits to other environments really interesting.

We tend to look down on the previous generation as they published relatively little. This fact, however, does not imply that they worked little or were less creative. It might just signify that they were more choosy about what they regarded as being significant enough to merit publication.

After large scale production ideals from the US overtook the European style, everything is produced for immediate publication, even the most tiny little idea. The number of journals, which has exploded accordingly, conveniently provides for the space. We still have seminars, but we read already published or accepted papers, which we do not want criticized, and we hardly expect anybody else at the department to understand our whole message. Travel and change of department only results in new personal relations, not new ideas.

It may be that we would urgently need more of interdisciplinary scientific fora in the future just in order to provide for encounters with the unexpected ideas we need to secure creativity.

3 Patronage

3.1 Introduction

The products of cultural activities, and the institutions for their production display an enormous diversity, and, accordingly, the ways for financing them also vary.

Some activities may be carried out entirely on a commercial basis. Others need public intervention for their survival. The main issue in connection to subsidies, in addition to that of the public good character already discussed seems to be the fact that the production period for cultural goods is very long, as is their economic lifetime.

It may extend over much longer periods than the lifetimes of individual artists or scientists, so that it becomes practically impossible for the cultural workers to recover the discounted values of all the future revenues, provided they can at all be anticipated.

Only after very long periods do the prices of cultural commodities reach substantial values, and this only for embodied goods. Painters, sculptors, and architects are thus better off than are composers, writers, and scientists. The uncertainty, inherent in future evaluations, however, makes the situation difficult even for those producing embodied cultural goods.

Investors in such objects tend to regard them as speculative investments, and then everything pertinent to the investors' volatile expectations comes to play. For these reasons the market can seldom provide for an adequate production of culture, and patronage or subsidy becomes an essential ingredient in this context.

3.2 Diversity of Institutions

Taking a quick look at the firms for cultural production we are indeed struck by their diversity: We have universities and schools for education; theatres, opera houses, and concert halls for the performing arts; museums and galleries for the visual arts; libraries and archives for literature. To these come all the historical monuments and entire townscapes

The functions of these institutions are very different. Historical monuments may just have normal commercial use, subject to certain antiquarian constraints.

Libraries, museums, galleries, and archives work as inventories, where pieces of the cultural heritage are stored, kept available, and conserved if necessary. There is a floating borderline to the commercial galleries, publishers, and bookshops.

Next come the institutions for the performing arts, concert halls, opera houses, and theatres, where music and drama are performed for the public. Here too we have the border area of commercial theatre and cinema, record and video production and distribution, the latter in fact offering the performing arts tinned and ready for consumption at home.

Finally we have the institutions for creating new cultural goods, such as the university departments and other research institutes, and the studios of the painters, sculptors, authors, and composers.

It is interesting to note that, whereas the innovative scientific activities are organized in prosperous publicly subsidized organisations, the artistic ones are performed in small-scale private enterprises leading a precarious existence.

Artists, except a few superstars, mainly conductors, architects, and singers, along with the remaining artisans, seem to be the only people in modern society to behave in accordance with Marxian subsistence theory of wages.

To some extent this reflects the tendency of our age to favour the material things above the spiritual. Nevertheless the fact is noteworthy as the conditions for production could in principle be the same in science and in art.

3.3 Uncertainty in Production

In all cultural production there is an extremely high degree of uncertainty concerning the market value of the ultimate product. This has to do with the time period for production, which is very long, also taking the initial training of the artist or scientist in account.

Things are also aggravated by the aforementioned facts that property rights to easily disembodied scientific and artistic innovations are increasingly difficult to protect, and that the full profits from outstanding achievement accrue over very long time periods, occasionally even much longer than a lifetime.

If Gauss had received only the slightest fraction of the value added each time his normal distribution is currently used for pharmacological experiments or industrial quality control, the discounted value would have been enormous.

In the same way Shakespeare and Bach, provided they could have recovered the present values of the revenues from their outputs over the total economic lifetimes, extending for Centuries, they would no doubt have been wealthier than any of the most popular detective novelists or pop stars of our time.

There are, on the other hand, large investments in learning time, under uncertain prospects concerning future harvests. Any distribution of talent tends to be highly skewed, and a reliable diagnostic at early stages is lacking. If we need a reason for the skewness it can be given in terms of definite upper bounds to top performance, quite like the case of the sports.

Uncertainty not only concerns the maximum level of achievement, but also the length of the top performance period, i.e., the length of the real production period.

No singer can have a reasonable estimate of how long her/his voice will survive. No top violinist can have any certainty about how long the common motoric disorders can be avoided, because there is no such thing as an ergonomic way of making music. No writer, composer, or scientist knows for how long the good ideas will continue to appear. Actors may even be dependent on such elusive things as youth and physical appeal.

In a system where revenue is proportional to the quality of achievement, anybody venturing into cultural production, lacking a reliable diagnostic, faces a lottery between a small probability of a very large profit and a large

probability of a small one. The only certainty is the non-recoverable investment cost, which is independent of the quality of the ultimate outcome.

It is not even possible to equate quality to market value. There are many instances where artists or scientists have been "in advance of their age", and have not been appreciated according to merit in their lifetimes.

Those responsible for Thomaskirche in Leipzig employed Johann Sebasitian Bach in 1723 with utter reluctance after having been unable to engage Cristoph Graupner, who was refused leave by his current employer. In the minutes it is noted that *"when it is not possible to get the most outstanding, one has to contend oneself with the mediocre"*. Today we can still compare their talents as each composed a still existent cantata on the text *"Meine Hertze schwimmt in Blut"*. Still at his death 27 years later, the local newspaper wrote in memoriam *"Bach may have been a competent musician, but he was a lousy schoolteacher"*. Among his duties at Thomasshule was to teach Latin to the schoolboys, a boring duty to the avoidance of which Bach even hired a deputy for his own money. It is natural that his employers did not excuse his lack of interest in this obligation on behalf of his compositions, as they for instance declared the St. Matthew Passion to be *"presumptuous and theatrical"*.

From science we can refer to the cases of Galileo, whose heliocentric cosmology invited complete personal disaster, Wegener whose theory of continental drift was completely ignored in his lifetime as it could not be tested, and Semmelweiss, whose early ideas on germs and infections led him to succumb mentally under the ridicule and persecution by his colleagues. In the sequel we will cite more examples of the extreme conservatism of the scientific community.

In the case of the arts it is even customary that prices increase sharply the very moment the artist is dead, just because this fact is a guarantee that the market will never be supplied with more products of that artist's hand.

3.4 Risk and Insurance

As most individuals do not have extreme risk preference so as to choose skew outcome prospects such as mentioned, a kind of insurance for the risks involved might be needed, where the few very high rewards are converted into more numerous smaller rewards.

A research organization such as a university can in fact be regarded as a kind of insurance company, compensating the many failures by the few great successes.

It is well known that even quantitative measures of productivity have highly skew distributions, 10 percent of the scientific research staff being responsible for 90 percent of all published work. This fact perhaps not even signifies a failure of the whole system, but rather a natural state of things.

Note that this has a certain relevance for the present rage for peer group evaluations of the performance of research organizations, as the mere fact of their popularity implies that we are not willing to accept the individual failures as a necessary cost.

A particular problem is that we often do not even know which are the failures and which are the successes. Evaluations are necessarily based on a conservative short run perspective, and, as indicated, really revolutionary innovations never were popular, not even among the contemporary peer groups.

The kind of insurance represented by the universities is totally nonexistent in the case of the arts. To some extent we tolerate mediocre scientists, but we do not tolerate mediocre artists.

Still, mediocrity is necessary to establish the very competition by which the outstanding performance is singled out.

A commercial reward system also tends to be highly dependent on fashion. Antonio Vivaldi was highly appreciated in early 18th Century Venice, and correspondingly rewarded. His misfortune was to die not as young as Wolfgang Amadeus Mozart or Henry Purcell. He lived long enough to get out of fashion, and his venture to start a new career for decent living in Vienna, the new capital of music, became a complete failure.

Having no chance to make any profits from the revival of interest in his music in the 20th century, manifested for instance in around 100 different CD recordings of *"The Four Seasons"*, he finished his days in a state of destitution, like so many other artists.

The really successful businessmen among the artists, such as Händel, or Rubens, always were a minority. Once artistic production on a freelance basis became the rule, the idea of the young bohemian artists who burned their work or tools to get some heat was born too.

Fig. 3.1: *Splendid view of Salzburg with the fortress of the Prince Bishops towering over it. The various ecclesiastical rulers were patrons of the arts; especially music, for a long period, even before the Mozarts. The great baroque composer Heinrich Ignaz Franz von Biber was an outstanding example of this. Among other things, of which we will speak more, he (probably) composed the "missa Salisburgensis", the most monstrous piece of church music ever written, with no less than 53 separate parts organised in six choirs, a continuo group, plus three trumpet choirs! It is a telling indication of the grandeur at which his patrons aspired. Leopold Mozart, father of Wolfgang Amadeus, composer and author of a brilliant violin tutor, lived and died in the service of his patrons. Wolfgang Amadus (or Amadé as he always himself spelled the name) Mozart, to the reproaches of his father broke loose from this kind of servitude, to live the precarious life on a more or less free lance basis. Who would have guessed that this city now, when nobody remembers the name of any of its Prince Bishops (maybe with exception of Markus Sitticus, the joker who watered the bottoms of his guests through ingeniously arranged fountains), mainly prospers from the festival to celebrate its most illustrious son. Mozart's life is extensively documented by his own letters (around 350 in existence) mainly to his father.*

Fig. 3.2: *Another splendid setting at the Mantova Ducal Court, the room for music making. It still bears a note on the door that maestro di cappella Claudio Monteverdi would make music there every fortnight. Monteverdi's correspondence the years he spent in Mantova is a continuous complaint about exigently heavy duties, bad salary and working conditions. Monteverdi eventually escaped to Venice and to one of the best appointments any musician could have in the 17th Century. To be quite true, recent studies have shown that the music room actually used by Monteverdi was different and much smaller than this gallery of mirrors.*

3.5 Patronage in Culture

In history almost all artistic top performance was sponsored by patrons. We may note that such patronage in general becomes more and more difficult in modern times. Only with affluence in a highly skewed income and property distribution is there any room for such conspicuous consumption as may favour the arts.

Fig. 3.3: *The court of the "melomanes" King Fernando VI and Queen Maria Barabara, with Farinelli and Scarlatti on the balcony. Painting by Amigoni. Domenico Scarlatti son of the opera composer Alessandro Scarlatti, is known to posterity through his 555 remaining keyboard sonatas. He spent the later part of his life as composer of harpsichord music and private teacher to the queen. He seems to have lived almost as a member of the royal family with no other duties than composing for the Queen. The patrons were little exigent, and the commitment to the patroness almost only shows up in rapid movements and laborious hand crossings becoming more and more rare over time in pace with the fattening Queen. Farinelli (Carlo Broschi), the other personage on the balcony, was the most famous castrato singer through the ages (recently commemorated in a successful movie). He was actually knighted and with time became a sort of minister having responsibility for such things as the building of aqueducts.*

In particular, though we tend to tolerate inequality resulting from windfall profits as results of lotteries, gambling, stock market gains, or top performances in the sports, we tend to be extremely intolerant with the formation of patrimonies inherited over generations. This displays in the severe taxes on inheritance in almost all the developed world.

Now, the saying that it takes three generations to make a gentleman has a certain relevance in the present context. Obviously, affluent wealth com-

bined with leisure always gave room for cases of extreme aestheticism and devotion to the arts. No matter whether we approve of these idle dandies or not, art patronage did in fact depend on them.

An offspring of wealthy patricians is more likely to support artists than a tennis star or a bingo lottery winner.

Though patronage was a means of financing artistic production, we should not just glorify it, because it could be very repressive to the artists. Haydn spent all his life in almost a sort of slavery of the Esterhazy, being forced to perform a modestly rewarded heavy duty, and to follow the princely family like other domestics on their continuous travels between the family estates in Austria and Hungary. In his oevre there are several hundreds of compositions, never played nowadays, for the baritone (a special sort of base viol provided with plucked resonance strings) which was the delight of his princely patron.

In the same period, W. A. Mozart was almost born to that same sort of servitude to the Prince Bishop of Salzburg, but broke himself free to become something of a freelance artist. As a matter of fact this was not easy, so a more powerful patron, such as the Emperor Joseph II, was needed to cover his escape. This sort of escape was typical. It started with a journey for study, permitted as it also gave occasion for displaying the splendour of the patron, continued with contacts with new and more powerful would be patrons, and ended with "defection".

A quite similar case from the century before is that of Monteverdi, who was the family composer of the Gonzaga Dukes in Mantova. The Gonzaga were a possessive family which for instance delighted in owning an entire community of dwarfs living in a special sort of cave in the mezzanine apartment of the Ducal Palace, like fish in an aquarium, just for the fun and entertainment of the princely owners and their guests.

There exists an extensive correspondence where Monteverdi complains of scant rewards and severe working conditions. Almost his whole family succumbed in the fever haunted swamps of Mantova. Not until 1612, was Monteverdi able to continue his career under the protection of a much more powerful and generous patron, the Republic of Venice, though the Gonzagas needed the satisfaction of formally dismissing him first.

Johann Sebastian Bach spent one month in prison for his audacity to resign his post with the Prince Wilhelm Ernst of Weimar before he in 1717 was able to leave for a new position at the court of Anhalt-Köthen.

There are, of course more pleasing instances of patronage to cite. Domenico Scarlatti was able to spend a large part of his life at the pleasant Aranjuez Palace, where he remained in the service of the Queen Maria Barbara, al-

most without any courtly duties, just composing his harpsichord sonatas for the pleasure of himself and of the Queen.

Likewise, in 1598 King Christian IV is claimed to have offered John Dowland the same salary as he paid his admiral in order to convince the famous lutenist to come to Denmark. Even if the sum might not have been that big, this indicates that competition among patrons for the most renowned artists played a certain role to improve living and working conditions for those.

There are but few instances in history of such overwhelming patronage that the protected artists actually got political power. One instance is in the reign of the so called "melomanes" in Spain, where the famous castrato Carlo Broschi, called Farinelli, who managed help the King to overcome his melancholy, ended up as a kind of minister.

Even more notable is the case of King Ludwig II of Bavaria, whose affection for Richard Wagner was so great that he arranged his whole life around Wagnerian ideas, and provided the composer with wealth which enabled him to buy a palace in Venice. As a rule regents with such excessive interests in culture were claimed to be insane, and disposed of.

Repressive conditions were not only a result of the arrogance of princes. J. S. Bach lived a much better life at the court of Cöthen than in the City of Leipzig, from which period his correspondence is filled with complaints about the lack of resources and meagre rewards.

Some musicians took the full step to entrepreneurship. Händel left the service of the Dukes of Brunswick to become an opera director in London, and in Hamburg Telemann made substantial earnings from producing chamber music in a periodical magazine *"Der Getreue Musikmeister"* to which lots of music lovers subscribed. Such life, of course, subjected the artist to all the uncertainties of private enterprise. Händel for instance went bankrupt.

However, the multiplicity of tiny autonomous states in central Europe, in particular in Germany, governed by Dukes, Prince Bishops, or aristocratic City Councils, also provided a sort of competitive demand for the best artists. Most rulers had genuine interest in culture. It was not always very deep, and their judgement not always the best, but artistic fame spread fast among the knowledgeable, and the rulers were particularly interested in showing off the best manifestations in competition with their equals. Though Duke Wilhem Ernst of Weimar could sentence Bach to one month of imprisonment for wanting to leave his service, he had no possibility to keep him permanently. Bach's itinerary took him from the service of the Count of Arnstadt, to that of the City Council of Mühlhausen, the Duke of Weimar,

and the Duke of Anhalt-Köthen, before he settled as Thomaskantor in Leipzig. Though Bach, as we know, was not altogether happy with its City Council, he could repeatedly use the King of Saxony to his favour in the disagreements.

This was in early 18th Century, but the same situation still existed in late 19th Century, when for instance the young Richard Strauss got his first employment from the ruler of the tiny Duchy of Meiningen, then the Kingdom of Bavaria, and then the Duchy of Weimar. In the centralized national states, England and France, a similar role was played by the nobility, but, being exterritorial, they did not have the same urge to show off. To an even higher degree the same holds true for today's aristocracy: the leading firms.

In the visual arts the case was similar: Well known is the greed and exigence of the Popes when Michelangelo was painting the Sistine Chapel and Raphael was painting the equally huge frescoes in the Papal Apartments.

Some patrons also collected scientists. Descartes actually died from pneumonia during a cold winter in Stockholm, where Queen Christina had invited him, and Katharina the Great of Russia actually bought an entire Academy of Sciences from abroad to adorn her St. Petersburg.

In general it was easier to lead an independent life for cultural workers who did not need capital for their work. This means that, in particular, composers, who needed a host of executors for their large scale works, which could only be provided by wealthy patrons, or architects, who needed expensive construction projects to at all be able to materialize their most ambitious ideas, were most apt to become dependent on patrons.

However, for better or for worse, such patronage is history. It has been replaced by modern sponsorship, and by finance from local or central government.

We may note that regional competition in Europe has meant a lot for the arts, as this is one of the few means of becoming spectacular among the mass of similar communities. The idea has spread that the image of a city of culture favours material production and growth particularly through the attraction on qualified manpower. Whether this is a myth or not is not important as long as the result is beneficial for culture.

The real danger today is the temptation to leave everything to the commercial forces. Several factors cooperate to such an end. One is the extreme neo-liberalism as dissipated from the economics profession itself, now perhaps more than ever before, and readily assimilated by young non-socialist politicians.

Related to this is the neutrality with respect to taste. *"De gustibus non est disputandum"* is accepted without reservation, and we do not dare to distin-

guish between good and bad taste. To let individual preferences decide what should be produced is both "rational" and "democratic", so if the general public wants popular entertainment of bad taste, let them have it!

4 Changing Attitudes

4.1 Background

The character of the consumption of culture, especially of the arts, has undergone very basic change over time. On one hand, consumption has dissipated to a much larger fraction of the population than in earlier times, on the other hand the involvement of the interested consumers has become much more passive than it used to be.

In addition, arts which used to be in the service of society have lost some of their social function and are produced for their own sake. This too in a sense is a sign of decreasing involvement, because this reduces the function of art to become mere recreation and entertainment.

4.2 Dissipation of Culture

The increasing dissipation of the consumption of culture can be explained in terms of the successive removal of various obstacles. In earlier times, music was available for those privileged that could afford the leisure time needed for learning how to make music, and for making it.

Later, the public concert halls and opera houses made it possible to become just a passive listener. It is true that all music making, especially if it was at a princely court, used to involve some listeners, but they were relatively few and essentially the same people as those making music. Anyhow, only a small selection of people were admitted to admire marvels, such as the talents of the flute playing King Frederick II of Prussia.

Even though the later emergent public concert halls and opera houses at times charged as much as to effectively exclude a considerable part of the population, they always were open to a different extent than were the courts.

An amusing example of how remote the idea of a concert hall was in the 17th Century is provided in *"Musick's Monument"* from 1676 by Thomas Mace of Trinity College in Cambridge. In this combined tutor for the lute and the viol Mace ends with a discussion of musical acoustics in general. The practical purpose is a plea to some wealthy sponsor to fund the construction of a concert hall in Cambridge according to Mace's own design.

It is in no way similar to any modern hall. The musicians are playing in a room where they do not see the audience and the audience does not see them, the idea being to protect the artists from any disturbance the presence of an audience might cause, such as coughing. The sound is supposed to be conveyed to twelve audience galleries through channels or pipes, about one square foot in crossection in the music room, but successively reduced to the diameter of a finger at the outlets in the listener's galleries. By the arrangement in different galleries persons of rank are also protected from the inconvenience of perspiring together with persons of inferior social standing. It is obvious that Mace thinks the concert hall itself is as novel an idea as the special design he proposes.

The public concert or recital, with tickets sold at a charge, itself is an idea dating back to mid 17th Century. However, music was mostly performed on small scale, in an inn or even at home. An early instance of unusually persistent public concerts, though at a small scale, is given by the series of 10-15 concerts a year which Carl Friedrich Abel and Johann Christian Bach were giving in London in 1765-1780.

Occasionally, as in the case of Danican Philidor's "Concerts Spirituels", organized during Lent 1725 when the theatres were closed, even a gallery in the Tuileries could be opened up for public concerts. Early instances of permanent concert halls are the New Music Hall in Dublin dating from 1741, where Händel's "Messiah" was originally performed, and the Holywell Music Room in Oxford dating from 1748. The concerts in the Leipzig Gevandhaus date from 1781, whereas the important advent of the foundation of the "Gesellschaft der Musikfreunde" (the Musikverein) in Vienna dates from 1808.

It is obvious that the time of the French Revolution is the period when the public concert halls in the modern sense arouse. Obvious is also the concurrence in time with the emergence of the orchestral symphony and with large-scale training of musicians in conservatories.

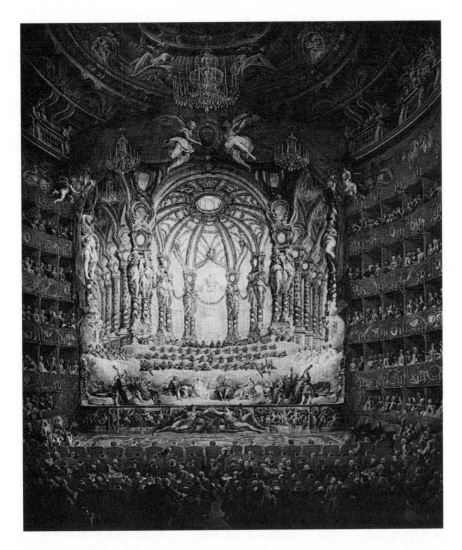

Fig. 4.1: *Splendour of the Baroque opera. In this 18th Century painting by Panini we see a performance given in Rome to celebrate the birth of the French Dauphin. Very soon after opera was invented in the 17th Century after the first experiments in the Florentine Camerata it developed to large scale spectacle with elaborate use made of the stage and the potentials of theatre machinery. Monteverdi's "Orfeo "from 1607 is described as "Favola in Musica" and is composed with an intimate madrigal-like touch to it, whereas Monteverdi's own late operas from the 1640's, "L'Incoronazione di Poppea" and "Il Ritorno d'Ulisse in Patria" are denoted "Dramma Musicale" and have developed all the elements of opera as we understand it today. Quite alike was the development from the "Masque" of the English court to opera in the days of Blow and Purcell.*

Opera always assumed a big machinery, from Monteverdi on, so it had to be performed in specially equipped houses, and those naturally had a certain audience capacity. It is very difficult to find operatic repertory which could be performed outside a stately theatre: there are Blow's "Venus and Adonis", Purcell's "Dido and Aeneas", and Händel's "Acis and Galatea", but that almost is it. Opera was the invention of the Baroque, and Baroque opera already made constant and extensive use of the most elaborate theatre machinery.

But access to the opera houses these days used to be utterly restricted. In the opera house at Drottningholm, the out-of-town palace of the Swedish Royal family, all the benches still carry the original plates indicating for which courtiers they were intended in the 18th Century. So, it was not exactly intended for the amusement of the clerks and artisans of Stockholm.

And when Händel was involved in his fierce economic warfare in London, the battle stood between the Royal Opera, and the Opera of the Nobility, which actually was an enterprise of the Prince of Wales.

The advent of public opera houses and concert halls no doubt dissipated musical culture to an enormously larger audience. In our days, the gramophone industry, broadcasting, and television have even more contributed to the dissipation of culture, by reducing the cost for the consumption of music to a tiny fraction of what it used to be, even compared to the open public concert halls and opera houses.

Exactly the same change occurred with respect to the general availability of literature through diminishing printing costs and the dispersal of public libraries, as contrasted to the private book collections of the nobility to which only a few happy mortals had access.

4.3 Leisure

As for the issue of passivisation, there are several reasons for it. One is the professionalistic ideal, actually dissipated from classical economics. According to Smith and Ricardo, maximum public benefit is to be obtained from complete specialization.

Everyone is a professional, and a producer, in just one field, and a consumer in all the other. This is in very sharp contrast to earlier ideals of civilisation, in particular such as preached by Baldassare Castiglione in his

"Il Cortegiano", dating from 1513-18, and being the bible of humanistic education ideals for Centuries.

Another reason for passivisation was the new ideological demands on the arts, explicitly formulated by the French Revolution, requiring them to be immediately accessible to all without any previous learning or addiction process.

The passivisation becomes a problem in Western society, because one of its facets is that such leisure time, as used to be available for the privileged classes only, has now spread to a large fraction of the population.

Increasing length of life, increasing time in education, lowered age of retirement, increasing vacation times, and reduced working hours both on a weekly and on a daily basis, all combine to make working time a surprisingly small fraction of total life time in the developed world today, significantly less than 10 percent.

Whenever politicians become preoccupied with these matters, they suggest consumption of culture as an appropriate activity for the almost boundlessly increasing leisure time. Religion and politics engaging less people than ever, there is not much else left.

Moreover, all the repetitive work for manpower being almost eliminated by automatic machinery the last decades, we are now witnessing unprecedented durable unemployment rates, which do not seem to be likely to be wiped out by the next turn of the business cycle. It is only to be expected that culture consumption will be suggested as a proper activity for the unemployed too, quite as it has already been suggested for the retired.

If the proponents of political measures for sharing the few remaining jobs among the employed and the unemployed have it their way, we will just witness even more of mere leisure time.

As for why culture is a suitable use for the excess leisure time, one single positive factor is usually cited, the negative one, that there is not much else, being referred to already, and that is: improved education. However, the spectacular recent improvements in education in the developed world have been focused on the "useful" material sphere of production, and nobody has yet proved that a doctor in electronics is more likely to appreciate the arts than a plumber.

Anyhow, it is very hard to understand how all that extra leisure can be filled by the passive consumption of culture, by attending theatre performances and concerts, and watching pictures in art galleries.

A more active involvement, such as was the use of the privileged of earlier generations, seems to be necessary if such a scheme is to work.

4.4 Addiction

Consumption of culture is subject to specific effects, which we could label learning or even addiction, utility of consumption in the technical sense of economics being in some way dependent on accumulated past consumption.

Provided cultural addiction is regarded as a desideratum, we deal with "merit wants", justifying various subsidies according to economic theory.

It is obvious that consumption of culture can take place on several levels, involving different degrees of understanding and involvement. As an example, symphonic music might, somewhat unconsciously, be perceived just as "beautiful" or captivating. This was actually the outspoken aim of the French Revolution.

Musical sound of more complexity could, however, also be analysed by the listener in its separate strands, represented by individual voices and instruments. For the enjoyment of counterpoint music, such analysis is essential. A deeper emotional understanding also assumes some knowledge of the grammar of musical rhetoric, for instance relating emotions to musical intervals.

At the intellectual level there are also all those messages that were abundant in the music of the past, the comprehension of which presumes capturing the basic principles of musical rhetoric, maybe even including some knowledge of outmoded number mysticism.

It may be taken as granted that the individual listener learns a little more in some of these respects in each session, and that the enjoyment increases by learning. Any concert audience is a mixture of people representing such different stages of the learning process.

Addiction in culture is a phenomenon known since the days of Pythagoras. In his native island of Samos, Pythagoras first witnessed some difficulty in attracting students, so he is reported to have paid a student three obols a day for listening to his lectures. After a while he pretended that he had no more money to pay the student, who, however, meanwhile had become an addict to learning, so he was now prepared to pay Pythagoras in his turn for going on with his lectures. Later, when Pythagoras founded his "brotherhood" in Croton, the members (like those of modern American religious sects) contributed all their property to the common fund. They were, however, entitled to leave the brotherhood and would then (unlike the modern sects) be entitled to retrieve twice the money originally contributed.

Fig. 4.2: *A great amateur musician: Mme Henriette de France, daughter of Louis XV to whom Forqueray dedicated his most difficult works. Painting by Nattier. The viol, or "viola da gamba" was a beloved instrument for noble amateurs in all Europe. In England of the period of the civil war, consort music for viols of various sizes and pitches was as popular a way of social intercourse as the string quartets became later. In the period of this painting the violins had taken over almost the entire market, and only the two extreme members, the tiny "pardessus de viole" and the large "basse de viole" remained. A lot of virtuoso music for the base was composed above all in France by Francois Couperin, Antoine Forqueray, Marin Marais, Louis de Caix d'Hervelois, and others. Except for the few virtuosi/composers themselves, the music, published to a large extent, was played by noble amateurs. Dedications, long "avértissements" and correspondence from the masters to royal or noble amateurs testify to this. To judge from the quality and technical difficulty of this music, the skill of these amateurs must indeed have been considerable.*

They, however, still had to keep their oath of not disclosing the secrets of the brotherhood. One member is known to have been drowned for telling outsiders about the existence of the dodecahedral solid.

4.5 Dilettantism

We also have to take account of amateurism, particularly significant in music, as an extension of the active involvement, and as a means of learning to understand more. In times past, the leisured class was deeply involved in this, as witnessed by the abundant production of chamber music for amateurs, from viol consorts to string quartets.

That music was most likely not composed for being performed at concerts at all, but just for social entertainment of the people making music. Therefore, performances of such music in concert halls in our days would look a little misplaced to people from the days these works were composed.

This is also testified by the fact that music publishers used to concentrate on chamber music which could be sold at a profit to an interested and wealthy group of amateurs. It would not have occurred to any composer to send a complete opera or large scale sacred work to the printers.

The reader may want to object that collections of various "concerti grossi" were in fact published. It is then overlooked that, though we are used to listen to entire symphony orchestras playing them, they, except the solos, as a rule needed no more than two violins, viola, cello and harpsichord, so we in fact still deal with chamber music performed by people that could gather in a drawing room. Sales of printed music was then also promoted by letting violas and double bases, playing in octaves with the cello, be optional, and by suggesting violins optionally to be replaced (or doubled) by recorders, flutes, or oboes, celli by bassoons or viols.

The turning to symphonic music proclaims the onset of a more passive attitude to the consumption of culture. We note that amateurism tangles the line of demarcation between consumption and production, and that there are numerous historical examples of amateurs whose skills in no way were inferior to those of contemporary professionals.

These things are not so pronounced in the visual arts, but there exist parallels. There is a process of learning to see pictures: understanding perspective in terms of geometry and colour shading, getting a feeling for the distri-

bution of weight in the compositions, and grasping the emotional message in a more or less vigorous brushwork.

As to the motif, the significance of all the symbols, quite like the meaning of musical intervals, can be learned. Iconography also involves the standard stock of episodes from history, religion, and mythology, represented over and over again, in the visual arts as in music. There has always been a significant extent of amateurism in painting too, though it has been less important than in music, most likely because the social nature inherent in music making tends to favour this particular form of amateurism.

4.6 Schliemann, Fermat, and Galois

As for science, we note that we need not go very far back in history to find successful amateurs, such as L'Hospital, Schliemann, or Galois. Heinrich Schliemann (1822- 1890) claims in his memoirs to have decided at the age of six to become an archeologist and to excavate Troy. The road there was long. He started his education as a business clerk in Amsterdam, where he discovered his remarkable linguistic talents. He obviously was able to learn a completely new language in about three weeks, and his diaries, when he later was travelling in Asia Minor, were always written, not only in the local language but in the local dialect. His further career eventually brought him to St. Petersburg and to Moscow as an extremely successful businessman, banker and stockbroker. By the age of 50 he had become a multimillionaire. He then decided to devote himself to the dream of his childhood, to excavate Troy, where he, according to Homer, thought it should be located, and sold all his possessions.

His wife did not wish to change her life that radically, so he divorced and married a young Greek woman, chosen from a set of portraits of girls eligible for marriage dispatched to him on request by the Archbishop of Athens. He thought that, as he loved the Greek language more than any other, he would only be happy with a Greek wife. The marriage indeed was a happy one, and the two children were named Agamemnon and Andromake!

Anyhow, Schliemann excavated, not one, but seven different Troys, dating from various periods, the one from the Homeric Age bearing obvious signs of violent destruction!

He obviously was satisfied with the results, because in a letter to his son he wrote:

"You should try to follow the example set by your father; who in any situation whatever has shown what a man can accomplish by energy hard as iron.

During the years in Amsterdam I accomplished what nobody did before nor will accomplish in the future.

When I became a businessman in St. Petersburg I was the most shrewd and cautious man on the stock exchange. When I began to travel I became the most excellent traveller.

Never before has a businessman from St. Petersburg written a learned book, but I have written one which has been translated into five languages and is admired everywhere.

Just now as an archeologist, I am a sensation in Europe and America, as I have discovered old Troy, which the archeologists have been looking for in vain for two thousand years."

A contrasting contemporary to Schliemann is Evariste Galois (1811-1832). Galois had a great love and extraordinary talent for mathematics. He applied for admission to the École Polytechnique three times, but was rejected. At one admission interview he answered a simple question with a sophistication that the professor could not comprehend. He also submitted a number of papers to the Academy of Sciences, but they were all rejected. It seems that the first two attempts failed because the referees, the great mathematicians Cauchy and Fourier carelessly just lost his contributions, the third because statistician Poisson did not comprehend it.

Degraded to student in a teachers' college Galois then became politically involved in an opposition movement against "le Roi Poire" Louis Philippe, together with other illustrious personalities such as Alexandre Dumas, and was imprisoned for a while. He died in a duel at the age of 20, but the night before the duel he wrote down that advanced part of mathematical group theory which is now called Galois Theory, as every student of mathematics knows.

It is interesting to note that by the same time as his contributions were refuted Dr. Savart's rather ridiculous *"Mémoire sur les instruments à musique aux cordes et à l'archet",* where he invented the trapezoid violin, mentioned elsewhere in this book, was read to the same academy and printed in its transactions.

Before the duel Galois took farewell of his friends, and the facts that his adversary is only known by initials, and that his own pistol seemed to have

Fig. 4.3: *Heinrich Schliemann, excavator of ancient Troy. Schliemann was a very successful businessman, educated in Holland. He built up his wealth in St. Petersburg. Schliemann had extraordinary linguistic talents. It normally took him three weeks to pick up a new language, and when travelling he always wrote his diary in the local language, or even in the local dialect. At the age of 50 he started a new life, determined to find Troy where he thought Homer had suggested it was located, and he indeed became a most sensational archeologist. He claims to have been determined to achieve this since his childhood when his father brought home a book on this topic.*

been unloaded have been interpreted so that the duel in fact was a concealed way of suicide. Scientific suicides due to the intolerance of the scientific community are spoken of elsewhere, but Galois hardly even had a possibility of becoming a scientist.

Another instance of a prominent amateur scientist is provided by Pierre de Fermat, judge in the city of Toulouse. Fermat made several notable contributions to science, such as Fermat's Principle concerning the way light rays

travel through a heterogeneous medium, but he is probably most famous for the so called "Fermat's Last Theorem". When reading his copy of the ancient Greek mathematician Diophantus's "Arithmetics" around 1637, in original Greek and parallel Latin translation he made several notes in the margin. Diophantus discussed the ease to find triples of integers that fulfil Pythagoras's Theorem, such as $3^2 + 4^2 = 5^2$. Fermat considered the possibility of finding triples of integers that fulfil the equation $a^3 + b^3 = c^3$, and found that there are none, neither are there any for higher powers. He noted in Latin *"It is impossible for a cube to be written as the sum of two cubes, or a square of square* (fourth power) *to be written as the sum of two squares of squares* (fourth powers)*, and generally for any power greater than two to be expressed as the sum of two equal powers. I have found a marvellous proof of this, which the margin is too small to contain"*.

For 350 years prominent mathematicians have tried their hands at recovering the proof, but the problem has been evasive. Fabulous sums, in view of the limited practical usefulness of the theorem, have been at stake as prizes, and the finally successful attempt due to Wiles was so complex as to require hundreds of pages and dozens of reviewers to evaluate the validity.

In this context we should also mention James Prescott Joule, Manchester brewer and enthusiastic amateur scientists, who spent much of the decade 1837-47 on research in what today is named thermodynamics. He was among the first to establish that heat is not a material substance, but rather a form of energy. The scientific community first took little notice of him due to his amateur status, though after he got in touch with Lord Kelvin he was taken more seriously. He came close to formulating the First Law of Thermodynamics, and the measurement unit for energy is now named *Joule* in his honour.

There have been many more important amateur contributions to science over the ages, and science generally still has a considerable non-specialist readership.

Some disciplines of the humanities, especially in the fields of archeology, art, philosophy, literature, and musicology, could even be regarded as mainly producing for a cultured general public, even though some of their representatives might object to such a description.

The natural (and sometimes social) sciences today unfortunately put a barrier to such amateur readership through clouds of technical terms. This is the effective cause of the emergence of "the two cultures".

On one hand it may seem odd that an educated person is supposed to know the dates for all important battles, whereas knowledge of basic physics or chemistry is not necessary, on the other one gets the impression that fancy

terms sometimes become an end in itself, rather than a regrettable obstacle for obtaining a wider readership.

4.7 Specialization

A return to more dilettantism would be contrary to the currently dominant professionalistic ideal, which is ultimately based on classical economic principles. Since Smith and Ricardo, we pretend to know how immense the productivity gains are from the division of labour, specialisation, and multilateral exchange.

Adam Smith in his famous observation on the division of labour, emphasized the resulting productivity gains in pin making.

With Ricardo we could imagine that based on such division of labour, education, maybe combined with selection according to natural talent, would establish a comparative advantage in one particular operation for each individual, so that the best aggregate result would always ensue from complete specialization and multilateral exchange, among individuals as among nations.

Do-it-yourself philosophies become second best solutions, appropriate only in the presence of taxes, preventing you from harvesting the full profits from complete specialisation, just as tariffs do in the case of international trade.

Anything individuals do, except one kind of work, is leisure and consumption, which is both the unique objective for the economic process and the means of recreation to attain maximum labour productivity.

4.8 The Ultimate Purpose

This, of course implies that producing material living standard is the goal for the whole economic activity, even if this is seldom explicitly spoken out.

Everything else, such as culture, derives its usefulness indirectly, either as refreshing the labour force, or by directly providing jobs as a productive activity. The value of a concert or theatre performance is thus, by cost ben-

Fig. 4.4: *The Dome of the Florence Cathedral Santa Maria del Fiore was constructed by Filippo Brunelleschi in the period 1420-1436 with an amazing arsenal of specialized precision machines, partly operated on the small movable platform hanging on the dome itself As a worthy companion to the dome, and a reminder of the long tradition, the picture shows the bell tower designed by Giotto di Bondone in 1334. The setup of Brunelleschi's work site and machinery was widely admired and is well documented in drawings by his followers. If the worksites of the medieval Gothic Cathedrals were known in equal detail the ancestry might be traced even longer back.*

efit analysis, established in terms of jobs for cloakroom attendants and sales of hot dogs and beers.

In principle things could be seen the other way around, material standard envisaged as an entirely indirect benefit in terms of its potential for favouring culture, but things are never seen this way nowadays, though we could argue that culture in fact is the only thing that remains of human activity in the very long run. In that perspective past material production tends to be buried in earth.

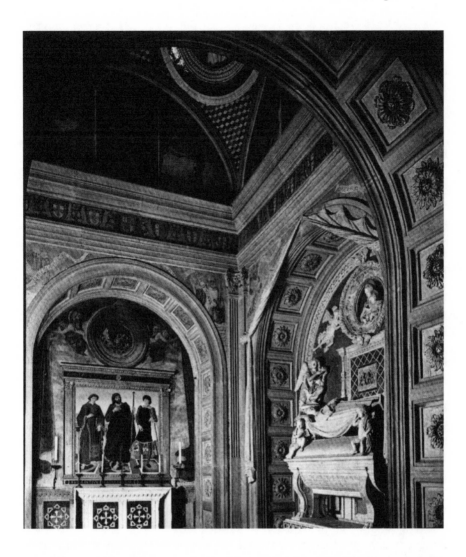

Fig. 4.5: *The "Cappella del Cardinale di Portogallo" in the exquisite renaissance church San Miniato al Monte in Florence. This chapel, dedicated to a Portuguese cardinal who was unfortunate to die in Florence in 1459 at the age of 36, is a real treasury of Florentine art. The tomb monument is sculpted by Antonio Rossellino, the altarpiece painting is by Piero di Pollaiuolo, the little circular ceramic reliefs are from Luca della Robbia's workshop. Opposite the tomb, not seen in the picture is a delicious annunciation by Alessio Baldovinetti. In all this is Florentine renaissance distilled.*

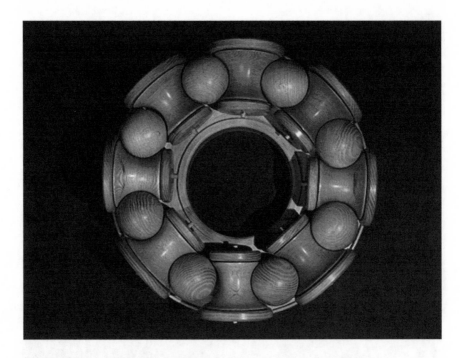

Fig. 4.6: *Ball bearing of a surprisingly modern look to reduce friction in rotational motion. Working model built in 1987 for Istituto e Museo della Scienza in Florence after a drawing in Leonardo's Madrid Manuscript.*

In earlier times, when people toiled hard to build the medieval cathedrals, things might have been seen in this reversed way.

Although we, in terms of textbook economics, could include the enjoyment of eternal life in the utility functions of our ancestors, and investments to this end, such as pilgrimages and work on cathedral projects, in their budget constraints, I am not sure that this way of interpreting their conduct would be doing them justice.

4.9 Florence and Vienna

Amateurism and dilettantism under the professionalistic ideal suggested by economists has fallen into disrepute and become a bit ridiculous, though the

names of amateur and dilettante where originally distinctions of honour, designating those that made something for pleasure and not for money.

It is implied, of course, that those doing something for money do it better than those doing it for pleasure. To some extent the willingness to pay from an audience is a test for the truth of this.

But, it must not be forgotten that, for instance, music was once made for one's own pleasure, without any intention to perform it for an audience. As a matter of fact music making involves not only the ears and the brain, but the whole body, and it is for this reason that just passably mastering some piece can give the performer a more intense pleasure than passive listening to a flawless performance by the best virtuoso in the world!

The professionalistic ideal could be contrasted to the dilettante ideal of the universal man, coined during the Renaissance, preached by Castiglione's influential treatise, and materialised in individuals such as Leon Battista Alberti or Leonardo da Vinci.

Florence as a cultural centre dates back to the period of fierce civil wars between the Guelf and Ghibelline parties, with intellectual giants such as Dante in the 13th and Giotto in the 14th Century.

But the real golden age is relatively short, the Fin-de-Siècle of the 15th Century, under the benevolent reigns of Cosimo di Medici, Pater Patriae, and Lorenzo di Medici, Il Magnifico. Afterwards it all abruptly ends in the nightmares of Savonarola's fanatic theocracy, and the tyranny of the later Medicis, promoted Grand Dukes.

In that short period we find painters such as Sandro Botticelli, Piero della Francesca, Raphael, Michelangelo, Andrea del Sarto, Leonardo da Vinci, and Piero di Cosimo, further sculptors such as Verrocchio, Donatello, Brunelleschi, and Ghiberti, architects, poets, and scientists, so as to provide a complete list of Who is Who of Intellectuals of the Millennium.

The occupations were happily mixed up. Leonardo's notebooks, as everybody knows, provide an entire encyclopedia of science and technology. He also was reported by contemporary sources as an outstanding performer on the lira da braccio, and to his various occupations belonged being engineer in-chief to Lodovico Sforza.

Well known are his anatomical drawings and the construction drawing for the "ornithopter". Less well known is that he worked on problems such as the inscription of regular polygons in a circle, or on the reflection of light in a spherical mirror.

In the period 1480-1500 Leonardo, as a matter of fact, mainly earned his living as an engineer in chief to the Duke of Milan, Lodovico "Il Moro" Sforza. In a letter to Isabella d'Este a contemporary commentator writes

that he (Leonardo) *"is keen to study geometry and cannot bear to touch the paintbrush"*. Leonardo's reluctance to complete his painting of the "Battle of Anghiari" commissioned by the Florentine Signoria also bears witness of this.

In this capacity of engineer, Leonardo worked on applied projects of hydrology, fortifications, and arms for his warrior patron, but he also more and more transformed into a pure scientist, fascinated by the basic laws of nature.

When he, after the overthrow of the Sforza Dukes, by invitation of King Francois I, spent his last years in France, his Royal patron mainly appreciated Leonardo as a "philosopher". According to Benvenuto Cellini the King doubted that *"there had ever been a more learned man than Leonardo"*, and he could only bear to miss him a few days a year as his conversation partner.

In this context it is appropriate to underline two things: First, Leonardo was not an isolated incident, but one of many artists/engineers. Second, the combination artist/scientist was nothing accidental, as could be inferred from the many instances, but a result of a substantial synergy in combining the various activities.

As for the ancestry, there is ample documentation for the construction process of Brunelleschi's cupola of Santa Maria del Fiore, the Florence Cathedral, started in 1420. It is true that the contemporaries admired Filippo Brunelleschi, not so much for the beauty of design of the dome and lantern, as for the organization of the work site, with all its ingenious cranes and other machines.

In a painting by Biagio di Antonio on the topic of "Tobias and the Archangel", the city of Florence can be seen in the background, and the tiny scaffolding, hanging on the cathedral dome in progress can also be seen. The setup is corroborated by drawings of this ingenious device, which could be moved further up in the process of work.

Estimating from its size, it could not accommodate many workmen. As it has been calculated that about 13,000 kg of material had to be lifted and moved each day, it is obvious that the use of cranes and other machinery was a necessary condition. Many of those machines may be seen in construction drawings by Brunelleschi's followers, such as Taccola, Francesco di Giorgio, and Leonardo himself. Moreover, a wide selection of these machines have recently been built up as working models in the History of Technology Museum in Florence.

It is thus obvious that a substantial part of for instance Leonardo's drawings represented not just science fiction fantasies, but working machines invented by himself or by his predecessors. The character of the inventions

is astonishingly modern, aiming at automation, and at economizing with energy, even manpower. The output was considerable. Leonardo alone left around 1,800 documented designs, of which 600 still exist.

Leonardo later aimed at producing a systematic encyclopaedia of machine elements, such as gears converting rotation speed and momentum, gadgets for transforming uniform rotational motion to back and forth motion, and devices reducing friction. Among the most curious items is a complete screw jack of astonishingly modern style.

The attitude of the artists-inventors-scientists varied. Brunelleschi preferred to keep a certain secrecy of trade, and even tried to get the Signoria to grant what is thought of as the first patent in history. His followers in stead preferred to get fame through publishing the results. A completely new thrust was illustration. Classical writers, such as the Roman architect Vitruvius, had used verbal descriptions alone which were very difficult to decipher and visualize.

Moreover, there definitely was a substantial synergy in the activities. To the task of designing a cupola of aesthetic appeal belonged to calculate the static stability of the structure, further to devise the material and shape of the building blocks, and how they would be fitted together. Stability even had to be calculated in a dynamic sense, at every stage of the construction, as the cupola was built without any wooden building mould or support at all. Further, the architect had to plan the construction work as a process, organize the worksite accordingly, and to devise all the machinery that was necessary.

Likewise, the sculptor/architect of a fountain also had to solve the water supply problem. Accordingly, organizing water supply and drainage in cities was another important task for the artist/engineer. Once the power of illustration in publications was discovered, it was the good draftsman who was at an advantage.

It is worthwhile to remind that despite its lack of professionalistic specialisation, the Renaissance was one of the most productive ages in the history of culture.

Of course we could assert that this state of affairs was natural when intellectual life was still in its infancy without even a sharp dividing line between art and science, and that evolution, involving successive splitting in specialities, has made such dilettantism obsolete.

But then we once again meet difficulties in confronting fin-de-siècle Vienna. This definitely occurred after the modern set of specialities had been firmly established in the intellectual field. Yet we deal with another of the most productive settings in the history of culture.

Fig. 4.7: *The famous dining room interior of Palais Stoclet in Brussels. It was built by the Viennese architect Josef Hoffmann in the period 1906-11. The years around 1900, the arts in many countries revolted against the imitation of previous styles, which is testified by the variety of terms associated with this change, such as the "arts and crafts", "fin-de-siecle", "Jugendstil" and "art nouveau". Nevertheless it was in Vienna that the most manifest and organized break took place. The change also penetrated to all facets of culture: architecture, painting, music, literature, and science. There was a surprising unity, interdisciplinarity and a moral ethos to the purpose of making culture rid of conventional lies of various kinds, be it in conventional rhetoric or deceitful decoration hiding the real function of an object. The Palais Stoclet though in a different European capital was Hoffmann's greatest chance of transferring his ideas to practice. The mosaics of the dining room are by another prominent Viennese artist, the painter Gustav Klimt.*

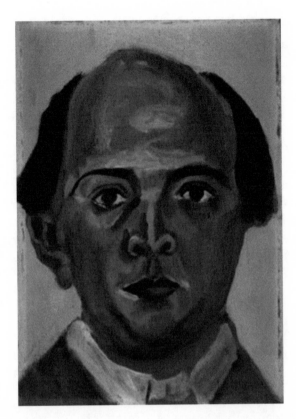

Fig. 4.8: *Self-portrait painted by composer Arnold Schönberg. There was not only much social intercourse and unity of direction among cultural workers in fin-de siècle Vienna, but also an impressive active interdisciplinarity which favoured amateurism in side interests. The productivity such dilettantism resulted in contradicts our specialization ideals. Schönberg painted at least half a dozen self-portraits of which this is the so called "blue portrait", due to its colour tone. In this context we could also mention philosopher Ludwig Wittgenstein who produced fine sculpture.*

The Fin-de-Siècle of the 19th Century in Vienna witnessed the simultaneous activities of scientists such as Freud and Wittgenstein, writers such as Zweig and Hoffmannsthal, composers such as Mahler and Schönberg, painters such as Klimt and Kokoschka, architects such as Josef Hoffmann and Otto Wagner, just to mention very few. It is almost difficult to find any field of the human intellect which was not cultivated there.

We also actually know that, in the case of Vienna, the protagonists were in close contact with each other, and that there was a very far reaching cross

fertilization across the various fields. Wittgenstein, for instance, was an accomplished sculptor, and Schönberg was a fine painter.

It is very unlikely, that the two cases cited are mere accidents, that side interests, interdisciplinarity, and else everything contrary to narrow specialisation had nothing to do with the outbursts of productivity.

There is obviously something wrong in applying the classical economic principles to the cultural sector. First we can advance the following obvious argument: Smith's observation may be highly relevant in the case of mechanically repetitive operations. However, as just the most mechanically repetitive operations are carried out by robots nowadays, everything pertinent to repetitive operation becomes generally less important for manpower than it used to be. We also note that activities in the fields of arts and sciences in particular are as far from the repetitiveness of Smith's pin-making as we can possibly get.

4.10 The Fin-de-Siècle

Before leaving Fin-de-Siècle Vienna, we should, however, underline that this renewal in culture was an international, at least European, movement. Artists moved extensively between venues: Josef Hoffmann made some of his most elaborate work in Brussels, whereas Alfons Mucha did the same in Paris. The movement went on simultaneously in Barcelona, Brussels, Budapest, Glasgow, Nancy, Prague, and Vienna, and its international character is emphasized by the variety of names: Arts and Crafts, Art Noveau, Fin-de-Siecle, Jugendstil, and Secession.

The main break was with all the pompous and imitating "neo"-styles of the 19th Century: Neo-Gothic, Neo-Renaissance, Neo-Baroque, etc. Nature in terms of lavish floral decorations became an important inspiration, like sensuality, in particular emphasizing the female forms, in contrast to the 19th Century when even turned table legs were sometimes considered indecent.

During this movement, broadly speaking, 1890-1920, one can distinguish two separate periods, the first, dominated by Nancy where the decorative elements almost concealed the functionality of furniture, metalwork, porcelain, whatever, the last, dominated by Vienna where the functionality of the objects was in stead emphasized, and excessive decoration denounced as

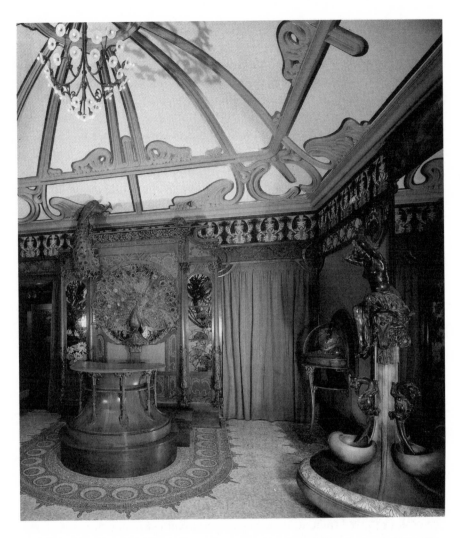

Fig. 4.9: *Chech artist Alfons Mucha produced this lavishly decorated jewellery shop interior for George Fouquet at 6, Rue Royal in Paris around 1900. The jeweller and the artist had a long collaboration also for jewellery. Mucha produced some of the most exclusive pices for famous actress Sarah Bernhardt - for whom he also designed performance publicity. It is notable that already in 1923 the whole interior was considerd outmoded and scrapped. It was later reassembled and put up in Musée Carnavalet. (Today transferred to Musée d'Orsay.)*

being similar to elaborate rhetoric as it concealed the function. "Das Haus ohne Augenbrauen" was an expression of this.

Actually we are ahead of the story we are going to tell in Chapter 6 about paradigm shifts. This was indeed one of the most important shifts in attitude to art. We will consider other paradigm changes, such as the baroque, or the romantic era, but not this one again.

A final remark should be added which links to what we already said about Nazi ideology following the multi-ethnical and intellectual environment in Vienna, quite as Savonarola's theocracy followed the particular blossoming of early renaissance Florentine culture. Some of the artists of the renewal movement later adopted an extreme nationalistic attitude. For instance, Alfons Mucha excelled in producing pictures that represented the typical Slavic national characters and virtues. Another extreme example is Swedish painter Carl Larsson, who started by putting up his ideal Swedish home in Dalecarlia, the land of all that was real Swedishness. He produced a picture book of his home that was translated and circulated in many countries. His full-wall painting in the Swedish National Museum of Art "Mid Winter Sacrifice" can still be seen by every visitor. Hitler would have been delighted to see all these mythological musculous blonds making human sacrifice to some obscure Germanic god. Maybe it is natural that such things happened in the periphery of European civilisation.

4.11 Nonlinearities

There is, however, something more to it. Underlying the classical economic principles referred to here, there is a tacitly assumed linear structure. Once education is finished for an individual, the comparative advantages are assumed to become fixed in proportion.

The productivity of the worker, who, on the basis of his comparative advantages, specializes in cutting the thread for the pins, remains unchanged no matter how many pins he cuts, and no matter for how long he goes on with just this single occupation.

There is no room for facts such as that for each workman ultimately there is decreasing marginal productivity due to monotony in any particular activity, and that the productivity of the traditional artisan might be increased by the pleasant variation of different operations as compared to that of the worker at the endless conveyor belt.

Introducing simple nonlinearities to cope with this would blow up the whole professionalistic ideal. Accordingly, it is possible that overall productivity might even be increased if labour division was not complete.

We should also recall that our discussion started with the identification of excess leisure time for which cultural activities have been considered an appropriate use. By way of introduction, it was noted that passive consumption would not be sufficient to meet this end and that consumers would have to take a more active interest in culture.

It does not matter whether we call the resulting activity production or not, but if we choose to, we note that the existence of excess leisure is an indication of too high an overall labour productivity which could be lowered by a certain measure of dilettantism, thus reverting to Castiglione's ideal.

It is true that this ideal was originally suggested for the select class of noble courtiers, but what, if not excess leisure, characterized this class? Their ideals could now, in fact, be extended to a much larger class of the population.

4.12 Superstars

At the opposite pole of cultural dilettantism is when a few superstars provide for all production in culture. To some extent this is the consequence of technological change pertinent to the cultural sector.

Because of the modern development in mass communication technology, through printing, broadcasting, and television, combined with the decreased cost and increased quality of making photo copies, records, sound and video tapes, a decreasing number of cultural producers can satisfy an ever larger demand.

Why should then anyone bother taking the subway to the local concert hall to listen to a mediocre violinist, or even fiddle himself for an even worse performance, if he can easily put a video tape into the black box and enjoy the best violinist in the world on a super cinemascope screen with hi-fi stereo sound, watching and listening in bed with a remote control in his hand?

Moreover, no artists in the world, performing live, can compete with those patchworks compiled from their own recorded best fragments. The listener can be saved from awful things such as tuning, and further processing can also remove repulsive features such as spitting singers and visibly perspir-

ing violinists. Instead, the performers can constantly show an attractive and relaxed appearance, no matter how demanding a certain passage is.

Undoubtedly this attitude gives rise to economic problems for local concert hall and opera companies. The formation of superstars is favoured, and the precarious existence of all the cultural workers, whose fault is not so much not being good enough as not being best in the world, is exacerbated.

To a certain extent, the same things happen in science, as teaching at universities can be reduced to an exegesis of a few texts written by Nobel Laureates and Academicians.

As a consequence the competition necessary to filter out the new superstars might then even collapse if the stratum below the superstars is removed.

4.13 Removing Constraints

Of course, there is no way to undo past technological development, and it is not even desirable, despite the problems caused. The reason for such development is always to remove obstacles to production and consumption by increasing the market and/or decreasing the costs of production.

Listening to music as compared to playing for one's own pleasure, removes the necessity of acquiring the instruments and the minimum skills needed for transforming the scores into sound. The cost in terms of money and time saved is considerable.

Next, performing for a physically present audience, as compared with broadcasting or televising, involves large transportation costs for the audience, which still remains rather limited in size and thus also results in large overhead production costs per listener.

By removing the spatial constraint of physical presence for the audience, transmission through ether media both eliminates the transportation cost and divides the overhead production costs among an enormously increased number of listeners.

Finally, recording and video taping eliminate temporal constraints in addition to the spatial ones, in particular, by making repeated performance of a given production possible as frequently as one wishes at almost negligible a cost.

This, naturally, again increases the audience enormously, thus reducing the share of overhead costs per listening session. Such a removal of constraints to consumption is beneficial, despite the unwanted side effects.

All this has a certain relation to a much discussed problem in the economics of culture, which has been associated with the name of William Baumol.

The problem pointed out by him concerns imbalanced economic development in two different sectors, one with improving productivity and one stagnant.

Goods production is assumed to belong to the first category, service production (including those of the cultural sector) to the latter. If wage rates are determined within the developing sector in accordance to marginal productivity of labour, and are also applied in the stagnant sector, then producing units in the latter are bound to be hit by financial problems due to increasing labour cost. It is assumed that there is no way out of this because labour cannot be substituted by capital.

Our above discussion would indicate that this is not so much a matter of differences between the cultural sector as compared to for instance manufacturing, but rather applies to different ways of cultural production, recording, broadcasting, video-taping, and televising being immensely more efficient modes of production than single live performances.

4.14 Historical Monuments

A different problem with the evolution of modern technology, arising from the necessary embodiment, is created for the cultural goods represented by historical monuments. Visiting such a monument requires physical presence and results in wear and tear on it. Efficient and fast mass transportation works in exactly the same way as does mass-communication and mass-reproduction.

The superstars among the monuments, such as Venice or Bruges, attract all the tourists. The problem here is not so much the neglect of minor monuments, though they may become the concern of local tourist boards, as the wear and strain put on the monuments singled out as superstars. Note the reciprocity to the previous issue concerning disembodied culture, where it

was not the demands on the superstars as much as the neglect of the rest that caused problems.

The unforeseen invasion in Venice by 600 hundred tourist buses one single weekend, when political repression in eastern Europe slackened, is a perfect illustration. We can consider how far this situation is from Goethe's Italian visit, which took half a lifetime to prepare.

It is impossible to leave these matters to some kind of invisible hand of the market, because its actions on the cultural heritage become all too easily visible.

The scandalous pop concert, again in Venice, on a raft in Bacino San Marco for 300,000 listeners, when the mosaics fell down from the vaults in the Palazzo Ducale, and it took an entire week to clean up the city from solid garbage left by the audience again provides a very good example. The day after the concert the first page headline in "Il Gazzettino" was *"mai più"* (never again). It is only to be hoped that the Venetians for the benefit of us all are able to keep this promise to themselves.

4.15 Standardization

The progress in communication and reproduction technology might also serve to enhance the ongoing development towards the standardization of culture, leading to a loss of diversity.

It has been pointed out that concert halls and opera houses tend to repeatedly perform works that represent only a tiny fraction of the total repertory available, and that the selection is surprisingly similar all over the world. A few figures illustrate this. The top list of operas contains 75 titles, whereas the European-American repertory consists of 350 works. This is to be compared to the huge number of 42,000 known operas composed since 1597 (the date of the first experiment in Florence). See Böttger.

When a city grows in importance it has to show up its new status by establishing an opera company and a symphony orchestra that can perform the biggest romantic operas and the biggest romantic symphonies. Of course, they also have to be housed in stately buildings.

The display is always in terms of size, quality being a secondary attribute by a sort of lexicographic ordering. Competition between cultural centres consists in performing a given, well-defined repertory, and only those able

to compete in the heavyweight class are admitted as candidates for excellence.

Hand in hand with standardisation goes the passivisation of the consumers of which we already spoke. Repetitive listening to the same works of music over and over has, as pointed out by Harnoncourt, the effect of smoothing out all the harsh places by anticipation, and depriving music of some its dramatic and expressive power. What remains is only one single dimension of sheer beauty, whatever that is. The arts become sedatives, "two grams soma (*Brave New World*) a day keep the facts of life away", providing a kind of escapism from reality, rather than a way of mirroring the realities of existence. By this, the traditional role of the arts in the Occident is lost.

In science there is a parallel process. Local schools disappear, and the dominance of just one international research frontier in each discipline is established by the international scientific journals of high ranking and their armies of referees.

The price is lost diversity in culture, and no doubt mass-communication reinforces this standardization process.

4.16 Concentration

It is not obvious why the recent technological development also is associated with concentration, because the radically decreasing costs, overhead as well as unit costs, for printing and recording would, on the contrary, seem to favour small-scale production.

Most likely economies of scale abide in the distribution networks. With the increasing size of the markets, those networks become ever more complex and expensive to maintain. They can be tangible in terms of a hierarchy of hired agents. Although there is then only a user cost for the links, the fixed costs for the nodes can still be substantial.

The networks can also be intangible, i.e., they can consist of files of information on retailers. Even such information storage incurs considerable updating costs which increase dramatically when the network is not in frequent use.

It is obvious that there are considerable economies of scale in these networks. For book and record stores it is easiest to deal with the big publishers

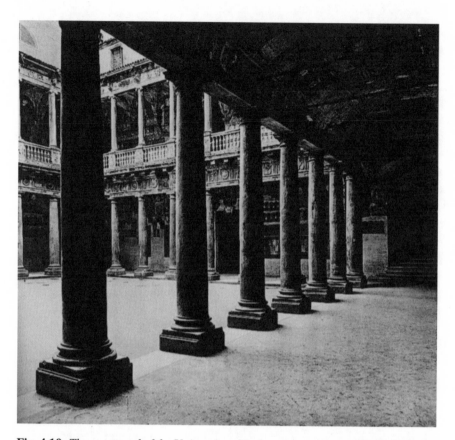

Fig. 4.10: *The courtyard of the University of Padova; reconstructed by the Venetian architect Jacopo Sansovino (1486-1570), best known for his library building the Biblioteca Marciana facing the Ducal Palace in Venice. The University of Padova, along with those in Bologna, Salerno, Paris and a few others, was one of the magnets of early European education, to which students from all Europe went.*

and labels, and it is difficult for small producers to get access to the distribution networks. The stage is thus set for oligopoly.

When discussing evolution and change in culture, we note that the process may easily take on an unpredictable and turbulent character. In the cultural sector we, to a large extent, deal with ideas. They can be easily dispersed, and the communication mode is extremely versatile.

A literary or scientific work can be printed and distributed by mail, the text can be advanced by fax or electronic mail, or its contents can be read and broadcast or televised.

Music can be distributed in scores from the publisher, it can be publicly performed, physically transporting the audience to the concert, it can be

broadcast or televised live, or it can be frozen on record or tape and distributed in this form.

In almost any case there are alternative distribution modes which are subject to simultaneous, irregular, and rapid development. In general all transportation and communication modes compete, and even physical transportation of people or goods can be replaced by telecommunication.

As an example consider the increased mobility of people due to improved transportation and the consequences for market areas of institutions such as concert halls and theatres. Mobility having increased in less than a century almost by a factor of 100, we note the arithmetical fact that potential market areas have increased by a factor of 10,000.

This, in conjunction with the agglomeration of population, would seem likely to ease the financial situation of those institutions.

On the other hand, the evolution of broadcasting, television, record and video production, providing competing alternatives, make the situation anything but simple.

Normally the different distribution modes do not simply replace each other, they rather continue to coexist. This coexistence has a rather complex nonlinear nature.

In general they are substitutes satisfying the same needs, i.e. competitive. But there is also an element of complementarity. Listening to recorded music may save people the trouble of going to the concert hall, but it may also prime musical interest in new audience urging some of them to attend live concerts. This situation is quite like the effect of prints and copies of antiques making people visit the sites of classical culture as mentioned in the introduction. Likewise some listeners of broadcasted music may even be induced to order the scores to execute themselves.

Several strata of evolving distribution networks provide for complexity. To this comes increasing demand which acts contrary to the decreasing transportation costs, creating a tendency to decrease the physical size of market areas instead of increasing it.

In the Middle Ages students used to walk by foot through Europe to the few centres of higher education in Salerno, Padova, Bologna, Paris, and Oxford, whereas today such centres are dispersed in each and every district. The decrease in the size of the market areas thus occurred despite a dramatic decrease in travel costs. As mentioned even the multiplicity of distribution modes for culture may itself tend to increase total demand.

5 Evolution in Science

5.1 Logical Empiricism

Logical empiricist philosophy of Science, as represented by Sir Karl Popper and others around 1950 provided the perfect philosophical foundation for modern empirical science. It finally did away with the naive empiricism founded on Hume's induction logic.

The abstraction and idealization process, always present in scientific modelling, be it zero dimensional mass points or utility maximizing consumers, was allowed for. The same was true about the theoretical concepts, such as gravity, electron shells, or the subconscious, which could not be completely defined in terms of empirically observed facts.

Yet there was a linkage to reality through the empirical generalizations, deductively derived statements in which the theoretical concepts had been eliminated, only empirically meaningful concepts, observable through operational rules, remaining.

For instance: Newton's theory contained the abstract concept of gravitation. From it Kepler's three laws of planetary motion could be derived through logical deduction.

Kepler's laws, however, do not contain the concept of gravitation, or any other theoretical concept. They are statements about the shapes, sizes and revolution times for the orbits of the planets, all of them concepts that are empirically observable through appropriate operational rules.

The important fact about empirical generalizations was that they could be refuted by experiment or observation. As they had been derived from the abstract theory by deductive logic, the theory had to be refuted along with any empirical generalization derived from it according to the laws of that logic, more precisely the *modus tollens* inference.

5.2 Newton, Kepler, and Galileo

The day Kepler's laws did no longer agree with observations in Astronomy, not only those, but Newton's theory of gravitation would have to be scrapped as well.

A general theory usually implies several sets of empirical generalizations. Thus, Galileo's acceleration law too follows from Newton's gravitation law. The more general a theory is, the more numerous would the empirical generalizations be, and the more dangerous a life would it live.

This is a nice thing, because the more audacious theories would so also be more frail in view of all the things they forbid and which, if observed, all increase the risk of refutation.

The service of logical empiricism was twofold. First, it gave theoretical reasoning in empirical science a sound basis in terms of the facts of reality.

Second, it did this without killing the theoretical concepts, thus keeping science in the state of an art where free speculation is allowed, saving it from becoming a dull procedure of collecting and organizing facts.

5.3 Refutation

Though logical empiricism primarily is a theory of science as a finished product, not of the process of producing it, there is implicit an idea of scientific development in it.

All acceptance of theories is provisional, and they can never be proved true, only false, provided they are not just probability statements, in which case not even falsification retains its character of a final verdict. Disregarding this last complication, it is tacitly assumed that a theory is definitely refuted the day its empirical generalizations are contradicted by observed facts. It is then replaced by something else.

What this replacement should be is not the business of logical empiricism. The situation happening when an accepted theory has to be refuted opens up a Paradise for scientific imagination to come into play and to create something new. The new theory has to be reconciled with the facts which caused the fall of the old, and it, of course, also has to explain the facts which the old one successfully did explain.

Fig. 5.1: *Boyle's Law (left) for an ideal gas as an approximation to van der Waals's law (right). Robert Boyle (1627-91) discovered the relation between pressure, volume, and temperature for an ideal gas that bears his name. Johannes Diderik van der Waals in 1872 generalized Boyle's Law to take account of the transitions between the gaseous and liquid states, and formulated a law which holds continuously over the phase transitions. He applied it to the case of oxygen even five years before liquid oxygen was at all produced. It is agreed that, though lacking in theoretical detail, van der Waals Law still provides a very good phenomenological description of the facts. The surfaces show how pressure (direction up) is related to temperature (direction left-to-right) and volume (direction back-to-fore). In the surfaces the "isotherms", curves for constant temperatures, are shown. We see how the much simpler surface approximates the more complex over considerable ranges. The deviation becomes prominent only once temperatures close to the condensation point are considered. For most gases this deviation becomes interesting only once quite extreme temperatures are produced and studied. But then the simpler law still retains its place as a useful approximation over a considerable range.*

Admittedly, it is unlikely that for instance Laws of Nature, corroborated by numerous observations, will later prove entirely wrong in their current ranges of application, and at the current resolutions of observation technique.

It seems appropriate to add a little note here about the bewildering richness of terminology: In addition to "laws of nature", one speaks of "theories", "principles", and "models", with no clear cut distinction at all between them. We have Kepler's Laws, Boyle's Law, the Laws of Thermodynamics, but the Theory of Relativity, Quantum Theory, and Chaos Theory.

One speaks of the Principle of Archimedes and Heisenberg's Uncertainty Principle, and Bohr's Atomic Model. Laws of Nature, in analogy to laws created by humans, such as Penal Law, seem to refer primarily to empirical statements, whereas theories may be broader and contain theoretical concepts with no unambiguous empirical meaning. Models often allude to pictorial interpretations of abstract theories. A study of how scientists describe their own or other scientists' contributions is highly interesting, but the main outcome would most certainly be that certain terms were preferred during certain periods.

5.4 Approximate Truth

It is most often when laws or theories, or whatever we call them, are extended to new ranges of application, or when the precision in observation technique has improved, that refutations occur. A good example is Boyle's Law, which holds in certain ranges of temperatures and pressures, and which can be seen as an approximation to van der Waals's Law, which has a more general range of application.

Another good example is Special Relativity Theory, which came to life when speeds close to the speed of light where focused in science, and the observation technique had become so refined that the Michelson-Morley experiments on the speed of light in two perpendicular directions became possible.

It is interesting to note that most outdated theories, such as Boyle's Law and Newton's Mechanics, after losing their footholds as exact truths, yet remain on the scientific stage as useful approximations. It would even be stupid to use the relativistic Lorentz transformations in Ballistics, as the speeds of projectiles are so far from the speed of light.

Anyhow, the central issue in logical empiricism is the refutation due to observations contradicting empirical generalizations, the subsequent reshaping of the theory being left to the discretion of the scientists.

5.5 Ad Hoc Explanation

One thing is explicitly forbidden in the reshaping process, and that is *ad hoc* explanation, i.e. introducing exceptions to the general law, thus disproving the contradicting facts by reference to time, location, or other trivial circumstances pertinent to the particular observation.

The important issue in connection with ad hoc explanations is not that they are simple minded, but that the practice of their use makes the theories impossible to refute. As science, according to the logical empiricist outlook, is linked to reality exclusively through the attempts to refute its empirical generalizations, adhocery will make it logically true and irrefutable, hence cutting its relations to reality.

Exactly what establishes an ad hoc explanation was never defined in quite a satisfactory manner. The general idea was that the circumstances for any exception from a general rule must be possible to establish by independent evidence. A good example of ad hoc explanations from economics would be to explain an actual history of transaction prices and quantities in a market in terms of "autonomous shifts" in families of supply and demand curves so as to fit the actual data points in the intersections of these curves.

But, as we will shortly see, there is a more subtle way of amending a theory so as to make it immune to refutation.

5.6 Normal Science

Thomas Kuhn in 1962 claimed that the continuing amendments of accepted theories, made in order to make them comply with extended ranges of application, and with refined observation techniques, in the long run tend to make the theories irrefutable, quite in the same way as would ad hoc explanations. Though this development process would not be trivial in the same sense as would sets of exception rules referring to date, time, and place, the effect would be equally disastrous: creating a theory which is hardly refutable at all, thus having a dubious empirical underpinning.

According to Kuhn, established theories therefore finally become so hard to refute that other reasons than those accounted for by logical empiricists

must have come into play in cases where such established theories have in fact been overthrown.

The scientific revolutions that without any doubt have occurred, must therefore have had other causes, even seemingly irrelevant factors, such as taste or whim. It is here that criteria such as elegance or simplicity come into play. The latter in particular has been commonly accepted under the name of the Occam's Razor Principle, but it still is a subjective manifestation of taste, because nobody has established whether truth is simple and elegant or complex and messy.

A good example of non-refutable theories is provided by the geocentric cosmology before the Copernican Revolution. According to it all heavenly bodies move around the earth, on circular paths whose centres move on circular paths, whose centres move on circular paths, etc. in any number of steps.

This theory definitely was not wrong, it could not even be proved wrong, because, as we nowadays know from Fourier's expansion of periodic functions, any recurrent motion can be represented by such Fourier series. The "theory" was logically true, hence not refutable, and so without empirical content. It could not be proved wrong, and definitely was not.

So, essentially, it was replaced by the heliocentric description of motion because the latter is simpler and more elegant, not because it had to be refuted due to observation.

The new theory also had the advantage that it, in contrast to the old, could be proved wrong, though it is not likely that this was the cause of the Copernican Revolution either.

The pre-Copernican cosmology provides an example where the reasons for irrefutability lie quite open: the arbitrary number of nested circular paths which are sufficient to describe the actual observed motion of the planets to current precision. It is quite like the case of fitting a polynomial of arbitrary degree to a time series. As we know a line can be fixed through two data points, a parabola through three, a cubic through four etc. The assertion that a polynomial fits a certain time series is hence not refutable.

But there are more subtle and perplexing cases. It is known that the family of solutions $y(t)$ to Duffin's relatively simple third order differential equation:

$$2y'''y'^2 - 5y'''y''y' + 3y''^2 = 0$$

contain solutions which are *arbitrarily close to any given time series f(t),* i.e. $|f(t) - y(t)| < \varepsilon$ *for all t,* and ε *arbitrarily small!* There is presently nothing such as an infinite number of degrees of freedom, nor is there any simple explanation for this such as if the equation were logically true, which it is not! The case is thus more subtle than one would at first suspect.

5.7 Supertheories

Theories that are all encompassing within a field of knowledge have had an irresistible appeal to scientists through the ages. The extreme ambition in this direction must have been the reductionistic view of a complete hierarchy of sciences, as proposed by Auguste Comte around 1830:

According to him Physics was basic to all the sciences, and Chemistry should ultimately be based on physical principles. Likewise, living organisms no doubt manifest life through chemical processes, so Biology should in its turn be based on Chemistry. Mankind belongs to the sphere of living organisms, and so Psychology should therefore be based on Biology. Finally, Comte's own invention, social science, called Sociology, should be based on Psychology.

Quite formidable a programme to make some kind of Euclidean Geometry out of the entire body of science, and quite credulous a belief in the power of deductive reasoning! As we will see below insurmountable difficulties met even the ambitious attempts to develop a complete mathematical logic as a tool for such reasoning.

5.8 Schumpeter

Joseph Schumpeter in his monumental posthumous "History of Economic Analysis" from 1954 actually preceded Kuhn in launching the idea of normal science. Schumpeter calls such states of science "classical situations". They are characterized by science presenting an "... *aspect of repose and finality, like a Greek temple that spreads its perfect lines against a cloudless sky* ...", as Schumpeter puts it in his ironical wording. Schumpeter implies

that we have a much exaggerated admiration for the consolidated classical systems, at the expense of the more turbulent periods of less structured scientific renewal.

5.9 Reductionism

There are particular disadvantages pertaining to the way of displaying science as an overwhelmingly impressive pyramid of logical deductions.

It gives a historically wrong picture of the actual development of science. In Physics courses, mechanics is introduced in terms of Newton's Law of Gravitation, Galileo's Acceleration Law, and Kepler's Laws for planetary movement being deduced from it later as various applications. Historically, however, both preceded Newton's Law, and were themselves preceded by careful experiment and collection of facts, by Tycho Brahe and others.

This is not unique for the case of Physics but holds true in most sciences. Microeconomics courses, for instance, nowadays start with axiomatic utility theory along with the concept of production functions, and only after a large number of steps do they arrive at market equilibrium.

In terms of history, Davanzati's curiosity was already in 1588 directed to the Paradox of Value: Why is almost useless stuff such as gold and diamonds so expensive, whereas air to breath and water to drink are free? These discussions led to the concepts of scarcity and utility as joint determinants of value, and ultimately to Marshall's market equilibrium theory.

Only later were the factors behind demand and supply analysed, the latter first at the level of cost functions and then at the level of production functions. Axiomatic variants of consumption and production theories were the last to appear on stage. Yet, we display the development in reverse order, just for the fun of the logical pyramid.

As a consequence of this, students become deprived of the pleasure of finding the way from the particular to the general, i.e. the route actual research has taken, and they tend to become bewildered the day they are to take off for their own research. The impressive monolithic bodies of knowledge tend to offset anybody but a few very sturdy ones from trying to change anything fundamental.

The desire of scientists, however; always was to present impressive pieces of deductive structure. Gauss is reported to have burnt all his preliminary studies, so as to clear away all traces of the actual laborious research process.

5.10 Generalization

Closely related to reductionism is the urge towards generality which most scientists seem to share. To make the issue concrete consider economics of the 1930's. It represented a beautiful very general and logical structure of interdependent markets in equilibrium. However, it could not explain the existence of disequilibrium states, unless the equilibrating variables, i.e. prices were sticky. In particular, unemployment, which everybody could observe as an empirical fact, could not be explained unless wages were assumed to be sticky. Some people had the idea that lowering wages would not help, because this would decrease purchasing power and hence reduce general demand so as to undo the effects of cheaper manpower. However, there were no means of analysing such things within existent theory, so many economists continued to claim that involuntary unemployment did not exist.

Lord John Maynard Keynes, one of the most innovative economists of the 20th Century then managed to create a completely new theory, called macro-economics in contrast to the already existent micro-economics. This was a real *tour de force*, as this meant thinking in new categories, macroeconomic variables, national income, savings, and investments, which were new, and not yet existent as empirical variables. After the "Keynesian revolution" they were in fact measured through newly invented operational rules of national accounting.

Hence the science of economics was in the possession of two different tools, microeconomics to analyse phenomena of the market, and macroeconomics to analyse phenomena of the entire economy.

As physics always was the ideal after which formal economic theory was shaped, it seems that economists might have been happy with this state of things. A collection of moving and colliding molecules would no doubt act under gravity as a sort of planetary system. However, a very large collection of molecules, enclosed in a container shows new phenomena. The average speed of the molecules is related to temperature, the constant pushes of these on the container's walls to pressure. Boyle's Law is a statement of relations between macroscopic variables, temperature, pressure, and volume, which are all new operationally measurable variables. Nobody ever had the crazy idea of actually deriving Boyle's Law from Newton's law of gravity.

Not so in the case of economics. In the 1960's an army of economists set out at discovering the "micro-foundations" of macroeconomics, whose ac-

tual result was the effective destruction of macroeconomics. There seems to be no other cause of this than an urge to have one single theory which would be applicable to the economic phenomena at all scales. To believe in the possibility of such a programme seems to come close to megalomania.

It is interesting to note that the same thing seems to be happening in physics. Physicists have long been preoccupied with the different results from Heisenberg's Uncertainty Principle, and Einstein's General Relativity, though the former applies to phenomena at the very small scale, the latter to phenomena at the very large scale. As there is a possibility that both might apply in the case of "black holes", of whose existence nobody can be sure, "string theory" became the hottest research issue in physics as a means to reconcile the two different theories. Ironically, string theory as yet has no independent test implications, and some physicists think it never will! This is again an aspiration to having one single theory explaining just everything. See "*The Harmonious Universe*" by Keith Laidler.

5.11 Hilbert's Programme

Above we referred to the reductionist view of a hierarchy of sciences, with the higher levels related to the lower levels through deductive logical reasoning. The structure of mathematical logic itself therefore becomes an interesting issue even for empirical science.

In order to answer such questions as whether the set of all sets was included in itself or not, Russell and Whitehead in 1910-13 published their monumental work *Principia Mathematica*. The book attempted to be an encyclopaedia of the whole body of mathematical logic.

David Hilbert then proposed the even more grandiose research programme that bears his name: To prove that the contents of the Principia were both internally consistent, and provided a set of tools by which all true mathematical theorems could be proved, if only in principle.

The idea was not to provide a proof machine which could replace the inventive ingenuity of human scientists, only in all modesty to provide a complete set of tools for their use. Whether anybody would be ingenious enough to reconstruct the original "wonderfully simple" proof of Fermat's Last Theorem after 300 years is still an open question, even once Wiles has published his much admired but enormously elaborate proof.

5.12 Gödel

In 1931 a deadly blow was, however; struck at the Hilbert Programme by the young Kurt Gödel, who proved that such a complete logic did not exist: Either it was not self-consistent, or it would not be complete in the sense of providing all the tools needed by mathematicians.

Gödel's proof for his Impossibility Theorem is not easily accessible to the layman, because the problem is translated into, and proved within, number theory, but there exist popular accounts of it, in particular Hofstaedter's brilliant book *"Gödel, Escher, Bach - An Eternal Golden Braid"*.

Gödel's advent should imply the end of all reductionism, be it on Comte's level or within the individual sciences, and tune the scientists down to a more modest pitch of aspiration.

Rather than aspiring to reveal science as the Schumpeterian perfect lines of a Greek temple against a cloudless sky, scientists should be happy to light torches and disclose patches of knowledge about a largely unknown reality cloaked in darkness. And they should agree that research is actually directed by such seemingly irrelevant factors as subjective taste about what is elegant, neat, and simple.

Such a shift in attitudes no doubt subtracts from the awe of the general public towards Science in its capacity of the new promise of salvation that replaced Religion, but it would reintroduce some of its beauty.

5.13 Chaos and Predictability

A different blow to scientific megalomania came more recently from Chaos Theory, which pointed out severe restrictions to the possibilities for scientific prediction. Since ages we were accustomed to regard evolving systems as either simple, deterministic, and predictable, or else as complex, unknown, and stochastic.

Determinism and prediction has formed the core of most of scientific reasoning, and Statistics, and its various application kits, Biometrics, Chemometrics, Econometrics, Psychometrics, and Whatever-o-metrics, have provided increasingly sophisticated sets of tools aimed at providing the deterministic predictions with statistically safe limits of confidence.

The ideal of a predictable system was, of course, the solar system. Despite minor, hardly observed anomalies, such as the tumbling Saturn moon Hyperion, the movements of the heavenly bodies were so stable that it was possible to make predictions thousands of years ahead, or even back, to the benefit of historians wishing to date some past event narrated in contemporary chronicles where eclipses had been mentioned.

Newton, who formulated the Law of Gravity in 1687, was even able to provide complete solutions for the movements of two interacting masses by means of his own newly invented infinitesimal calculus.

5.14 Laplace

He was not able to do the same for three or more interacting bodies, but around 1800, Pierre Simon Laplace, one of the greatest names in partial differential equations, still believed that a sufficiently powerful "brain", knowing the positions and momenta of all mass points of matter in the universe, could calculate its entire future and past.

The potential for science was unlimited, and Religion was concerned about the fate of the free will in such a world of determinism and predictability.

5.15 The Weather Factory

The perspective for a science such as Meteorology was promising. The laws governing the motion of the molecules in a fluid, such as the atmosphere, were known as the Navier-Stokes Equations. It was just a matter of collecting information and processing it, and predictions could be made for any perspective. So, farmers should be able to plan their holidays years in advance.

In 1922 Richardson came up with the idea of the Weather Factory, something like a huge theatre, where a host of scientists and assistants were collecting the telegraphically incoming observations on temperatures, wind velocities, and air pressures from all over the globe, and processing them.

As this was before the age of weather satellites and computers, Richardson only despaired at his estimate that 64,000 people, equipped with paper, pen,

and slide rulers, were needed to predict the weather, even at the actual speed at which it developed, and of course much more were needed to make real predictions. His dream was that some time it would be possible to make the predictions with a less excessive demand on resources.

This time would now definitely have come, as the super-computers and weather satellites are there.

5.16 Social Engineering

Another practically important field for predictions is of course Economics. Knowing the future for business cycles, interest rates, exchange rates, and stock market prices would be of invaluable use for government and businessman alike.

The Navier-Stokes equations for the motion of the economy did not exist, so after the Second World-War an army of scientists were put to work with formulating the missing equations and estimating them from whatever there existed in terms of collected statistical data.

International projects attempted to couple together the huge national super-models, each of them made up from hundreds of equations and variables. There was a firm belief that social reality, in contrast to physical reality, was so complex that even the hugest models had to omit essential variables and relations, so statistical methods came to play, but, except for that, there was no doubt about the existence of the correct "Navier-Stokes equations" for the economy or about their usefulness for prediction.

Social science went farther than natural science as it aimed, not only at predicting, but at controlling. The idea of Social Engineering was born. With minimal and smooth correcting adjustments, worked out by wise governments and central banks (guided by economists) could, was it believed, any undesirable wrinkle be ironed out.

Even the numbers of policy means, needed to achieve any given combination of goals, such as full employment and price stability, could be calculated, like the number of workers in Richardson's weather factory. In a way this idea still lies behind the dual responsibilities of government and central bank. The naivety of this idea was indeed fantastic, because it among other things took for granted such linear structure as is necessary for the decomposition of matrices into a hierarchy, which Herbert Simon's definition of "minimal groups" actually amounted to.

Unlike the case of Meteorology, where, for reasons which will be discussed in the following, forecasts are limited to five days, long term forecasting is still an important issue for economists.

5.17 Poincaré

It is now time to return to motion under gravity. Despite Laplace's optimistic forecast, thousands of treatises over Centuries in vain attempted to solve the problem of three bodies, moving under Newtonian gravitation. The answer was finally given by Henri Poincaré in 1889 in a contribution to a scientific contest announced by the Swedish King Oscar II.

The idea of the contest, was, of course, not his Majesty's own, but suggested by somebody else, the prominent Swedish mathematician Gösta Mittag-Leffler, who, by the way, has been supposed to be the reason why there is no Nobel Prize in Mathematics. (Nobel might not have wished to risk that a prize went to the man who had run away with his mistress. So, maybe the contest even was a way to compete with the Nobel Prize, not yet existent, but on its way.)

The real issue for the contest was to show whether the solar system was stable or unstable. Poincaré, who won the prize, restricted the discussion to the three body problem, or, to be quite exact, to a simplified version of it, where two big planets influence each other and a third small dust particle, whose reverse influence on the planets can be neglected.

The essence of Poincaré's conclusion was that the motion of the dust particle, though perfectly deterministic, even determined by very simple equations, was not predictable. Its path bore a greater likeness to a stochastic process than to the closed form solution of any familiar differential equation, such as the familiar one for the two body problem.

This was the first discovery of deterministic chaos. Its implications are revolutionary: Determinism is *not* the same as predictability. Chaos, which has been shown to be a likely phenomenon in all nonlinear dynamical systems, puts severe limits to forecasting. Not even if we possess the perfectly correct models of what we want to forecast are we able to actually do so. Statistics is of no help at all in delivering confidence intervals for the forecasts, because the chaotic system wipes out every systematic information, so there is nothing to put these intervals around.

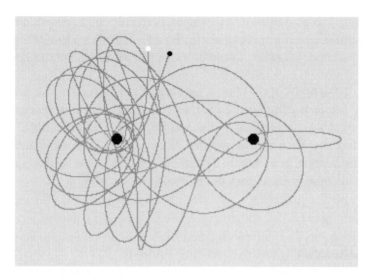

Fig. 5.2: *The problem of two bodies, moving under gravitation, being solved by Sir Isaac Newton in the 17th Century, the corresponding problem for three (or more) bodies defied closed form solution attempts for Centuries. By the end of the 19th Century Henri Poincaré, treating a simplified three-body problem for two planets and one speck of dust (whose influence back on the planets could be ignored), showed that the movement of the speck would be unpredictable and hence not possible to state by any closed form formula. The picture shows a computer simulated orbit for the little speck in the gravity field of two big attractors. Note that it is a 2-dimensional projection of 3-dimensional phase space, so it is only seemingly that the complex orbit intersects the two attractors, which could not be. As we see, the orbit is nothing like the nice elliptic orbits known from Newton. Poincaré's discovery was the first detection of the phenomenon of deterministic chaos. It has deep consequences for all sciences as it implies that determinism and predictability are not the same. Poincaré's treatise was the prizewinning answer to a scientific contest announced by King Oscar II of Sweden.*

The reason is trivial, it is related to computation errors. In the chaotic system these errors are magnified until they dominate completely, and this in a surprisingly short while. Greater accuracy in measurements, even to astronomical costs, only prolongs the safe prediction period marginally.

In Richardson's weather factory the numbers of workers, even equipped with modern computers and a continuous flow of satellite data, could be multiplied any number of times without notably improving the outcome.

So, we have come to understand the difference between determinism and predictability. A system is deterministic if its course is determined uniquely by the initial condition - known exactly to the last place in an infinite number

of decimals. It is predictable if the computation errors are kept within bounds. This condition is, unfortunately, not fulfilled for chaotic systems. For a while there was a hope that chaos would be a rare phenomenon, but this hope was in vain.

After all, the orbits of the planets can be predicted to reasonable accuracy, and only minor bodies, such as Saturn's tumbling moon, Hyperion show manifestly chaotic behaviour, so the optimism was understandable.

But it has now been shown, whether scientists like it or not, that chaos is an omnipresent phenomenon in dynamical systems, about as likely as is an ordered outcome, such as periodic or quasiperiodic motion.

5.18 Linearity

How could such an important phenomenon be overlooked for so long? The answer is simple: First, scientists were interested in systems that could be solved in terms of more or less simple function formulas whose values could be calculated and tabulated once and for all. A system whose outcome is not even computable does, however, not have such a solution formula, so chaotic cases were ruled out from the very beginning.

Second, scientists of all disciplines first focused linear systems (where any curve is approximated by some suitable straight line), because they were so simple to deal with. Chaos does not occur in linear systems, nor, as a rule, in solvable systems, so it was quite natural that it was not detected as long as the scientists believed in a real world of linearity and closed form solutions. Now we know that both linearity and solvability are so rare and unlikely characteristics as to merit to be neglected altogether.

More recent attitudes towards nonlinearity have been different in different disciplines. In Physics quite early studies of oscillators recognized the necessity to introduce "soft" and "hard" springs, thus modifying the linear Hooke's Law. Particularly in studies of forced nonlinear oscillators, by Duffing in 1918, van der Pol in 1927, and Lord Rayleigh already in 1894, strange phenomena were noted, which hinted at chaos.

In Economics, on the other hand, the decades 1950-70 were devoted to research in linear Growth Theory, focused on models that produce exponential growth which, if they were true, would make Earth eventually expand from accumulated solid wastes at the speed of light.

It was a tour de force to detect chaos as Poincaré did, using just paper and pen, so it is also understandable that it was not taken much note of.

5.19 Lorenz

The next important contribution was in Meteorology, by Edward Lorenz in 1963. By introducing a number of simplifications in the Navier-Stokes partial differential equations, he arrived at a version with three simple ordinary differential equations, further reduced to first return maps, which he studied by the help of a digital computer.

Having interrupted a very long computation, he later resumed it from a point mid in the simulated process, but with a very slightly different number of significant digits as input, and was puzzled by the completely different outcomes of the two simulations. He then focused his study on this divergence phenomenon, and concluded that the sensitive dependence on initial conditions made the system unpredictable.

The revolutionary conclusion was that weather is unpredictable, except for very short periods. There is no point in making long run forecasts, because after a while the disturbance to atmosphere, even if caused by a butterfly flapping its wings, would be as big as that caused by a volcanic outburst or a nuclear bomb test. We can expect to be able to take major disturbances of the latter type in account in the calculations, but we cannot aspire to keep account of every butterfly.

This should have put an end to Richardson's fantastical aspiration, but Lorenz's contribution had practically no effect for ten years. The paper was too mathematical for his fellow meteorologists, and the mathematicians, who both would have been interested, and been able to understand the contribution, did not have the habit of reading the Journal of Atmospheric Sciences where it was published.

The lesson to learn from Gödel, Poincaré, and Lorenz is that we should not believe in superscience visions of a Laplace, a Comte, or a Hilbert.

Perfection and absolute progress become as dubious in science as in the arts, and we are led to believe even more in Kuhn's paradigm of a taste driven development.

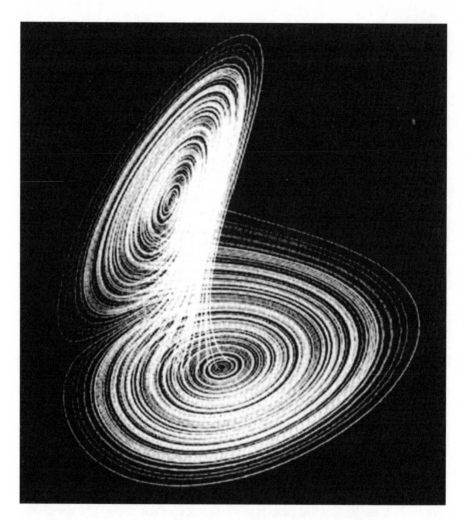

Fig. 5.3: *The Lorenz chaotic attractor. In this three-dimensional picture, a moving point traces a curve which spirals inwards around one of the eyes of this "mask" for an irregular number of times, then suddenly jumps out and is immediately caught by the region around the other eye to start the same process again. This goes on for ever and ever and produces a chaotic trajectory. Starting a simulation of this process anew, no matter how close we take the starting positions, produces an entirely different time series, though the object of the mask itself is always traced, no matter how we run the system. The mathematical system is a much simplified version of the equations that govern the movements in the atmosphere given the conditions for convection and heat diffusion. The unpredictable character of these trajectories is the reason why weather forecasts can be made for at most five days.*

5.20 Aesthetic Principles

In this way we better understand the role of aesthetic principles in science. Above, we noted the belief in the soundness of the Occam's Razor Principle.

In all ages scientists have admired the simplicity and elegance of certain theories, and there is no better example of this than the issue of optimality.

Everybody knows that social scientists, in particular economists, make extensive use of optimization principles, but in the history of science, optimization without a knowing subject has been extremely important even in the natural sciences.

The entire physics of Conservative Systems, as formulated by von Euler, Lagrange and Hamilton, uses minimization of the sum of potential and kinetic energy as its basis.

In Optics, Fermat's Principle for how light travels through an anisotropic medium, and its simpler variant, Snell's Law for how light is reflected or refracted in a boundary layer between two different isotropic media, state that rays of light travel along routes which minimize (or sometimes, as it was discovered later, maximize) the travel time.

Other physical structures, such as soap films, spanned by wire frames of the most various shapes, minimize surface tension, hence surface area.

In the case of beehives, Charles Darwin noted that their shape, hexagonal in crossection, dodecahedral in the junction of the two cell layers arranged back to back, minimize the expenditure of wax with mathematical precision.

Later D'Arcy Wentworth Thompson in his wonderful book "*On Growth and Form*" built an entire philosophy of biological forms on that outlook.

5.21 Maupertuis

It therefore is not surprising that Maupertuis, the notable leader of the first Polar Expedition, dared to coin the general "Principle of Least Action" in 1746. According to it all changes in physical systems take place in such a way as to minimize the action used for the transition. Maupertuis was very insistent about the exact truth of this his general principle.

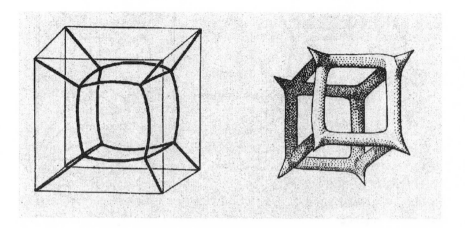

Fig. 5.4: *From D'Arcy Wentworth Thompson, "On Growth and Form". Drawing of a bubble suspended in a cubical cage, and skeleton of the radiolarian Lithocubus Geometricus. This attractive book, provided with lots of imaginative pictures, tries to deduce the development of the shapes of living organisms from physical principles, such as surface tension, structural strength, and ease of movement. From the last, the prevalence of symmetry axes for animals can be deduced. Skeletons formed on originally soft membranes tend to develop in shapes outlining minimal surfaces. Thompson also considers how for instance successive growth of molluscan shells results in spirals, screws and helices.*

In 1744 the great mathematician Leonard von Euler, in his pioneering treatise on the calculus of variations, already demonstrated that motion in a so called conservative (i.e. non-dissipative) force field minimized action.

The pretentious Maupertuis, without any substance at all for it, claimed that this held true for all changes in Nature whatever; and even hinted at Euler's theory as a "neat application" of his own general principle, thereby implying that it was he who was the true originator.

Maupertuis was an important person, as he had been invited by Friedrich II to become president of the Berlin Academy of Sciences, after the invitation was first declined by Voltaire, who did not want to accept the honour, because it would have forced him to leave his mistress in Paris.

Surprisingly, Euler, who also belonged to the Academy, actually conceded precedence to his powerful president, though the pretensions of the latter obviously were not founded.

However, Maupertuis was attacked by another member of the Academy, Johann Samuel König, who pointed out that, though action was minimized for light reflected in a convex mirror it was actually maximized in a concave mirror.

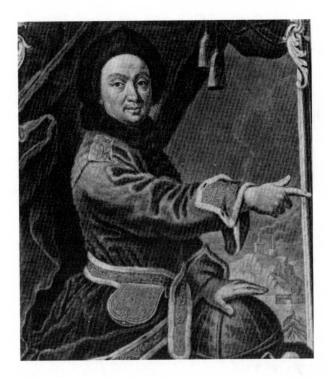

Fig. 5.5: *Pierre-Louis Moreau de Maupertuis, here in an outfit alluding to his polar expedition, coined the principle of least action. This was the ultimate expression of the belief in Nature's tendency to optimize. The principle in this form turned out to be wrong; though Maupertuis, having a position of power as President of a Royal Academy of Sciences, tried to defend the wrong principle by all means, trying to damage his opponents. He also with some success tried to claim research results of others for himself. This type of scientists, unfortunately, still exists.*

The fight first seemed to end by König having to leave the Royal Academy. However, Voltaire himself finally joined the battle, and launched his "*Les diatribes de docteur Akakia*" against the President. Though Voltaire had to leave Berlin in a haste for fear of revenge, the Maupertuis case became so much of laughing stock among the learned encyclopaedists in Paris that Maupertuis eventually had to take an indefinite leave from the Academy for reasons of "poor health".

Maupertuis is most interesting in the present context as a proponent of optimality principles, but also as a representative for that pompous but more or less empty type of scientist, which always existed, and which can be contrasted to the pioneers, who did not get any support at all from their

contemporaries, or who got it too late. This category will be discussed later in this Chapter.

5.22 Leibnitz

The philosopher and mathematician Leibnitz coined the even more grandiose dictum in his "*Theodicée*", dating from 1710, that this world was the best of all imaginable worlds.

This idea has gone to posterity primarily through an even more famous satire by Voltaire, the "*Candide*" from 1762, where the learned doctor Pangloss, even to our contemporary amusement, explains the nose as being created to the purpose of being a support for eyeglasses, and the legs to the purpose of being suitable for being dressed in trousers.

5.23 Metaphysics

Of course, a metaphysical principle is close at hand for Leibnitz and Maupertuis alike. The full title of Maupertuis's *magnum opus* in fact reads: "The Laws of Movement and Rest Derived from a Metaphysical Principle". Maupertuis referred to Nature as the optimising subject, whereas Leibnitz referred to God.

With reference to the beehives, Darwin spoke of "*the most wonderful of known instincts*", resulting from evolution under natural selection. The power of natural selection thus was so great that it even selected those bees as survivors that could best economize with wax.

In economics, Adam Smith spoke the "*invisible hand*" that guided men, acting under self-interest, to attain public benefit.

Metaphysics may seem to be unavoidable in the case of optimality in science, be it attained through the guidance of God, Nature, Wonderful Instinct, or Invisible Hand, but two observations are in place.

First, let us return to the philosophy of science, which makes a distinction between causal and teleological explanations. To make a long story short, the former states an efficient cause (anterior in time) for the *explanandum*, the fact to be explained, whereas the latter states a final cause (posterior in

time) for it. In the first case things happen for certain reasons, in the second they happen to certain ends. It has been commonly accepted that the first is the truly "scientific" way of explaining things.

However, a teleological explanation may also be used as shorthand for a much longer causal one. In Biology, the function of the lungs or kidneys is explained in terms of the services they do for the body, though a full explanation would involve the argument that organisms equipped with organs that efficiently fulfil their various purposes tend to better survive in the process of natural selection.

This latter argument may be suppressed and regarded as implicit, and so the distinction between the two types of explanations fades away. To emphasize this, the term functional explanation is sometimes used instead of teleological explanation.

Second, the optimising subject is not essential at all for the explanation. Any optimization principle, such as those formulated by Euler, Lagrange and Hamilton, work without any subject carrying out the optimization process. The formulation in terms of optimization may then be regarded as a parsimonious and elegant way of expressing an equilibrium or a dynamical process.

5.24 Aesthetics

In my opinion it is much more reasonable to regard optimization in science as the result of application of an aesthetic rather than of a metaphysical principle.

Few scientists explicitly admitted the influence of aesthetic principles. However, for instance the great mathematician Hermann Weyl in a frank interview admitted that he preferred the beautiful even to the true (probably in terms of what he liked to publish, maybe an elegant conjecture rather than a messy proof). In the same spirit the physicist Paul Adrien Maurice Dirac, inventor of the Dirac Function which greatly facilitated to widen the class of tractable partial differential equations in Physics, wrote that it was more important to "have beauty in one's equations than to have them fit experiment".

In this context it also is appropriate to recall that Poincaré considered aesthetics to be a more important element in scientific creativity than even logic.

The optimality issue is a little more confused in social science, where conscious individuals are considered, and to whom optimising behaviour is imputed or could be imputed. Often social scientists leave it open whether their theoretical agents optimise or only act *as if* they optimise something. This is a comfortable position, and the issue is not simplified when supra-individual optimisers such as the invisible hand also come into play.

Anyhow, aesthetics does not involve any kind of danger for leading science astray, as long as empirical check of the consequences is there. Before formulating his three famous laws of planetary motion, Johannes Kepler tried to organize the planetary orbits on spheres inscribed in and inscribing the five regular polyhedra: the tetrahedron, the cube, the octahedron, the dodecahedron, and the ikosahedron. As there for geometrical reasons only exist these shapes with triangular, square, and pentagonal facets, he was particularly satisfied with the fact that the sequence of supporting shells for these polyhedra corresponded to the number of known planets. Unfortunately, this beautiful theory did not fit the facts, and Kepler himself discarded it in favour of his later laws for the elliptic orbits, which as we know led to the development of Newton's theory of gravitation.

In 1990 "*The Mathematical Intelligencer*" announced an outright beauty contest for mathematical theorems among its readership. Among the official candidates were two theorems by Euler:

$$V + F - E = 2$$

where V is the number of vertices, F is the number of faces, and E is the number of edges in a polyhedron, and the series formula:

$$1 + \frac{1}{2^2} + \frac{1}{3^2} + \frac{1}{4^2} + \ldots = \frac{\pi^2}{6}$$

Neither of them did win the prize, which was awarded to:

$$e^{i\pi} = -1$$

There have been several attempts to define beauty in terms of various characteristics pertaining to the aspects of simplicity and complexity. We should note that none of those would capture what is really at issue here, because proof is an integral part of the theorem, and, for instance the Euler series

Fig. 5.6: *Kepler's first attempt at cosmology, "Mysterium Cosmographicum" of 1596. A cube is incribed in a sphere, which inscribes another spehre, in its turn inscribing a tetrahedron. The sphere inscribed in this further inscribes an dohekahedron (with twelve pentagonal faces), and so it goes, until all the Platonic solids have been used. Kepler was delighted that the total number of spherical shells equalled the number of known planets, and tried to organize the planetary system in terms of orbits on these shells. The outmost shell was supposed to contain Saturn's orbit (Pluto being unknown as yet), and the next nested one would contain Jupiter's. Kepler was struck by the fact that the ratio of the radii of these two shells so well approximated the ratio of the actual orbit diameters for these planets. Unfortunately, the rest was not recocileable with facts, so Kepler abandoned this beautiful theory to favour of the elliptic orbits.*

would lose all its attraction if it was just a definition of π in terms of a series.

Such a "dynamic" interpretation of the concept of beauty in science also perspires through the discussion of this topic in the remarkable book "*The Mathematical Experience*" by Davis and Hersh. The feeling of beauty is attributed to the alternation between feelings of tension and relief related the complex and the simple, and to the realization of expectations. Note how close the experience of following mathematical reasoning comes to listening to a piece of music with its alternation between dissonance and consonance.

In general, it is true that, as long as science is allowed to apply its idealization procedures and to use its theoretical concepts, as long is it admissible for the scientists to incorporate either aesthetic or metaphysical principles to their taste. As already stressed, other procedures of science guarantee the relation to the facts of reality.

The internal development forces of science, however immaterial they may seem to its purpose, have proved extremely important. They save science from the dull fate of becoming mere collection and classification of facts, and they are responsible for almost all scientific development up to now.

There is no guarantee at all that a systematically planned research programme, such as we nowadays, since the successful experience of spacecraft research planning, are more and more aiming at, will in general be as successful as the traditional.

Maybe even planning fits in the list aesthetic principles, admittedly given an absurdly bureaucratic feel for beauty. Here, however, is an answer from a responsible Chinese "main stream" mathematician from the days of the Cultural Revolution to inquiries from a visiting committee of distinguished US mathematicians:

"There is no theory of beauty that people agree upon. Some people think one thing is beautiful, some another. Socialist construction is a beautiful thing and stimulates people here. Before the cultural revolution some of us believed in the beauty of mathematics but failed to solve practical problems; now we deal with water and gas pipes, cables, and rolling mills. We do it for the country and the workers appreciate it. It is a beautiful feeling."

The quote again comes from the most enjoyable "*The Mathematical Experience*" by Davis and Hersh, referred to already.

Fig. 5.7: *Symmetric icon designed by Clifford Pickover. Many recent pictures of fractal geometrical objects emphasize the aesthetic properties of pictures to a degree that makes the borderline between science and art floating; The intriguing detail of many fractal images and the infinite variation between the regular and the irregular has a strange attraction, especially when complex patterns are the outcome of very simple algorithms. The reverse of this is the recent science of image compression which attempts at finding the appropriate algorithms needed to reproduce any given picture. The driving force behind this is the attempt to save storage space for picture files, as it takes much less to store the "recipe" for a picture than to store the picture itself, but it cannot be excluded that something can be found out about aesthetic properties through the algorithms for their generation.*

5.25 Computers and Visuality

The internal attitudes in science have been changing over time. For a period pure mathematics was concerned with sets, compactness, continuity, and

existence proofs, examples almost being banned. This preoccupation with set theory, which some people regarded as a disease, dissipated to many other disciplines.

It is obvious now that, with the visualisation tools which the digital computers provide, vision, intuition and imagination have again come into the foreground. Many scientific pictures produced by chaos theorists today may even leave people uncertain as to whether these are produced for scientific or artistic purposes. Good examples are three bestsellers: "*The Beauty of Fractals*" by Peitgen and Richter from 1986, "*Symmetry in Chaos*" by Field and Golubitsky from 1992, and David Mumford et al. "*Indra's Pearls*" from 2002.

The reader may also enjoy reading the enthusiastic account of the potentialities of the computer for visualization by Clifford Pickover from 1990, "*Computers, Pattern, Chaos, and Beauty*".

There is a recurrence of certain ideas. *First*, the general importance of aesthetics in science is stressed. *Second*, the affinities of art and science are emphasized. *Third*, it is implied that the new interdisciplinarity that arose with chaos theory and fractal geometry, may become the platform for a general renewal of scientific creativity. *Fourth*, it is suggested that the visualization capabilities of the modern computer provide important tools for discovery and understanding.

The first two conjectures have already been discussed at length, and we leave the third, because, given the obvious value of interdisciplinarity in our days of extreme specialization, it is too early to evaluate the specific role of chaos theory for a more general scientific renewal. The last conjecture, however, warrants some more comment.

In an article entitled "*Film and video as a tool in mathematical research*" in the "*Mathematical Intelligencer*" from 1989, Robert Devaney reports the following interesting experience. Devaney had hired a couple of computer science students at the University of Boston to program a production of pictures of Julia Sets for complex trigonometric functions.

"*The students were quite pleased, and rightfully so*" Devaney writes, "*They spent hours over the next few weeks generating all sorts of interesting pictures. Eventually, as always seems to happen in this field, they grew tired of seeing the same old images over and over again ... They started thinking on a grander scale .. . Why not make a film of how these Julia sets changed? This seemed like a fun project to me, although I must admit that I never expected anything of interest mathematically to come out of it.*"

"*The first screening was to take place at a meeting of the staff of the Academic Computer Centre. I was asked to explain briefly how the film was*

made and what it meant mathematically. I expected that the latter would be no problem, because I thought I knew exactly what I would see.

However, as the film run, I was absolutely dumbfounded by what I saw... Clearly there was something vastly different ... and I was at a loss to explain why this was so.

The results of these efforts have always been mathematically stimulating. Not all films have yielded the dramatic surprises of the first film, but they all give a completely different perspective with which to view bifurcation problems. Usually this results in a theorem or two."

Devaney claims to have discovered the occurrence of bifurcations in a way he would have been unable to conceive by looking at any sequence of momentary pictures.

The discovery is not very surprising, but none the less highly significant. The human brain has the remarkable capacity of interpolating the sequence of discrete pictures of a movie into a continuous process. If the parameter is time, we know from experiment the insights gained from making sequences of pictures of a slow process, such as a growing plant, and watching it at high speed, or from looking at a fast process, such as an explosion, and watching it in slow motion. Adjusting the time scale to suit the human eye and brain is in essence quite similar to the telescope and the microscope, as this just interchanges time and space. It may even be interesting to reverse the direction of a process. Just looking at an Oliver & Hardy movie in reverse gives an intuitive understanding for how absurd a process of decreasing entropy is.

Now, time is just one parameter and there is no need to concentrate on it. The Devaney discovery points at the scientific potential for computer animations. In this connection we should also mention the successful visualisation experiments that have been made with four dimensional objects, such as hypercubes, in terms of the shadows they cast while they pass through our familiar three-dimensional space, corner first, edge first, or face first - quite as in the case of a normal cube passing through a two-dimensional water surface. For a readable account the reader is referred to Thomas Banchoff's excellent book.

From this little digression we also gather how the computer, just like the microscope and the telescope, becomes an instrument or even an extension of the human brain and senses.

By stressing the potential of the computer, nobody actually questions the superiority of the brain. Perceiving continuous movement from a discrete series of pictures is synthesis, perceiving music is analysis.

Recalling that any sound is just a one dimensional periodic variation in air pressure, it is indeed remarkable that the ear and brain can distinguish pitch and duration of a note as separate elements. Moreover; it can simultaneously perceive temporal variations at a slower time scale such as rhythm. Moreover, identify the particular mix of overtones and special transient characters as a particular instrument or singer. Moreover, simultaneously be able to separate the sounds of a large symphony orchestra and chorus in its various strands. All this from a one dimensional sound track, that is really amazing.

For this reason it is not altogether crazy to try to present scientific information for the ear, in particular not if the information is periodic. Maybe, our remarkable aural analytical capacity can understand something which vision cannot.

In 1966 Mark Kac asked the question: "Can you hear the shape of a drum?" The point of departure was the fact that any closed region, delineated by a boundary curve of some shape, is represented by a series of ascending "eigenvalues", characteristic of that particular shape. The ascending eigenvalues represent various subdivisions of the shape in smaller patches, in terms of successive refinement, and their physical counterparts are the various overtones of the basic pitch. The relation can be one of rational numbers, in which case we deal with harmonic overtones, or it can be irrational. Anyhow, the particular mixture of overtones produces the particular pitch and timbre, or possibly the noise of the object. In this way what we hear is associated to the shape of the object.

In an amusing article in the *Mathematical Intelligencer* 1989 Carolyn Gordon deals with a more general case of different shapes, spheres and tori in higher dimension. With the article goes a record where you can listen to a Beethoven sonatina played on a six-dimensional "spherical piano".

Both for this and for producing information visually, the computer is just another aid for our natural perception. Understanding things such as relativistic four dimensional space-time or a Riemann Surface is quite difficult, but even to see solid three dimensional objects such as the regular polyhedra or mathematical knots is not so easy.

As late as 1987 George Frances published his remarkable "*Topological Picturebook*" aiming at teaching mathematicians to draw pictures, and in 1992 Ralph Abraham and Christopher Shaw published their "*Dynamics*", illustrating a surprising selection of issues from dynamical systems theory in drawings. It cannot be overestimated how much the visual representation facilitates both the learning, and the heuristic discovery processes. The computer obviously facilitates this process.

5.26 Ethics

Aesthetics is not the only "strange" element that could be incorporated in science due to the many degrees of freedom in speculative theorizing.

Ethics is another such element. Early speculations in Economics on the nature of interest started from moral aspects: What is a justifiable reward for lending money and abstaining from consumption, and what is usury or exploitation of fellow humans in distress?

To answer such questions, a surprisingly modern analysis was needed and supplied by medieval scholastic doctors. Obviously, the purpose of analysis, admittedly "unscientific", does not necessarily have any bearing on the quality or objectivity of the analysis.

This has a certain bearing for the discussion in modern times about the possibility of an objective social science in spite of political involvement by the scientists.

In this context it is interesting to note an idea advanced by Janik and Toulmin in "*Wittgenstein's Vienna*". They claim that the contents of the "Tractatus" have been completely misinterpreted due to the lack of understanding of Wittgenstein's preoccupation with the moral and ethical aspects of political rhetoric. It is interesting to note that his analysis of meaning has turned out to be of value as pure abstract analysis, even for those who do not even understand its alleged contents of criticism of the inherent immorality in public rhetoric.

To the issue ethics and science also belongs that of its relation to political ideology, which is basic for the possibility for establishing an objective social science at all. Gunnar Myrdal argued that all social science must necessarily be politically biased, and that the only way to save some scientific appearance at all was through requiring that all social scientists state their political bias. It was later demonstrated that the problem of objectivity was not quite so problematic, as the interest of a social scientist to prove the necessity of some political action, does not necessarily mean that the theory constructed to this end cannot be checked through normal logical empiricist rules. In hindsight this seems fairly trivial and obvious.

5.27 Pioneers

In the context of scientific renewal we should note that, just as we like to make us an idealized picture of science as ever moving to higher levels of understanding, just so do we like to think that any real progress proposed by the pioneers is readily accepted. The truth is that, despite the image scientists want to keep of their open mindedness, their majority always were utterly conservative and sometimes even evil minded. Pythagoras set the stage in the 6th Century BC. Harmony was a basic concept in the Pythagorean picture of the world, i.e., everything in the physical world was assumed to behave like harmonical notes on the lyre. Accordingly, all proportions would have to be rational, and the very suspicion of irrational numbers was sheer heresy. The discovery that the square root of 2 was an irrational number was considered utterly disturbing and kept a secret. It was for Euclid to prove the irrationality of the square root Centuries later.

The notable case of Galileo in 1616, who was forbidden by a clerical court of law to adhere to his heliocentric cosmology is historical, and the causes of the threat of punishment for heresy political, as the Farnese Pope Urban VIII, who first protected him, turned against him once it was suggested that the stupid protagonist in the dialogue would represent the Holy Father himself.

So, why not forget such incidents from a less enlightened period altogether? In fact heresies have been and still are continuously punished by the scientific community itself, who is utterly conservative. If the new contributions represent truth, they may eventually become irresistible, but in the meantime their proponents may even suffer personal disaster. To shift perspective a little, we cite a few examples closer to our own age.

5.27.1 Semmelweiss. A most notable example is Semmelweiss (1818-65), a Viennese physician of Hungarian origin, who was the first to detect infectious germs in certain diseases.

He noted a marked difference in death rates in puerperal fever among the patients in two different clinics of his hospital, and attributed the difference to the fact that the physicians in one also carried out autopsies without necessary hygienic precautions.

Though the washing of hands he introduced proved efficient in reducing death rates drastically, he became a victim of ridicule and persecution from his colleagues, until he succumbed complete mental breakdown and died in an asylum.

5.27.2 Cantor. Georg Cantor (1845-1918) suffered a fate similar to that of Semmelweiss. As a mathematician, concerned with the infinite, of which his contemporaries had only semi-cooked ideas, he managed to prove such things as that the dense set of common fractions are exactly as numerous as the counting numbers, from one to infinity, whereas the continuum of points on a line belong to a higher order of infinity, so that common fractions, but not continued fractions are countable. He even proved that the continuum is exactly as numerous as the set of all subsets of the infinite set of counting numbers. These and many more results were so astounding that Cantor himself at some point is reported as having exclaimed "I see it but I don't believe it".

His colleagues, in particular his former teacher Leopold Kronecker, himself immortalized through his little "delta" function, met with persecution, and Cantor too died in an asylum.

5.27.3 Wegener. Somewhat later, Wegener (1880-1930), observing the way the coastlines of Europe/Africa and the Americas fitted together; suggested the complete theory of convective motion in the surface of earth and of plate tectonics as a cause of earthquakes.

During his lifetime there were no experimental means of actually measuring the plate movements, so it was only after his death that his theory became one of the most fundamental issues of Geology. This is the only case cited here, where there was no active persecution, just neglect of the theory as long as there was no overwhelming empirical evidence to support it.

5.27.4 Beringer. Such observation of similarities may also be totally misleading. Since Greek antiquity it was common to consider fossils as first drafts for animals, which for some reason were not perfect enough, and therefore not provided with the special "*vis plastica*" which would transform them into real living animals. With the birth of palaeontology as a science, it was generally accepted that fossils were remnants of animals that had lived in the past, though scientists who preferred creation to evolution still held such ideas surprisingly late. In the US there still exist creationist schools of science.

A particularly tragicomical case was that of Johann Beringer, professor at the university of Würzburg, who in his "Lithographiae Wirceburgensis" of 1726 withheld that fossils were experimental animals which God had discarded at Creation. Mean colleagues seem to have buried artifact fossils for him to excavate and discover, such as fossil stone wrapped in their skins, and objects carrying the name of God in Hebrew letters, so as to make him

Fig. 5.8: *Spiral waves in the Beluosov-Zhabotinski reaction. The Russian chemist Boris Beluosov discovered the occurrence of regular autonomous chemical oscillations in a mixture of chlorine dioxine, iodine, and malonic acid. He was refused access to the scientific journals for decades, because the referees did not believe in the result, and did not care to try the experiment themselves. In a spatial setting the reaction generates diffusive multicoloured waves such as on the picture. Note the parallel to the case of Evariste Galois, whose contributions were rejected by the French Academy, and who was even denied access to higher education.*

really certain about his hypothesis. This continued for decades. The unhappy Beringer not only published the results, but he also sold his findings to museums all over the world. When he finally found his own name on one of the objects, the fraud became all too obvious, and he spent what money he had on buying back all the objects he had sold. This rather sad story is not entirely without interest as a testimony of academic attitudes.

5.27.5 Bolzmann. In 1906, Bolzmann, one of the founders of Thermodynamics and Statistical Mechanics, who gave his name, along with Maxwell, to the famous energy distribution among molecules in a dilute gas, committed suicide in desperation under the scorn and ridicule from his fellow scientists, only a few years before a complete victory for his theories. We al-

ready spoke of the suicide of the young brilliant mathematician Galois at the age of 20 in 1832.

We might regard an act such as suicide as an extreme overreaction, but it is not uncommon among intellectuals who face a complete denial of the recognition they feel they merit. Stephan Zweig, who had escaped the Nazis, and had become a recognised writer in the free world, killed himself in desperation at seeing no possibility of getting his production ever published in German.

5.27.6 Beluousov. In 1950, Russian biochemist Boris Beluosov discovered autonomous standing colour oscillations in a compound of chemicals. The discovery now provides one of the basic examples of chemical oscillators, found in almost any book on applied dynamical systems.

But Beluosov did not even manage to get his results published! And, this was not because of political repression in Stalin's Soviet Union. It was because the referees of Western scientific journals laughed at his results and assumed unnoticed impurities in the mixture, without ever caring to try the experiment themselves.

The results were not acknowledged until they were later presented by a younger collaborator, Zhabotinski, who just replaced one chemical substance, and who now shares the honour in the name of the Beluosov-Zhabotinski Reaction.

5.27.7 Lösch. A parallel case to Beluosov from the field of economics is August Lösch, who in 1939 completely renewed location theory. Lösch could not accept the Nazi government, so he was denied the permit to teach (the *venia legendi*). But he was not regarded as enough of a threat to be actively persecuted either.

He was even able to travel to the United States as a Rockefellar Fellow, so he could easily have defected if he had been offered a position. But location theorists were not as attractive as nuclear physicists or cryptation specialists, and location theory for some reason never was regarded as a high status area even in economics, so he returned to a life as a private scholar in Germany, living on the verge of starvation. As a matter of fact he died at the age of 39 from a trivial infection due to his poor general state of health.

5.27.8 Turing. By the way, the attractive cryptation specialists had their problems too. The most legendary of them all, Alan Turing, was so important to the British intelligence that his freedom of movement even after the Second World War was limited to a degree reminding the life time imprison-

ment of the chinaware specialist Böttger by Elector Augustus the strong of 18th Century Saxony.

When a police investigation of burglary in Turing's home indicated that he was a homosexual, a fact which combined with his intellectual capacities was supposed make him a dangerous potential traitor, things became even more precarious, Turing chose to take his life at the age of 42. Too revolutionary scientific novelties are a threat, not only to the scientific communities who see their professional expertise outdated, but also to the societies who are keen on monopolistic exploitation of practically useful novelties.

5.28 Pseudoscience

These examples, together with reference to entire disciplines that arise and die in the lifetime of an individual, Race Biology and Lysenko's Genetics being the most notable examples, clearly demonstrate how much the development of Science relies on taste and fashion. It must in this connection be stressed that such "disciplines" were *not* invented by the political leaders, even if a wish to please them played a certain role. To a large extent they definitely were inventions of the scientific community itself, whose representatives led political power in the direction they thought it was heading. In this context it also is natural to think about the pre-sciences Alchemy and Astrology. Quite apart from being stepping stones for the development of Chemistry and Astronomy, they were in their original state not so unlike "real" sciences as it might flatter us to think.

Take the example of Astrology. Its basic philosophy was that the sun, the moon, and the planets influence our lives. Taken as a general statement, nobody could argue against these obvious facts. As for the more particular practices, the success was always judged by two means: (i) success in prediction, and (ii) loyal support by authorized colleagues of the profession. Now, first of all, there is a statistical probability that any forecast becomes true, especially if it is not too precise, and the astrologists certainly were knowledgeable people conversant with the sciences of their day, so the probability of success might have been higher than average.

Moreover, if a famous astrologist made a horoscope for the death date of the current ruler, or for the ascendence of his successor, then any ambitious successor consulting the expertise might choose the predicted time for attempting murder. If the attempt was successful, it added fame to the astrolo-

gist and to the profession as a whole. And this latter fact explains why a majority of the profession as a whole agreed upon what was good practice, just leaving a few dissidents around. The reader may be more convinced by one concrete example: British astrologist Willaim Lilly, author of *"Christian Astrology modestly treated"* of 1647, was consulted by the Parliament army at the siege of Colchester during the civil war. Historians agree that it was his declaration that *"it was written in the stars that the city would fall"* that made the difference for the soldiers to make the effort to actually conquer it.

Now, the case of Astrology is not entirely different from modern Economics, in particular as far as the work by advisers to governments, to banks, or just to the general public through press and television is concerned. The self-fulfilment character of forecasts for stock market prices and exchange rates is even stronger than in the case of Astrology.

A classical quote from Lord Keynes's *"General Theory of Employment Interest, and Money"* 1936 is worth reproducing here:

"A conventional valuation which is established as the outcome of mass psychology of a large number of ignorant individuals is liable to change violently as the result of a sudden fluctuation of opinion due to factors which do not really make much difference. Thus the professional investor is forced to concern himself with the anticipation of impeding changes, in the news or in the atmosphere, of the kind which experience shows that the mass psychology of the market is most influenced by."

It is hence quite sufficient that investors, who, though they do not believe it themselves, suspect that somebody else thinks there is some mysterious connection between some political event and say the rate of interest. Though there is no substantial connection from the political to the economic facts, it nevertheless is profitable for investors to act so as to give rise to that very connection. Or, even worse, it is sufficient if they think that other people think that other people think that ...and so on in an infinite regress.

This produces self-fulfilment. In 1936, when Keynes was writing his magnum opus under the impressions of the Wall Street Crash, the spontaneous instability of speculators' expectations was the issue, but today the whole profession of economic advisers can act as a laser pump and coordinate the speculators, now including huge pension funds. It is obvious that they, especially when acting as a body can make their prophesies self-fulfilling.

Economic advisers have their models, but so did astrological advisers. There is a consensus among economic professionals about which models are reliable and which are not, but that also held true for the astrologers.

Bad practice of the dissident minority of today may easily become good practice of the professional majority tomorrow

This is not to say today's Economics is at the level of Astrology. The intention is to point out that both consensus and practical forecasting power in the presence of self-fulfilment are too feeble instruments to establish the difference between real science and pseudoscience.

Further, the comparison astrology/economics is not such a big offence to the latter as someone may imagine. After all, Johannes Kepler, the great astronomer, who discovered the three laws of motion for the planets around the sun, was a keen astrologer, and from astronomical data he predicted events such as invasions by the Turks, famines, outbursts of bubonic plague, and the like. He also considered himself to be the only truly qualified astrologer, and the rest of the lot as imposters, ignorant of the good forecasting practice. See Goodstein and Goodstein, "*Feynman's Lost Lecture*".

5.29 Female Scientists

Another characteristic of the conservatism of the mainstream scientific community is their attitude to female scientists. Only quite recently, in a historical perspective, were women admitted to the universities, and even later was it possible to get access to the academic careers. These social inhibitions went hand in hand with confused ideas of the unsuitability for one half of humankind to devote themselves to any kind of demanding intellectual activities.

However, even outstanding female scientists always existed. Attitudes in this respect have been shifting over the centuries. In ancient Greece female scholars were admitted among the Pythagoreans, but over many centuries there was a hostile attitude.

Recent focus on feminist researchers in gender studies, and the controversies they arouse, may create the misleading impression that female researchers are somehow naturally destined to this kind of soft interdisciplinary research, or at least to taking some special female perspective when they devote themselves to more traditional studies. If not, they even risk being regarded as traitors to their gender. In my opinion even this is an underestimation of the female intellect, as this tacitly implies that it is not competitive as far as traditional science is concerned.

In order to give a counterimage, we next consider some outstanding female researchers from the field of mathematics. This field provides good examples, because there exists ample documentation, and because it is an old science with practically no demand on laboratory resources or the like. Just the proper brain, paper and pencil are sufficient.

From Alexandria at the dawn of Christian civilisation there is the example of **Hypathia**, the daughter of a mathematician of reputation. Having learnt the trade from her father, she developed a skill for problem solving which made her famous in all the Greek speaking world of antiquity. The Christians, however, regarded her as an anomaly of nature and an offence to God, so Patriach Cyril gave order to have her killed. And so she was, in a most cruel way: According to legend, the pious congregation killed her through scraping her flesh from the bones with sharp oyster shells. See Gibbon's *"Decline and Fall of the Roman Empire"*.

The case is interesting, as it in one sense set the stage for many centuries: Female mathematicians were often daughters of mathematicians, and learned the subject from their fathers. This, of course, was not only the case in science and in the case of females. We know dynasties of, for instance, musicians, where the trade was taught from father to son, even for centuries, as in the extreme case of the Bachs (1560-1840) and the Hotteterres (1600-1800). However, female mathematicians had to exert their skills in secret, as access to public education was blocked, so education at home provided an alternative.

An interesting case is **Sophie Germain** (1776-1831). It is said that, after reading about the death of Archimedes, who was supposed to have been killed by a Roman soldier whose questions he did not care to answer as he was absorbed by a mathematical problem, Sophie Germain decided to devote herself to a topic which could be absorbing to such a degree. In this case her father was not a mathematician (He eventually became director of the bank of France). Her parents first tried to discourage her from the study of mathematics which was considered not becoming for a young lady, but finally yielded to her obsession. At the age of 18, after having studied calculus on her own during the Terror, she wanted to enter the newly founded École Polytechnique to study for the famous professor Lagrange. However, in this egalitarian age, women were not admitted to the school.

So, she dressed up as a man and took the identity of a former male student, M. LeBlanc, who had interrupted his education. After a while, seeing the test results, the professor, however, got curious of how the former most mediocre student could have turned so brilliant, so he invited the student to an interview. Sophie Germain saw no other solution than to disclose her real

identity. The professor was broad-minded enough to allow her to continue the studies, under her disguise. She later made a lasting acquaintance with the greatest mathematician of the age, Carl Friedrich Gauss, who appreciated her much, but she always published her contributions under the pseudonym of M. LeBlanc. In fact she made considerable advances toward solving the riddle of "Fermat's last theorem" for the case of the fifth power. See Simon Singh's "*Fermat's Last Theorem*" for details.

Another interesting later case was **Emmy Noether** (1882-1935). She was typical in the sense that her father was a professor of mathematics. After the first world war she was encouraged by the great mathematicians David Hilbert and Felix Klein to apply for the position of "privatdozent" (honorary associate professor with a qualification to teach), but was rejected by the faculty with the argument: "*What will our soldiers think when they return to the University and find that they are expected to learn at the feet of a woman?*" She made important contributions to mathematical physics, and was acknowledged by Albert Einstein to have influenced his thinking considerably.

6 Perfection in Art

6.1 The Role of Art in the Society

Quite like the case in the Sciences, commentators of the Arts, be it art critics or artists themselves, tend to nourish the dual idea of a continuous progress and of perfection actually being attained in the contemporary state. This tendency has been particularly true in the most self-confident ages, such as the Renaissance and the Enlightenment. Vasari's "*Lives*" or Cellini's auto-biography most certainly represent orgies in human pride of the individual or collective achievements.

In all periods earlier than our, the arts were children of their age, and previous ideals were scrapped without mercy as hopelessly outdated by each new generation. They were also servants of their age in the sense that they had the social function to glorify clerical or secular power.

As an example of how much of perishables music was, we may take Bach's *St. Matthew Passion*, one of the greatest works in the history of Church music. Bach's life is well documented, so the passion seems to have been performed three times in his lifetime, 1727, 1736, and 1740, each time after considerable rearrangements and additions. Moreover; there is no evidence at all that his Christmas Oratory was ever performed as such. Some of the highlights went into a most occasional oratory, *"Hercules am Scheidewege"*, in honour of the birthday of a very feeble and insignificant young Prince, so it is most likely that it was performed only once and in this form.

Likewise, an opera by Mozart and his contemporaries would have been performed a dozen of times in Vienna if it was a real success, and then it could be performed again in Prague, but that was it.

Today the situation is quite different. The arts are recognised as just arts with an intrinsic value of their own, and we are in the unique position to

hoard the entire artistic heritage of many generations in libraries and museums, even performing its products in theatres, opera houses and concert halls.

A value is imputed to culture as a public benefit, as a means of recreation for a hard working population, which, refreshed through this benefit, can improve their productivity. The view of the patronless creative artist, producing for mankind, and for eternal posterity, is an idea of romanticism, and could not even have been imagined by the boastful Cellini.

6.2 A Unique Opportunity

Contemporary people thus have a unique option, which never was open to our ancestors, to select from a large menu of culture from different period styles according to their taste, or even to consume it in mixtures.

In any large museum, the visitors can, and do, pass from classical Greek sculpture through Renaissance painting to Modern art in one visit, and in any concert hall of reputation, the audience can listen to works by Bach, Mozart, Brahms, and Schönberg in one single concert programme.

The question naturally arises whether we are at all able to really understand and assimilate such diversity, when humans in the ages when these works of culture were born obviously could not or would not. It has been proposed that we only have a partial understanding of all this, and that we use culture in a way which was never intended, as mere relaxation, escape, and recreation.

At the same time contemporary art now, be it painting or music, tends to become something very exclusive. To be quite exact, popular art still engages a majority, but in the field of the so called serious art, the fans of the past outweigh the fans of the present by orders of magnitude.

Whenever it was tried in our age to again put art to the service of power - just think of the art of the Soviet and the Nazi empires - it turned into complete disaster from every viewpoint of good taste, so the cultural legacies of these regimes mainly exist in terms of the forbidden subcultures which they called forth by opposition. Perhaps the despotism of these regimes is just too close? Maybe future generations would visit their monuments, like we now visit the Pyramids, the Great Wall in China, or the Colosseum?

The rage of the Revolution in France, in which so many fine works of art were destroyed, then regarded as mere symbols of the hated aristocracy,

shows how hate can blind. We can see this now, but we cannot decide whether aesthetic values were destroyed with the Nazi and Soviet "art".

More problematic is the fact that most people would claim, not without reason, that contemporary monuments ordered by democratic regimes, such as all the war monuments placed in the market places of all European towns and villages, hardly display any better taste than the monuments of the tyrants.

Undeniably, art is something different from what it used to be, and, being in the unique position to have access to all the previous heritage, we are also able to ask: Has there been any continuous progress? Is Renaissance Art better than Medieval Art, Baroque Art better than Renaissance Art, Classical Art better than Baroque Art, Romantic Art better than Classical Art?

The natural answer, in terms of our revealed preferences, as we consume it all simultaneously, is that, like the case of the sciences, development is not only a story of progress but also one of shifting tastes.

6.3 The Baroque Transition

There are many examples of aesthetic transitions triggered by shifting tastes and social functions for the arts. For instance, Renaissance sculptors, such as Donatello and Verrocchio, perfected the representation of the human body in marble and bronze.

Later, the Baroque artist Bernini transformed sculpture into something that conveyed a feeling for texture along with the feeling for the solid shape, via light and shadow, by means of undercutting, so that the sculpture no longer was a true solid copy of what it represented.

The change is easy to understand in terms of the theatrical Age of the Baroque, where statues in the stage of a church or princely court were intended to be beheld from a certain respectful distance.

The purpose was very different from that of the portrait sculptures of wealthy Florentine Renaissance merchants, placed in the intimate ambience of private homes. It is more doubtful whether the shift represented any real progress, because the Renaissance sculptors definitely had the skills to work with undercutting if they wanted to.

Fig. 6.1: *A female portrait bust by renaissance artist Andrea Verrocchio. Florentine renaissance sculpture aimed at the same kind of lifelikeness as did the classical Greek and Roman. The sculpture should be an identical solid copy of what it portrayed. According to Panofsky there is a strange remainder of this in the fact that early renaissance portraits sometimes display the ears as if glued tight to the head. This strange feature was interpreted as being dependent on the practice of making death masks of the deceased, which were then used as sort of moulds for first casts - obviously too uncritically with respect to this detail.*

6.4 To Romanticism

From the field of music another good example is provided. A new aesthetics arose during the Romantic period and was associated with a major social change: the emergence of huge concert halls and opera houses for enormous audiences, replacing the more intimate music making at home, in church, and at the princely court.

Fig. 6.2: *Another female portrait bust by the baroque sculptor Lorenzo Bernini. Baroque artists wanted to give particular facial expressions by the interplay of highlight and shadow on the face. They also wanted to aim at impressions of the texture of flesh and textile. These effects were attained by an increased use of undercutting, whereby certain parts of the sculptures no longer remained exact solid copies of what they represented. Baroque sculpture was therefore often arranged in relation to a given light source, in a stage-like manner. The theatrical altarpieces, such as the famous "Ecstasy of Santa Teresa" also by Lorenzo Bernini, even more than this portrait, bear witness of this point.*

This institutional change called forth an increase in the size of the orchestra, which became an organizational challenge for the Maestro conductor, so that a Toscanini and a von Karajan could single themselves out like Alexander and Napoleon from a host of average generals. The record holder probably was Johann Strauss Jr., "the walz king", on his visit to America when he employed 100 sub-conductors to direct 10,000 musicians.

Making even as many musicians as there are in a normal symphony orchestra play on the beat was a formidable task. Making them play in tune was unthinkable, so the continuous vibrato, and a new kind of extreme legato playing, suitable in the new acoustically dry venues, were invented.

As shown by experiment, arresting the sound of the string section of a symphony orchestra at any one moment would reveal the most unexpected and awful discord. Fortunately, the ear is capable of interpolating an average pitch which is in fact never produced at any one moment from the constantly varying pitches of the multitude of individual instruments.

Volume was favoured for instruments and voices alike, and subtleties in articulation and phrasing, such as had been considered important during the Baroque and Classical periods, were forgotten, being impracticable anyhow in the dry acoustics.

The transition affected every facet of music making. The counterpoint style of composition was abandoned, and melody, just coloured by different orchestration shades, became the all dominant aspect of music.

The sense of progress was enormously strong and shows up in comments on the music of earlier periods. For instance the famous composer and most influential musicologist of his day, Sir Hubert Parry, in his *"Studies of the Great Composers"* dating from 1886 wrote that Bach was *"deficient in common sense"* as *"he worked so much by himself and had so little opportunity of testing his works by the light of experience in performance"*.

About Mozart he wrote: *"He represents the type of man who is contented with the average progress of things and finds no necessity to aim at anything more novel than doing what comes to him in the best manner he can."*

These verdicts sound quite ridiculous in our ears, and though they were written a Century ago they were written half a Century after the first revival of the great compositions of the Baroque and Classical periods.

6.5 Musical Instruments

The set of musical instruments in use was itself entirely changed. The pianoforte replaced the harpsichord, the guitar the lute, and the viol family retreated in favour of the violin family. The latter was completely reconstructed, new instruments being more heavily constructed, and existent ones being reinforced so as to be able to carry an increased tension from strings made from steel instead of from gut. Many excellent Stradivaris and other

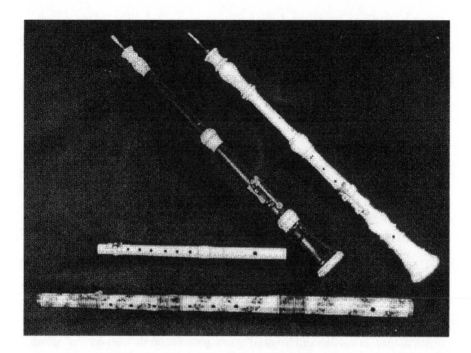

Fig. 6.3: *Historical flutes and oboes. After the emergence of the Böhm keywork systems the wind instruments kept their shapes and modes of tone production, but were provided with elaborate keyworks, which much facilitated the playing of certain passages, which had required awkward fingerings. Though this for once may seem to be an indisputable advantage, Harnoncourt questions whether it is advisable to play music written for historical instruments on modern ones, because the composers may be assumed to have written the awkward passages intentionally on purpose to sound difficult, an affect which may be hard to obtain unaided by the actual technical difficulties on the proper instruments. As a rule it is dangerous to underestimate the instrument knowledge and intentions of the composers. On one occasion a modern instrument builder built a violin using holographic techniques to check out the eigenmodes of the top and bottom plate. The instrument was then used in a blind test for a knowledgeable audience and compared to a fine old instrument. The audience judged the new violin superior as long as the performer played scales, but the roles were reversed once a Mozart movement was played. All woodwind, except the recorders, went through the Böhm transformation. As for brass, elaborate valve systems were introduced at the same time, making the instruments much easier to play. However, a historical trumpet, having a full scale of notes only several octaves up, using the means of overblowing, produced a very soft sound, which mixed well with strings, and which is impossible to produce on a modern trumpet. For instance in Bach's 2nd Brandenburg Concerto, the oboe and trumpet play the soli together with a violin and a recorder. The modern trumpet along with a recorder, that would be completely absurd.*

Cremonese instruments are still showpieces, and even in actual use, but very few of them are in their original condition.

Most of the Stradivaris survived the reconstruction process thanks to their robustness, though a large number of more delicate instruments, such as those by the Absam master Jacobus Steiner, were just destroyed in unsuccessful attempts to adapt them to a new function.

This change did not in any way represent progress, as practically all the "innovations" had been open options to previous generations of instrument makers in terms of their actual practices.

For instance, when the design of the violin was changed in the 19th Century, the purpose was to enable an increase of string tension by reinforcing the bass bar and setting the neck at an angle. However, exactly this same design change, was applied in 17th Century England in the transition from renaissance to baroque viols.

It is true that this historical change of design was mainly applied to new instruments, but not even rebuilding of old ones is without precedence. We just need to consider the extension of the compass of Flemish harpsichords in 18th Century France, so frequent that it was even given the special name "rávalement". It was a complicated operation, as the instrument case, keyboard, and soundboard, with its bridges and barrings, had to be extended on the base side.

The reconstruction was mainly applied to the highly prized Ruckers harpsichords. Occasionally the French did the same to viols by famous English masters, such as Barak Norman and Richard Meares, through adding a seventh base string.

Romantic woodwind and brass was provided with elaborate garments of keyworks or valve systems, whereas they had previously relied on the natural harmonics resulting from overblowing, and on the use of simple finger holes, occasionally provided with a few keys for holes that could not be reached by the unaided fingers.

As a result the trumpet, for instance, which used to have a full scale of notes only four octaves above its basic pitch, and whose players used to be paid as much as an entire string section, could now be used by children in music schools. Even after the rediscovery of how to master the historical instruments, very few players in the world are able to play a historical trumpet in Bach's 2nd Brandenburg Concerto! Baroque trumpet players were not only well paid. In some parts of Europe, they even enjoyed special protection by law, for instance in quarrels, it was forbidden to hit on their mouths.

The gain with the romantic orchestra instruments was always one: power. Due to very basic physical principles, power is, however, always attained at

the cost of lost dexterity. Automatic control theory worked these facts out in detail for systems, such as aeroplanes.

However, losing the possibility of diligent articulation in music was not even considered a sacrifice, and so the contemporary sources reported progress, though we should rather speak of a paradigm shift.

6.6 A Fast Transition

The transition was extremely fast. The famous Kirckman harpsichord workshop in London finished its last instrument of the kind in 1809, but in the cold winter 1816 already, numerous harpsichords were consumed as common firewood in the Paris Conservatoire.

Likewise, the last great viol virtuoso and composer Karl Friedrich Abel died in 1787, and with him died the viol. It was so well buried that it could even be re-invented for a while by the Viennese instrument builder Staufer in 1823 under the name of "arpeggione". Modern viola tops were simply cut out from viol tops by Barak Norman, which shows up as the decoration comes upside down.

The break was not only fast, but also very complete, all the old-fashioned instruments being scrapped, and the performance principles being forgotten. It is interesting to note that, since the romantic revolution, practically nothing has happened to the instruments of music over a very long time period.

Later, when people wanted to find out how the music by Bach and Mozart had once sounded, the original instruments of their times had to be reconstructed, and the performance practice had to be regained. This process became laborious, because, as we will see, the reconstruction of the historical instruments also included recovering the knowledge of how to make them.

It turned out that making them anew started from the mistaken basic idea that the modern technology was always better than the old, resulting in almost worthless new hybrids, which had never existed, and on which it was impossible to try out the performance techniques described in the old treatises.

Bernard Shaw prophetically hit the head of the nail in a witty comment on an experimental concert with historical instruments he had witnessed:

"If we went back to old viols I suppose we should have to make them again; and I wonder what would be the result of that if our fiddle makers

Fig. 6.4: *The method of perspective drawing illustrated by Albrecht Dürer. A fixed point on the wall represents the watcher's eye. An assistant stretches a string to a point on the lute to be pictured. This point can be located on the rectangular frame by a pair of rulers, and when the hinged "window" is closed, the point can be transferred to the drawing. This procedure is then repeated to get a sufficient number of points to outline the object. Dürer wrote two treatises on projective geometry, one general, and one particularly devoted to the drawing of the human body.*

were to attempt to revive them, they would probably aim at the sort of 'power' of tone produced by those violins which ingenious street-players make of empty Australian mutton tins and odd stool legs."

6.7 Discovery in Art

We will return to the issue of music, but let us remark that what was said was not to deny that there ever was any progress or discovery in the arts.

Of course, there always was! Once upon the time even the borderline between science and art was floating, as were the internal borderlines that now divide the arts. Leonardo was an artist and a scientist at the same time.

Giotto and Michelangelo worked as painters, sculptors and architects, and almost all the renaissance artists in Florence started their careers in the goldsmith's shop.

To return to Vasari, his contemporary artists, whose works we now admire for their expressive qualities, themselves took great pride in their technical innovations. Let us mention a few:

In Painting there always were continuous experiments with pigments and solvents for paint in tempera (egg), oil, or fresco, some of them successful, others not. We might regret that Leonardo tried a new mistaken method in his "Last Supper" in Santa Maria delle Grazie in Milan, but on the whole there was progress.

Perspective drawing, using one two or three vanishing points, always attracted the interest of artists, and some of them, for instance Dürer, in their pictures even show scientific equipment used for making photography like pictures. Dürer, by the way, wrote two theoretical treatises on perspective: *"Institutionem geometricam"* 1533, and *"De symmetria partium humanorum corporum"* 1557.

Leon Battista Alberti in his still enjoyable *"Della Pittura"* dating from 1436, describes an implement similar to Dürer's, called "the veil". It consists of a piece of almost transparent cloth stretched in a frame with horizontal and vertical equally spaced threads of a different nature interwoven, so as to produce a window with a coordinate system, through which the outlines of objects to be drawn could be watched and so transferred to a paper with a similar coordinate system.

This implement was recommended for the drawing of irregular objects with curved edges and surfaces. For more regular objects, such as square floor tilings, and circles inscribed in such tiles for column bases, vertical walls and ceilings, all seen in correct central perspective, Alberti gave the appropriate geometrical construction methods. The discussion is remarkable for its clarity and stringent reasoning. He also described the working of air perspective as it changed colour due to the *"density and moisture"* of the atmosphere, and the ways of shading curved solid objects with respect to the sources of light.

Technological aids used by later painters, such as the "camera obscura" and "camera lucida", were claimed to have been extensively used by, for instance Vermeer van Delft and Caravaggio. David Hockney's in his wonderful book *"Secret Knowledge"* brings together very convincing evidence that such "photographic" aids were used already around 1420-1430 in Flanders. The ways painted intricate textile patterns fold over three dimensional bodies seem to have been impossible to draft just by "eyeballing". However,

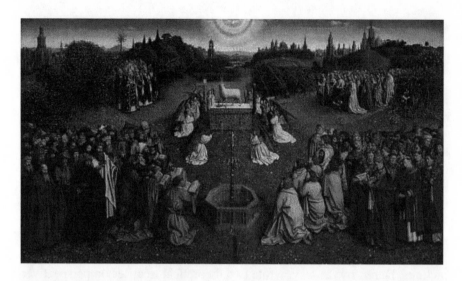

Fig. 6.5: *Van Eyck's painting "Adoration of the Lamb". According to David Hockney it is a patchwork of optically created images that are pieced together in order to attain an impression of depth which optics alone cannot produce. According to Hockney, the different groups of people are produced "photographically", whereas the whole picture is a collage. The inconsistency in terms of geometrical perspective shows up in for instance the octagonal well having a different vanishing point than than the altar.*

the photographic pictures also shared the shortcoming of modern photography, in terms of reducing the depth of space. According to Hockney, the painters using such aids remedied this fact by making "collages" of multiple photographic images. As an example van Eyck's famous Ghent altar piece "Adoration of the Lamb" is given. Whereas each group of people has a photographically deceptive look, the picture is not coherent in terms of mathematical central perspective. The octagonal fountain in the foreground has a different and much lower vanishing point than the altar with the lamb further back in the picture. In this way a sense of depth is created. As contrast, a the very flat image of a last supper in impeccable central perspective by Castagno is shown in Hockney's book.

It is interesting to note that Alberti's treatise was published in two editions, one in Latin dedicated to Giovanni Francesco Gonzaga, Duke of Mantua, and a vernacular, more practically oriented version dedicated to Filippo Brunelleschi.

Alberti was one of those renaissance men often mentioned along with Leonardo da Vinci for their frugality of mind and universality of interest. A

Fig. 6.6: *Example of an extreme accuracy in painting. This is a detail from a the painting on next page by Jean-Martial Frédou of Jean-Baptiste Antoine Forqueray holding his richly ornate instrument. The detail to the left shows the very particular tailpiece, the part to which the ends of the strings of the instrument are fixed. To the right is the picture of a loose viol tailpiece in the Musée des Arts Decoratifs in Paris. The correspondence between the picture and the object is such that organologists think it is possible to uniquely identify them, and they have even measured the swinging string length from the proportions of the picture. This is interesting evidence for things such as the very low placement of the bridge, also corroborated by literary evidence. The accuracy is such that, by enlarging parts of the painting, it can be seen which strings were overspun and which were not. It is even possible to find out the exact shape of the bridge through skewed projection, though it is painted almost from above. Baroque painters delighted in painting objects in very skew projections, such as skulls you could see only if you looked from a certain point very close to the picture, or even better by the help of a mirror.*

lawyer by education, he, besides the treatise on painting, also wrote one on architecture *"De re aedificatoria",* and one on moral philosophy *"Della famiglia".* His greatest fame to posterity probably rests on his buildings, such as Sant Andrea in Mantua built in 1472.

Reflected distortions in convex mirrors have fascinated artists from van Eyck to Escher, and Baroque pictures abound with hidden objects painted

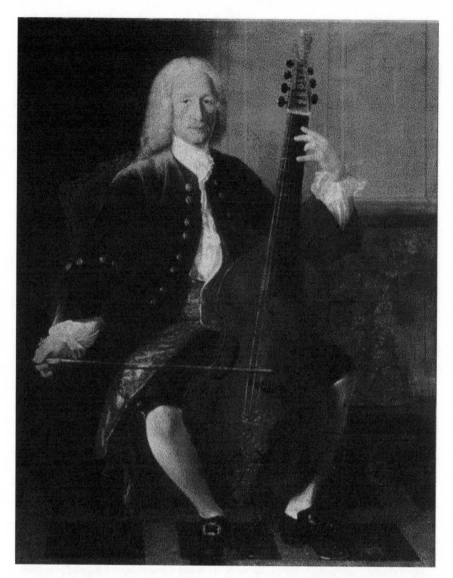

Fig. 6.7: *Check Forqueray's right hand, another detail from Jean-Martial Frédou's painting. This shows the particular French way of holding the bow with one finger on the stick and one on the hair. This invention is attributed to Sainte Colombe, and was assumed to facilitate virtuoso playing. The older English manner used two fingers on the hair. Note the underhand hold, opposite to that used with a cello. This makes upbow the heavy stroke, which is a particular advantage in playing accentuated chords as those are always played from the bottom to the top strings. With the viol bowing one saves a little bow for each string crossing, with the cello bowing one always loses bow and may so easily get "out of bow".*

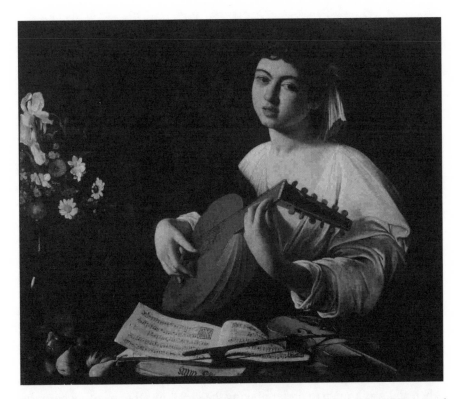

Fig. 6.8: *"The Lute Player" by Michelangelo da Caravaggio (1573-1610), one of several extremely accurate pictures of musicians and musical instruments, shows a music score in such detail that it has been possible to identify the music.*

in such skew projection that they can only be seen with the help of mirrors. In modern times Salvador Dali wanted to sculpture a horse of normal front crossection but 30 km long to be seen in central projection from the front view, but he did not find a sponsor.

In summary, the artists discovered projective geometry as much the as scientists ever did, and they were very proud of their discoveries, as they could use them to produce more illusory and convincing pictures. For us who are accustomed to the trivial ease of photography, this pride is difficult to understand.

An example of to which extremes the accuracy of observation among painters could strive is provided by a portrait by Jean-Martial Frédou of the famous composer and violist Jean-Babtiste Antoine Forqueray. The instrument he is holding is painted with such accuracy that it has been possible to

identify the tailpiece, which was separated from the instrument and is now in the collections of the Musée des Arts decoratifs in Paris. From its length it was possible to calculate the vibrating string length of the original instrument.

Moreover magnifications of the painting have made it possible for organologists to determine exactly which type of material was used for each string, and to find the design of the bridge, which is seen in an extremely skew projection almost from above.

As for the way of treating the instrument, it also is possible to see for instance the typically French right hand technique of holding the bow with two fingers, as different from the older English way using three. In the same way the painting by Jean-Marc Nattier of Madame Henriette de France, illustrated in Chapter 4 could be used as a textbook illustration of how to play the low strings by throwing the instrument forward.

Painting musical instruments with great accuracy, as "nature mort", in portraits, and in general devotional or historical paintings, was a popular topic among painters. The accuracy makes one suspect that most of them were musicians themselves. We could just mention Dürer, Carpaccio, Caravaggio, Veronese, Vermeer, and Gainsborough as a few examples from various periods where this was in fact the case.

Gainsborough painted a portrait of the last viol virtuoso Karl Friedrich Abel, and was known to prefer playing the viol himself to painting portraits.

Special mention is also appropriate in the case of Michelangelo da Caravaggio, the master of chiaroscuro painting, whose pictures from 1595-1597 portray instruments with extreme accuracy, and in one case a music score (including text) has been identified as four madrigals by Jacques Arcadelt.

To the important innovations by painters come the invention of colour shading air perspective, which too is a truly scientific discovery. Engraving and etching techniques, "cire perdue" techniques in sculpture, Gothic vaulting in architecture, measured notation systems in music, are just random items from an endless list of progress. In Chapter 4 we already dwelt in detail on Brunelleschi's well documented devices and organization for the construction of the dome of Santa Maria del Fiore in Florence.

The major transitions between the periods which we have baptized by such names as the Renaissance, or the Baroque, however, represent shifting tastes, rather than progress, quite in contrast to the views held by contemporary commentators.

6.8 Rediscovery in Music

Music is a particularly interesting example for the point we want to make, because, in the rediscovery of the compositions from the Baroque and Classical periods, and the attempts to perform them anew, we witness an example of a complete return, not only to an earlier performance practice, but to the reproduction of a once scrapped instrumentarium, which even had to be reproduced by an outdated technology.

The compositions from the Baroque and Classical periods were literally rediscovered right at the summit of Romanticism, when Mendelsohn in 1829 and Berlioz in 1859 revived the works by Bach and Gluck.

Having mentioned these famous "rediscoveries" it should be remembered that "old" music was actually never totally forgotten. For instance, Baron van Swieten, librarian of Emperor Joseph II, organized regular concerts with music by Bach and Händel in the big hall of the imperial library, in which among others Mozart took active part. To judge from Mozart's letters there was a considerable public interest in this, and Mozart actually composed a set of six fugues in this style for Baron van Swieten.

Returning to more recent rediscovery, the natural thing to do at first was to perform the historical music according to the aesthetics of the day, replacing instruments that no longer existed, using the entire bulk of the romantic orchestra and choir, and ignoring instructions that nobody any longer understood.

To make things more precise, suppose somebody at that time found an early 18th Century "pièce de viole avec basse continue" by an Antione Forqueray or a Francois Couperin, and wanted to perform it. Most likely there would not have been a viol available, nor a harpsichord. Accordingly, a cello would be chosen for the solo part and a grand piano for the continuo part.

The cellist would have been puzzled with the frequent occurrence of chords of six notes when his instrument only had four strings. Moreover, he would have had no idea about how these chords sounded on an instrument provided with frets to keep the chords ringing for quite a long time.

Another difficulty would have been the compass. Those pieces jump between notes as low as a fourth below the lowest note of the cello, and passages very high up, where the cello can hardly sound reasonably well at all.

The score would have looked sprinkled with funny ornament signs for mordants, trills, apoggiaturas and the rest, whose exact meaning was no

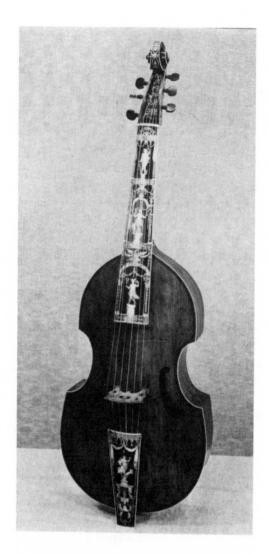

Fig. 6.9: *18th Century base viol by Martin Voigt. This has the traditional old English layout, with six strings tuned in D, G, c, e, a, d'. The tuning in fourths and a central third, more "guitar type" than "cello type", was appropriate for the playing of chords. The playing of chords was also facilitated by the frets, which made all the notes, except the highest, which had to be played above the seven frets, sound like open strings. The frets were not fixed but movable according to the tonality of the piece. The French added a seventh low AA string, and so enlarged the compass to more than 3 1/2 octaves, AA to d" and even higher. Much viol music, though often adapted for the cello, is hardly playable at all on that substitute, due to compass, tuning, and sound character, which too was very particular on the lightly strung and lightly built instruments.*

Fig. 6.10: *From a pièce de viole by Antoine Forqueray. A total of 30 pieces arranged in five suites remain by this famous master. His son Jean-Baptiste Antoine published the music, adding three pieces of his own to the second suite, among them a most fantastic chaconne. The relation between father and son was strange. For unknown reasons the father seems to have hated his son, making the King throw him into prison, a practice not uncommon in 18th Century France. The same fate occurred to the young Marquis de Sade, though the reasons in the latter case are easier to understand. With Marin Marais, Antoine Forqueray provided the fixed stars of the French viol firmament. While Marais was said to play like an angel, Forqueray was said to play like the devil. The published music was dedicated to Mme Henriette de France. The picture shows some of the chordal writing. Chords of six notes, though not in the picture, were quite common. Note the detailed information about how to play contained in this score - the numbers in the solo part indicate which finger to use, the dots the string which has to be played. (In the base line they, of course refer to which kind of harmony was supposed to be improvised.)*

longer known, including two different kinds of vibrato. Vibrato as an occasional ornament, indeed! Any modern cellist would have been playing vibrato on every note all his life, and could not even have imagined what a note without vibrato sounded like.

The type of original we are here referring to would by no means be the toughest challenge for a string musician. After all, even if there are unfamiliar signs, the piece would use modern measured notation in normal score.

Much viol music has been notated in various tablatures assuming different tunings of the instrument. For the viol there were around 50 different ways of tuning the strings, and, if the music were transferred to normal score, the performer would lose all information about how to play it. We should also mention in this connection that tablature notation was not only used for lute and viol music, but even for keyboard music. For instance Buxtehude's harpsichord music is written in old organ tablature which most modern keyboard players would be unable to read.

Somewhat more of a challenge is illustrated by the great Salzburg composer Heirich Ignaz Franz von Biber who composed a set of fantastic violin sonatas on the topic of various episodes from the life of the Holy Virgin, commonly called the *"Rosary Sonatas"* or *"Mystery Sonatas"*. Most of them assume "scordatura", i.e., that the violin is detuned in various ways.

For instance, in the sonata devoted to the Resurrection of Christ, the middle strings are supposed to be literally crossed over the nut and bridge, the higher string thus being put in a lower position. Using a normal tuning the piece would hardly be playable at all, and Biber's own very special and complicated notation has to be learned by the performer. Such tasks, almost comparable to Champollion's deciphering of the hieroglyphics, were, of course, not even tried in the early attempts to revive Baroque music.

To return to our exemplificatory mild challenge of a normal "pièce de viole", the pianist would be in even more trouble than the cellist, finding only one sequence of left hand notes, occasionally provided with cryptic chord signs indicating the kind of harmony that the keyboard player was assumed to improvise, instead of the usual complete score with all the notes to be played written out to the detail of every single 128th.

Improvisation was part of the performer's equipment as much as for any contemporary jazz musician, and furious pamphlets were once written against composers, such as Bach, who disclosed their distrust of the capacity of performers by writing everything down. The practice of improvisation being forgotten, it became the special task of editors to provide for the realisation of the figured bass in published music, though performers often obey every detail of it as if it had been from the composer's own hand.

Some of the music was pleasing even performed the way of the first trial, so this kind of practice has remained, even after the final success of the early music revival. So, Bach's three viol sonatas are played by every cellist, or even viola player (most of the passages sounding better on a viola than on

Fig. 6.11: *Example of tablature notation of viol music from Tobias Hume's "Captain Humes Musicall Humours" of 1605. Hume was a mercenary soldier, serving in the campaigns of the Swedish warrior King Gustaf Adolf II "My Life hath been a Souldier, and my idleness addicted to Musicke" he writes on the opening page. Further he writes: "And from henceforth, the stately instrument Gambo Violl shall with ease yeelde full various and devicefull Musicke as the Lute". This remark is supposed to have infuriated the great lutenist John Dowland who had some influence at the English court, so Hume never got admission to play there, despite repeated requests. He led his life as a soldier, remaining something as uncommon as an amateur composer, and he died in poverty. He also left one later publication "Captain Humes Poeticall Musicke" dating from 1607. The six lines in the picture represent the six strings of the instrument, and the letters a, b, c . . . indicate the number of halftone steps up from the open string note that the performer has to move. The durations of notes are indicated on the line above, by minims, quavers, crotchets and the like, which are supposed to apply until a new sign appears. Dots after the crotchets are used in the modern way, dots on a line indicate that the open string is to be plucked with the left hand. A column of letters always indicates a chord. This way of notation is very precise as it tells not only which note is to be played, but also on which string or in which position. The challenge is thus much less than that provided by Biber's way of notation, where the performer continually has to use all his/her musical intelligence to play the right notes. The performer, however, has to know how the instrument has to be tuned. This is often indicated by a short instruction to tune it "the lyra way", or "the bandora way".*

Fig. 6.12: *Number XI, "The Resurrection" from Biber's Mystery Sonatas, dating. from 1676, the most extreme example of scordatura composition. The key signature is a mixture of three sharps and two flats, which does not seem to represent any known tonality. Nevertheless, the piece is in G-major, the basic violinistic one sharp tonality. The solution to the riddle is given by the four quavers printed before the music: g, d', g', d". The four strings, normally tuned g, d', a', e" are just changed a little, the a' and e" just tuned one note down, but the beaming must be taken to indicate that the order has to be changed to g, g' d', d". This would not work with the normal stringing, because one string would break and the other just yield a weak noise, so the middle strings must literally be crossed over the nut and bridge, thus bringing a lower string in a higher position. The notation, being usual score, means that the violinist has to play the piece as if it was tuned the normal way - of course never playing a note in a different position from that intended by the composer, and always taking note of the unusual combination of sharps and flats. Quite a challenge! In his Mystery Sonatas, composed for the various meditations of the Catholic Rosary and narrating episodes from the life of Holy Virgin Mary, Biber used no less than fifteen different tunings. Anybody who has listened to this fantastic music could testify that it is anything but just experiment or mere challenge to the performer. The sound produced by the instrument is very special, and very much related to the emotions of the particular topics of the meditations. Heinrich Ingnaz Franz von Biber, Bohemian by birth, was Kapellmeister at the Court of the Prince Bishop of Salzburg, and the most famous Salzburg composer before the advent of Mozart. He composed another collection of scordatura music, chamber music for several instruments, "Harmonia Artificiosa-Ariosa", and lots of more normal music.*

a cello), despite the fact that not even the cello can reach down to the low AA string as required in the original score.

Some of such performance style even turned into great art in its own standing. Undeniably Glenn Gould's different recordings of the Goldberg Variations have an artistic value, though his interpretations are so far from Bach's original composition *for a two manual harpsichord* that we should distinguish the "Gouldberg" from the "Goldberg". The same is true about many a performance of Bach's cello suites, of which the last originally was for the no longer existent 5-stringed instrument "Violoncello Piccolo".

6.9 Tuning and Temperament

To take another example, consider Bach's two collections of *"Das wohltemperierte Klavier"*, containing 24 preludes and 24 fugues each in all the Major and minor keys. (By the way Bach was by no means alone in the period 1725-35 to compose such sets of keyboard works. The author knows of at least another collection, by the minor composer Joh. Chr. Schickhardt.)

It has been commonly claimed that this was a first demonstration of the possibility of playing in all the keys using the "modern" equal temperament. For instance Sir James Jeans in his *"Science and Music"* of 1937 writes:

"Bach subsequently advocated the system (of equal temperament); not only were his clavichord and harpsichord tuned to it, but he wrote the well-known forty-eight to prove that it enables compositions in all keys to be played without disagreeable discords."

The question is why the greatest genius in the history of music would have cared to compose in all the tonalities, if the pieces sounded exactly identical, except for absolute pitch. He could have composed half the work in C-Major, half in a-minor, and let any copyist transpose them to the different more remote keys.

Modern computer software does this just at the click of your mouse! Even if it was not that easy for the 18th Century copyist, the mechanical triviality of the process has not changed.

The suspicion is that the music in fact was intended to sound different. We also know that Bach was very meticulous about tuning his instruments himself, and that he used a temperament of his own.

As a matter of fact the "modern" equal temperament for keyboard instruments was known and described in the Renaissance already, but it was not in use because it was considered a bad solution to the problem of the Pythagorean "comma"!

The problem of tuning, which must always end up in compromise, is the following: A pure fifth represents the theoretical frequency ratio 3/2. Now, ascending by fifths in 12 steps should bring us back almost to the note we started from, though several octaves up, 7 to be quite exact. It almost does but not quite, as $(3/2)^{12} = 129.75$, whereas $2^7 = 128$.

The equal temperament solution is to tune all the fifths at $2^{7/12} = 1.498$. In this way the impurity is distributed equally between the fifths, and the resulting ratio falls but little short of the ideal 3/2. Each half note step increases frequency by the same factor, the fifth being 7 steps up in the total of 12 notes of the octave. In this way the octaves become pure and the fifths share the mathematically necessary imperfection equally.

So why was this system considered inferior in the Renaissance? The answer is that fifths and octaves are not the only intervals in chords.

The third is equally important. Its theoretical frequency ratio is 5/4. In equal temperament we get $2^{4/12} = 1.26$, which is really awkward, though we are by habit accustomed to it. The adaptability of the ear is truly marvellous, because most of us are ready to accept all the different temperaments at once without even noting the differences.

Through the entire Renaissance "mean tone" temperament was used, because it provided pure thirds. It was based on another mathematical fact. Superposing 4 equal temperament fifths almost results in a third 2 octaves up, to be exact $2^{4/12} = 5.0625$, to be compared to the theoretical $2^2(5/4) = 5$.

Making the thirds pure, i.e. corresponding to a frequency ratio of 5/4, would result in fifths that are $5^{1/4} = 1.495$, which means that they are somewhat more impure than in equal temperament but still tolerable, especially when combined with pure thirds. The big problem with mean tone temperament is that not all the thirds can be made pure, only 8 out of the 12, the remaining 4 being left as they could be.

This implied that compositions were restricted to a limited number of keys, and that modulations through the keys had to be restricted as well. To remedy this several ingenious temperaments were invented in the Baroque.

Bach's own pupil Kirnberger describes a sophisticated compromise between equal and mean tone temperaments. Starting from 1 pure third, divided in 4 mean tone fifths, next 7 pure fifths were tuned. It then happened that the one remaining fifth almost became an equal temperament fifth.

The mathematical formula reads $\left(5^{1/4}\right)^4 (3/2)^7 \left(2^{7/12}\right)^1 = 127.9999$ which falls very little short of 128. As a bonus the resulting thirds become quite pleasant too.

This ingenious mixture of mean tone, Pythagorean, and equal temperaments makes it possible to play in all the keys, and to modulate through them. Yet, the keys sound different, and it becomes understandable that contemporary sources speak of the different characters of the different keys, some "heroic", some "passionate" some "sad".

Kirnberger's description may very well codify Bach's practice. So, using equal temperament for *"Das wohltemperierte Klavier"* we may lose the essential message.

6.10 The Modern Harpsichord

As for the instrument, the harpsichord is very different from the grand piano. What is most obvious is action - the strings are not struck by hammers, but plucked by quills. So, it was natural to first focus on this aspect.

Wanda Landowska put drawing pins in her grand piano in order to check out what kind of sound the harpsichord had. In 1911 she managed to convince the Pleyel company to produce a harpsichord with real plucking action for her, the first produced in over 100 years. That great artist made wonders with it, which we can still enjoy on records, though nobody would say today that it was a harpsichord she was playing.

Another difference between the grand piano and the harpsichord is not as obvious as action: In the modern piano very strong steel strings are mounted in a metal frame under immense tension - 17,000 kg for one instrument. By the nut, the strings are connected to the soundboard, which obviously has to be very strong too, being made of laminated wood, having considerable thickness and impressive barring. The bottom of the instrument is open, so there is no air resonance at all.

The bottom of the historical harpsichord, on the contrary, is closed, providing for a powerful air resonance. The soundboard is of very thin spruce - down to 1.5 mm along the edges for a board 1 m wide and 2.5 m long. This, of course, cannot support high string tension or heavy stringing.

When the instrument was revived, nobody believed in the significance of these latter factors. Soundboards of existent historical instruments were not

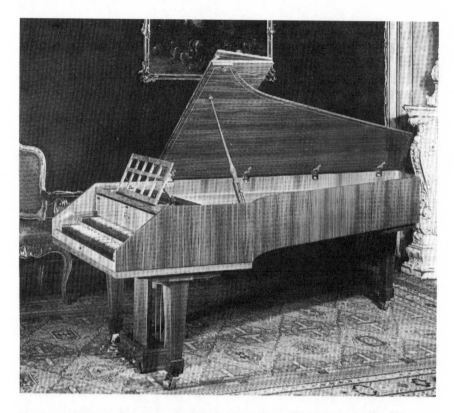

Fig. 6.13: *The modern harpsichord, a 175 kg piece from around 1960 by the Sperrhake industry in Passau, Bavaria. Production of historical harpsichords ceased by 1800. When they were produced again it was done by adding plucking action to an instrument that essentially was a variant of the modern grand piano. The sound of these huge instruments, however, was weak, and the action heavier than on the modern grand. The historical articulations described by for instance Carl Philipp Emmanuel Bach were literally impossible to use on these neo-historical instruments.*

exactly plane, so in this respect the modern instrument should look more beautiful.

As a matter of fact special double pinning techniques had been used to keep the strings aloof from the soundboard of the historical harpsichord when, not if, it got buckled due to seasonally changing air humidity.

Accordingly, the new manufacturers used the same type of soundboard as for the grand piano, also provided with an impressive barring beneath, and then, of course, the dimensions and the tension of the strings had to be in proportion.

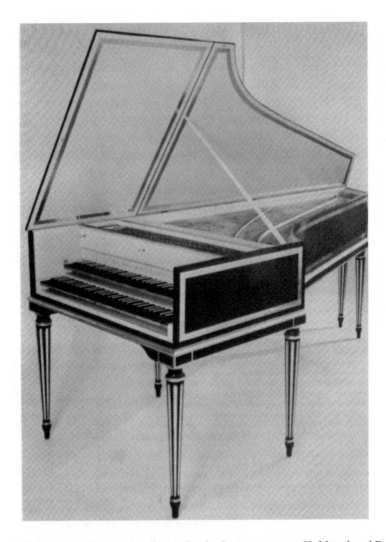

Fig. 6.14: *Historical harpsichord copy by the Boston masters Hubbard and Dowd. In 1965 Frank Hubbard at Harvard University published a treatise on the historical design and making of harpsichords. Hubbard in a unique way joined academic scholarship with practical artisanship. He founded a firm in Boston that produced not only harpsichords but also harpsichord kits. The ingenious idea was to use industrial techniques for such mechanically repetitive work as assembling the case, making the stand and lid and sawing out the keys. The really work intensive fine adjustments were left the customers, who could thus, using their own working time, get a fine instrument at less than half the cost of a finished one. A whole generation of harpsichord makers got their first training assembling Hubbard kits, and the design was eventually forced on that part of the industry that managed to survive.*

The problem was with the plucking action. As this was what distinguished the harpsichord, it could not be dispensed with. In the historical instruments quill had been used, but such a pluck would almost not be audible. So, particularly hard, tanned leather was used for the plectra.

Nevertheless, the energy supplied in this way was much smaller than that produced by a striking hammer. The sound produced therefore was very weak. Accordingly, several registers were added, some with strings as thick as pencils, but then the framing had to be strengthened even more, and the sound hardly became any louder.

Some people became accustomed to this kind of sound, assumed that this was the way music with historical instruments should sound, and decided to like it. Others, such as the famous conductor, who never admitted any harpsichord to his concerts, and who described its sound as that of "skeletons copulating on a tin roof", dismissed the entire early music movement as rubbish.

A particular disadvantage was that with all those registers action became very heavy. The harpsichordists had to develop strong fists and strong fingers which would work with perfection no matter how unreliable the action was, because the keyboard player is at the disadvantage, compared to other instrumentalists who carry their own instruments along, of having to accept whatever the venue happened to be equipped with.

In an amusing article from 1983, one of the greatest harpsichordists of the Century, Ralph Kirkpatrick, who also catalogued the part of Domenico Scarlatti's oevre that had survived the earthquake in Lisbon, and who wrote a delightful biography of the master, describes what harpsichord playing was like those days:

"I realized... that to dominate the excessively heavy action ..., I must cultivate a piledriver strength and a total independence in all ten fingers. I knew that this technique had little to do with the indications furnished by 18th Century source material ... It had, and still has, aspects that I have always considered profoundly unmusical.

Nevertheless, I embarked on years of finger exercises, designed to cultivate an ability to get even the most resistant keys down with a steely precision.

Those years of finger exercises, after all, have stood me in good stead ... At the end of a summer vacation involving heavy gardening and shovelling of dirt ... I always found that two weeks would be sufficient to put me back in shape.

I remember one occasion in 1967 when I was just about to complete ... a terrace, a telephone call came ... asking me to play the Fifth Brandenburg

with Karajan two weeks later ... although I never did finish the terrace, I was not the least worried about the state of my hands. My reaction when confronting those keyboard players who ... never shake hands is to bring the conversation around to the carrying of baggage ..., the cutting of firewood and so forth.

With the arrival on the scene by Hubbard ... there began what for me was a joyful period; but it began too late. I now discovered new resources for playing and I enjoyed the privilege of bringing out the beauties of an instrument rather than being obliged conceal its defects."

This situation was really absurd, because the old treatises on harpsichord playing describe practices which are only possible with an extremely easy and reliable keyboard action, being impossible even with a modern grand of the highest quality. In this way the instrument literally blocked the way to regain the historical way of playing it.

The story could be told similarly for all the revived historical instruments. Thurston Dart in his pathbreaking book *"The Interpretation of Music"* 1954 coined the nicknames "pianochord" (for the piano-harpsichord), "luthar" (for the lute-guitar), and "cellamba" (for the cello-viol/viola da gamba).

His verdict was that those instruments bore almost no resemblance at all to the historical harpsichords, lutes, and viols, and that they effectively blocked the way to historical performance.

6.11 Back to Originals

After a while, people started to suspect that there was something wrong in this whole approach, and that it was better to attempt to perform according to the aesthetics of the periods in which the works in question had been composed. Some people always say that nobody is alive to tell what the music sounded like in Bach's days, and that he might have preferred the modern grand piano if he only had one, or maybe even an electronic keyboard. That is, of course, as true as it is trivial. Bach might even have preferred to be computer scientist rather than a composer. As a matter of fact, to reply with another triviality, he was not.

Frank Hubbard in his influential *"Three Centuries of Harpsichord Making"* in 1965 described the structure and making of the historical harpsichord, and started a workshop in Boston, which, besides finished instruments, also produced instrument kits. These were extremely significant,

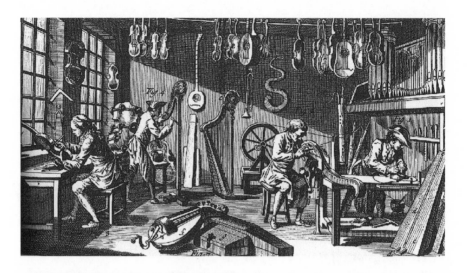

Fig. 6.15: *Interior of a luthérie from the Diderot-D'Alambert "Encyclopédie". Pictorial evidence, along with existent museum pieces, and literary evidence provided the material for Hubbard and other organologists who wanted to reconstruct the historical instruments of music. The "Encyclopedie" proved to be a real treasury.*

because most of the good instrument makers that started work in the wake of Hubbard all over the world started from a Hubbard kit. Finally their joint effort forced the industry, represented by big firms such as Pleyel, Neupert, Sperrhake, and Wittmayr, either out of business or else to accept a new standard.

So, such harpsichords, that had once been burnt as common firewood, were carefully reconstructed, and it was realised that only those could render justice to baroque keyboard music.

It was even found out that the historical harpsichord, though it was much more delicate in construction and only had a fraction of the weight of the modern harpsichord, was immensely more powerful in tone. Now it also became possible to regain the techniques and articulations described in the historical sources. This whole development was extremely interesting as it led back to the original solutions, to the old instruments in their original design, and to the performance practice as described in 17th and 18th Century treatises.

Not only were the original instrument designs revived, but it was found that they had been optimally constructed by the old artisans.

Fig. 6.16: *Experimental models of the violin. To the left a porcelain violin. There was a constant experimentation with materials and shapes. Except brass such materials as porcelain, glass, and tanned leather were tried. On the right a 19th Century monster with surface area increased wherever it did not obstruct the movements of the right or left hand.*

This happened despite the fact that modern materials and industrial production methods were tried at every stage of their recovery. Heron-Allen in his amusing treatise *"Violin Making as It Was and Is"* dating from 1885, reports the most fantastic experiments. Wood was replaced by brass, tanned leather, porcelain, and glass.

The shape of the violin was changed to comply with geometrical ideals, as in the cases of Collins's circular or Dr Savart's trapezoidal, or it was just inflated like an amoeba anywhere where it did not become an obstacle to the movement of the hands. The neck was occasionally replaced by a wind instrument bell piece. But nothing proved to be an improvement.

Not even modern synthetic glue, which is the true nightmare of every violin repairman. Traditional glue, made from animal hides, has kept Egyptian furniture intact in every joint since the Middle Dynasties, and it is immensely strong, as very long joints with only a few millimetres of thickness

keep together over Centuries in a working machinery under constant stress and strain, such as a violin or a cello.

Yet it is so brittle that the violin repairman can easily open a precious Cremonese with a knife without harming it in the least. This is never possible with any modern synthetic glue.

The backward development process to recover old artisanship, dissipated to such details as the harpsichord jacks, which regained their old design of just a rigid pearwood stick, a pivoting holly tongue, a quill plectrum, a hog bristle spring, and a piece of felt as damper. The action actually became more precise than with all the up to ten different adjustment screws the jacks used to have in the hey-days of the "pianochord".

6.12 The Early Music Revival

Again, the same story could be told about all the other historical instruments of music. Museum pieces were copied, and were constructed by methods described in contemporary sources, such as the D'Alambert-Diderot *"Encyclopédie, ou Dictionnaire raisonnée des sciences, des arts et des metiers"* dating from 1751-80, which is a real treasury for makers of musical instruments.

Once the instruments were there, the historical sources on performance practice could be studied anew. The demand was so considerable that several publishers even specialized in facsimile reprints of books, such as C. Ph. E. Bach, *"Versuch über die wahre Art Klavier zu spielen"* from 1752, L. Mozart, *"Gründliche Violinschule"* from 1756, and J. J. Quantz, *"Versuch einer Anweisung die Flute Traversière zu spielen"* from 1752, just to mention a few examples from one decade and one language area.

It is remarkable that so much resources over a period longer than a Century were spent on regaining a piece of culture which had been regarded as completely worthless, and also that it was so hard to regain it. This if anything is a reflection of varying tastes.

The people first engaged in the early music revival could adequately be described as dabblers, fanatics, and cranks, sometimes unable to discern mere appearance, such as wigs and 18th century clothes, from substance, such as frets or gut strings. Only after a transition period, more serious protagonists came to dominate the scene, and by now the scenery has changed

Fig. 6.17: *Early music pioneer Arnold Dolmetsch and his family in period outfit in Heslemere. The early music movement always had a trace of masquerade, but such pictures also reveal a difficulty to recognise what is essential and what is not. Maybe the pioneers thought that they would feel like people of Centuries past in such outfit and so produce a better interpretation, or maybe they wanted to constrain the movements of their arms and hands by using authentic clothing. If so, the last idea might not be so crazy after all. There exist serious speculations about 18th Century court dress being an impediment to the use of very fast tempi. In a recent video recording of the "Water Music" on the Thames the first violinist cut off half his wig in order not to obstruct the instrument, a strategy not likely to have been used at the original performance.*

so completely that it is rather daring to play Mozart's symphonies with the big romantic orchestra.

Parenthetically we should take note that all this was not mainly a reflection of nostalgic historicism. Exactly the revolutionary composers of our Century, such as Hindemith, Schönberg, and Stravinsky, were deeply involved in the early music movement, and we may safely conclude that the renewal in post-romantic music was closely related to the early music revival.

Although the protagonists of romanticism aesthetics once talked about progress when this, now laboriously regained, piece of culture was once

scrapped, we should understand that it was not progress but a paradigm shift, exactly of the sort we met in science.

Note the obvious parallel in the visual arts in the Pre-Raphalite movement, where the renewers actually took inspiration from painting in the days of Fra Angelico and Bottcelli.

6.13 Meaning and Beauty

We noted the floating borderline between early art and science. Discovery, bearing all the signs of science, always was there in the arts, and we may also recall the discussion of the importance of aesthetic criteria in scientific modelling.

It is natural to assume that there still is a basic unity of the arts and the sciences. The idea that science is the pursuit of truth, art the pursuit of beauty, is in fact not true to either. We saw before that science incorporates many aesthetic elements. In the same manner it is true that art more aims at understanding than at producing sensations of sheer beauty.

6.14 Harnoncourt

Nikolaus Harnoncourt in his brilliant book *"Musik als Klangrede"* from 1982 points out that we in our time have lost the understanding for the deeper meaning of music by focusing so much on beauty. Great art can, and should, if needed, be ugly rather than beautiful, and if we insist on interpreting the ugly as beautiful in some disguised sense we do not understand art any longer. This is his message.

Art like science has many degrees of freedom. It can convey meaning at different precision levels, even be a language as Harnoncourt points out. These degrees of freedom are beneficial - they can be used for deeper level messages, for the fun of the composer, or even to accommodate the wishes of a patron.

In this way an artist, such as Michelangelo, was not notably hampered in his creativity, by a despotic patron, such as the terrible Della Rovere Pope Julius II.

Fig. 6.18: *Sandro Botticelli's "Primavera" from 1478 is a famous allegory completely stuffed with symbols. This symbolism, particular of renaissance humanism is particularly subtle in its dual interpretation in terms of pagan antiquity and Christian religion. The central figure, representing Venus, is also a picture of the Virgin Mary, as indicated by the halo-like opening around her head. The Cupid above her could also be an angel, and Mercury has the typical pose of St. Sebastian. The picture is completely stuffed with fertility symbols. When Zephyr blows his mild breeze, branches grow out of the nymph's mouth, and the ground becomes covered with flowers wherever Flora walks.*

According to Harnoncourt there was a thorough break in the character of music by the time of the Revolution in France, not only coincident in time but caused by it and consciously promoted by the conservatories expressly founded to this end.

Music before that change had been a language, which had to be learned like other languages. This was not to the taste of the Revolution, because knowledge and learning had been restricted to the privileged classes. To promote egalitarianism a new music should be created, one that immediately touched the hearts of the concert audience without any need to learn its messages. Harnoncourt calls the new music, that of the Romantic era, "painting", as contrasted to the "speaking" music that had existed before.

It is obvious that polyphonic music, or music using counterpoint, such as fugues, assumes a different level of attentive involvement from the listener than does orchestrated melody. So earlier the audience had to learn to listen.

6.15 Rhetoric in Music

There even is something more to all this. The elements of music were intended to connote certain affects or ideas. We already spoke of the different moods attributed to different keys, provided temperament was correctly chosen. But, even such details as the individual intervals conveyed a meaning to the knowledgeable audience of those days.

According to Mattheson's *"Der vollkommene Kapellmeister"* from 1739, music is speech in emotions, following all the guidelines of classical rhetoric. The idea that music is a kind of rhetoric itself goes back to Quintilianus's, *"Institutio oratoria",* which was rediscovered in 1416.

Mattheson describes the composition process in terms of "inventio" (conception of the idea), "dispositio" (organizing the contents of the work), "decoratio" (elaboration of the idea), and "pronuntio" (performance), in complete accordance with classical oratory.

A piece of music should also contain: statement of facts, proposition, proof, refutation, and conclusion, just like any dialectic discourse.

The particular relation to emotions or "passions", was proposed in Descartes's *"Traité des passions de l'âme"* dating from 1649.

So, there was not only trivial imitation of natural sounds: birds, bells, barking dogs, galloping horses, fanfares, fighting soldiers and the like. Chord and note sequences, even mere intervals, gained a meaning in an abstract sense just as words and phrases. Intervals, like chord progressions, were even given fancy names that identified their character: "Exclamatio" for the minor 6th, "passus duriusculus" for the minor 2nd. The messages could only be understood if the meaning of the words had first been learned.

The composers also used other ways to convey information. In Bach's Church music there are lots of references to the exact places in the Holy Bible, by such means as the numbers of beats in the base line. Of course, only few such references have been identified, and the language of intervals is still only understood by scholars.

6.16 Art and Science

It is nice to note the complete reciprocity between Art and Science: Whereas scientists, in their attempts to explain various phenomena, take pleasure in

Fig. 6.19: *The magic square in Albrecht Dürer's engraving "Melancholia". The blackboard in the allegory shows the so called magic square. The first row reads 16, 3, 2, 13, the second 5, 10, 11, 8, the third 9, 6, 7, 12 and, the fourth 4, 15, 14, 1. The magic square consists of all the natural numbers 1 through 16, arranged in rows and columns in such a way that all row and column sums add up to the same number: 34. Also, the main diagonal, sloping down from upper left to lower right, adds up to 34, and this number also is the highest "eigenvalue" of the matrix. Solving such mathematical puzzles always was a favourite occupation of intellectually inclined artists, and Dürer most obviously was very knowledgeable in mathematics.*

Fig. 6.20: *Perspective study by MC. Escher. The Dutch graphic artist delighted in penetrating queer geometries as nobody else. The point of this drawing is the following. In normal central perspective you see a railway track or a pair of parallel overhead lines vanishing in a point. But, suppose you lie on the back on the ground under such overhead lines, and move your head back and forth. Then what you see during movement is more like a slice of a melon with vanishing points on either side. This study displays a kind of scaffolding seen in this way. The idea was used by Escher in his famous engraving of the small larvae rolling down a staircase, though there was even more sophistication to the geometry of the engraving. It is doubtful whether anybody ever had a deeper intuitive insight in geometry than M C. Escher, though when the famous geometrician Coxeter organized a conference to his hounor, where the geometry of his work was penetrated, he is reported to have declared that he understood nothing at all.*

formulating simple and elegant theories, artists are delighted to use their work to convey information and messages.

The case is not unique for music. In painting the story told by a picture is quite like the plot of an opera. Of course, the beholders have to know the Holy Bible and Ovid's Metamorphoses better than is common today, but there is again more to it. There is a quite similar language of symbols, corresponding to the affects of intervals, such as pomegranates and rabbits for love and fertility, snakes for death.

Dürer's famous engraving "Melancholia" contains a picture of the so called magic square, a square matrix of the first 16 integers whose columns, rows, and diagonal all add up to the same number, also equal to the highest eigenvalue.

In more recent days various preparations for Escher's graphics display very deep studies in queer geometries, even such as have been proposed in relativistic cosmology. See the illustration. Also, compare Hockney's "collage" idea above. So, there definitely are scientific aspects of the most varying kinds in the arts.

6.17 Art as Sedative

Today we consume music in a quite different manner from earlier generations according to Harnoncourt. We do not care about meaning, we want it as soothing sedative after the turmoil of real life.

This end is more easily attained by the standardization of the repertory. Only a few composers are performed, and only a small fraction of their total production, not even necessarily the best part of it, if such a thing can be defined. On the other hand the same selection is offered all over the world. Opera houses and concert halls offer the same programmes in London, Paris, Vienna, New York, and Tokyo. For a visitor it would be impossible to tell from the repertory in which part of the world the venue was located.

The audiences seem to love this listening to the same pieces over and over again. They also do it in their homes. Who knows how many recordings there are of "The Marriage of Figaro", "La Traviata", or "Carmen", while many record companies not even care to listen to sensational rediscovered masterpieces by long forgotten composers.

In this repetitive listening we, according to Harnoncourt, even cheat the composers, by anticipating the shocks in terms of dissonances or crescendi that they had once prepared, thus escaping the shocks.

In other words, music lovers of today are all like the Spanish King Felipe V to whom the famous castrato Farinelli (Carlo Broschi) sung the same four arias every day, year after year, this being the only means of getting the melancholy monarch out of bed and agree to being shaved and dressed.

The lesson to be learned from all this is that the social function of the arts, as well as the fashion of appreciation has been shifting so frequently that progress hardly is a more significant ingredient in development than is shift of paradigm.

7 Economic Principles

7.1 Introduction

From the illustrations of progress and development in the arts and sciences, to which we, in line with title of the French Encyclopedia *"...des sciences, des arts, et des métiers"*, should add the crafts, we would like to outline a theory for development, particularly suitable for these sectors.

Objects or manifestations of art are often characterized as being unique, in contrast to mass produced goods and services. The same is true in science as well, because any reproduction of scientific ideas necessarily is a consequence of ignorance or even intentional fraud.

This makes theorizing about development in the cultural sector particularly hard, because we are accustomed to measure progress by means of growth in the numbers of well-defined objects. On the other hand, progress, or even just development, in these areas is justly seen as improvement or merely change in quality, rather than in quantity.

Most often we try to measure improved quality by quantity, by a priori defining a hierarchy of classes of basically similar objects, ordered in terms of quality, a Rolls Royce having higher quality than a Fiat, and a PhD having higher quality than a college graduate.

Then, the average quality of an aggregate can be measured quantitatively, in terms of the relative distribution of objects in these classes. The quality of manpower in a plant can thus be measured by the average length of education, and its quality is regarded as being improved if this average increases.

Education time as used in the example makes things unduly simple because it is itself a quantitative measure which can be used in ordering the different classes. In most cases such a possibility is not available, and the classification order is bound to become more or less arbitrary. It is much

more difficult to say why a Rolls Royce is superior to a Fiat than why a PhD is superior to a college graduate.

Except the fact that such classifications tend to be arbitrary, one might wonder how to describe or model a development through which a previously nonexistent object is born. This just adds a new dimension to the space we are studying. Mathematical methods do not favour the modelling of such changes.

7.2 Böhm-Bawerk and Smith

In economics many ideas of improvement through qualitative change have been advanced, but none has been translated into a successful formal model. There are two such excellent examples: Böhm-Bawerk's theory of roundabout production, and Adam Smith's theory of labour division.

Böhm-Bawerk, in his *"Kapital und Kapitalzins"* from 1900, discusses how step by step the production process becomes more and more roundabout, but pays off in terms of an increased productivity which more than compensates for the time spent on capital formation:

"A farmer needs and wants water for drinking. The spring bubbles at some distance from his house. In order to satisfy his need for water he can choose different ways. Either, he goes each time to the spring and drinks from his hollowed hand...

Or ... the farmer makes a jug from a block of wood and carries in it his daily use at once from the spring to his living place ... but in order to achieve this it would have been necessary to make a not insignificant detour: the man might have to carve on this jug a whole day, he should, in order to be able to carve it ..., fell a free ... even before that produce an axe, and so on ...Finally ... in stead of one tree he could fell many, hollow them all in the centre, build a pipe from them, and bring an abundant stream of water to his house. Obviously roundaboutness is now even more considerable. As a compensation it leads to a much enhanced achievement."

Likewise Adam Smith in his *"Wealth of Nations"* from 1776 speaks almost lyrically of the productivity increases resulting from specialization of labour. His famous example is that of specialized pin-making, where both organisation and training, combined with specialization in accordance with natural talent, result in improved productivity:

"One man draws out the wire, another straightens it, a third cuts it, a fourth points it, a fifth grinds it at the top for receiving the head; to make the head requires two or three distinct operations; to put it on, is a peculiar business, to whiten the pins is another; it is even a trade by itself to put them into paper; and the important business of making a pin is, in this manner, divided into about eighteen distinct operations...

Each person, therefore, ... might be considered as making four thousand eight hundred pins a day. But if they had all wrought separately and independently and without any of them having been educated to this peculiar business, they certainly could not each of them have made twenty, perhaps not one pin in a day."

It is interesting to consider how economists would nowadays model the benefits of roundaboutness or specialization. Roundaboutness would be introduced as an increase of some homogeneous input of capital in the production function, a proxy for the quantity of jugs and pipes, whereas division of labour would just be represented by a multiplicative productivity constant, multiplied either into the quantity of some again homogeneous labour input, or else just into output.

This practice must be regarded as very crude, doing no justice at all to the original ideas. It is obvious that not much of the phenomena discussed by Böhm-Bawerk and Smith are caught this way.

7.3 Increasing Complexity

Economic development always had one aspect of increasing mass or volume: of people, households, commodities, services, firms, communications.

There is another salient feature, a qualitative aspect of increasing complexity, diversity, and specialization of function. Typically, the various components of a more complex whole also seem to become internally more complex, more complex the more specialized their function is.

This development towards increasing specialization and internal complexity seems to be almost a natural law, like the degradation of energy in thermodynamics, though it has a direction reverse to that represented by energy degradation, towards higher order and organization.

In this respect economic development is similar to the development of the species in zoology: from a few primitive organisms at a low level of spe-

cialization and internal complexity, to highly organized ecosystems of specialized and complex organisms.

It can be maintained that this difference of direction (towards increasing "enthalpy" in stead of "entropy") is a salient difference between matter living and dead. Human society in this respect then seems to be just one aspect of life.

The economics of development, as indicated, focuses on increasing quantity rather than increasing diversity. This is natural because quantitative increase in well defined sets of objects is always easier to analyse than increasing diversity of the set structure itself. Yet the latter is the more interesting feature in the development process.

It therefore seems necessary to take a new start for modelling economic development whenever qualitative issues have to be focused, even if it may have to be a simplistic one.

7.4 The Development Tree

Such a starting point could be an analogy to the Darwinian development tree. As can be seen from archeological findings, the development of the tools of primitive man started with multipurpose stone tools, for instance, not differentiating between the operations of cutting, scraping, and sawing, just like zoological development started with primitive organisms of low differentiation, such as amoebas.

In the course of time the saw developed as distinct from the knife and from the scraper; i.e., the lines branched exactly as they do in the biological development tree. Some reflection convinces us that this process of branching and specialization is universal in the development of whatever human implements we study, be it just simple hand tools, or musical or scientific instruments. The question is what the reason for this increasing specialization is.

The idea of regarding the development of human implements as analogous to the development of biological organisms is not new. A few contemporaries of Charles Darwin actually saw things this way. Among those was Karl Marx, who, however found no use for parallels to the ideas of mutations and survival. Accordingly he did not detect the greatest potential for Darwinian evolutionism in economic development. If development is just a

Fig. 7.1: *An analogy to the Darwinian development tree for simple hand tools, showing how tools for splitting and smoothing, such as the saw the axe, the knife, the file and the plane may have developed from a simple stone age general purpose cutting tool, and the same for piercing tools. Such analogies for the emergence of human implements of variuos kinds to the evolution of the biological species have been popular since the 19th Century. Also the ideas of mutations and survival of the fittest found their counterpart in the case of man made implements.*

result of wilful planning by the humans, for better or for worse, then there remains nothing to model.

Anthropologist Gordon Childe in the 40's, however, emphasized these deeper parallels, and George Basalla in *"The Evolution of Technology"*, suggests both mutations, or innovations for the fun of *"homo ludens"*, and a selection mechanism due to various socioeconomic forces.

Basalla poses the question whether it would really be likely that such variety as we find in the real world would result from the conscious planning to satisfy basic human needs concerning shelter, nourishment, and the like. Why should, for instance, about 500 different kinds of specialized hammers have been produced in Birmingham in 1867?

Moreover, he asks whether the automobile, constructed when the combustion engine was invented by Nikolaus Otto in 1876, really was necessary. He claims that the automobile essentially was a toy in the decade 1895-

1905, and that it in no way was triggered by any kind of shortage of horse-power.

An even more basic invention, the wheel, which seems to have been invented in the Near East about 5,000 years ago, was in fact in the Middle Ages completely scrapped in that very region, transportation henceforth making use of the more efficient means of camels rather than of carriages drawn by ox or horse. This state of things remained for a period of about 1,000 years!

He also cites the remarkable fact that the Aztecs of Mexico used working axle and wheel for animal figurines, designed for ritual purposes or just as toys, though there is no evidence at all that wheeled vehicles were used for utility purposes.

Basalla gives good reasons for why this was so: carriages were just not very useful in the jungles and mountains of Mexico. Likewise, with the decay of Roman power in the Near East and the need for military transport decreasing one can well imagine that the roads were just left to decay.

But no matter what the reasons, the interesting thing is that these things were invented *without being useful at all*, and hence became more like random mutations in Biology, just set out for test whether they were useful for anything (if only as toys). They might then linger on and their use in practice might explode whenever a niche is opened up, quite as the imported American wine-louse, which almost destroyed all European vineyards, or the decorative imported weed that is about to transform Lake Victoria into a swamp in our days.

Basalla pursues the analogy between the evolution of living organisms and that of human artifacts in great detail. First of all he compares the number of different animal species, estimated to 1,500,000, with the number of patents, as representing different "species" of artifacts, taken only in the US from 1790 to around 1980, which amounted to 4,700,000. So, he concludes that the complex richness of the world of artifacts is hardly less pronounced than the world of living organisms.

Of course, not all patents represented economically or even technologically viable inventions. As late as in the period 1855-1905, when the laws of thermodynamics were perfectly established, more than 500 patents were granted by the British Patent Office for various perpetual motion machines, and only in 1914 did the US Patent Office issue a general declaration that any drawings for perpetual motion machines had to be accompanied by working models. Anyhow, the number of patents indicates an order of magnitude. A proportion of 10-50 percent of all patents have been judged to have economic significance.

The remaining useless fraction is interesting too as it demonstrates the frugality and urge in the human mind of inventing things just for the pleasure of it, so justifying the "mutation" analogy.

Earlier writings on these matters, such as Samuel Butler's essay *"Darwin and the Machines",* dating from 1863 classified the "mechanical life" in genera, species, and varieties, and attempted to sketch a development tree in analogy to Darwin's.

In these writings there is an absurd preoccupation with the lack of reproductive capacity among the machines, and attempts to make the analogy complete by considering machines making machines on their own. Coupled with this is a fear that machines somehow would "take over" the role of mankind. At this stage the analogy, however, ceases to be fruitful. We do not need self reproduction, because humans see to it by reinvestment that viable things are reproduced.

Basalla also claims that there is missing a clear idea of the selection mechanism in these early writings, and that they flip between the idea of technological evolution being a continuous, collectively social process, and a discrete process of distinct inventions with great names labelling each one of them. He stresses that there is nothing exclusive in the outlooks, and that there is discontinuity and continuity as well.

He, however, has no idea of mathematical bifurcation, competing attractors, basins of attraction, niches for the survival of human implements, or the general way the totality of technology feeds back to provide these niches. In my opinion the process producing the bifurcating evolution tree, and the discrete/continuous dichotomy could become much more understandable, using such simple mathematical ideas.

7.5 Continuous Evolution

Basalla gives detailed evidence for the fact that our common impression that technological development is a sequence of discrete revolutionary inventions is in part based on an inadequate knowledge of the actual history of technology which makes us ignorant of all the minor stepping stones between the great historical moments.

It is quite like the case of reading a concise history of music, focusing on say, Palestrina, Monteverdi, Bach, Mozart, Beethoven, Brahms, and

Fig. 7.2: *James Watt's steam engine from 1775 above, an electric motor developed by Charles Page in 1838 below The attempts to develop electric motors came very soon after Hans Christian Oersted and Michael Faraday around 1820 had discovered the electromagnetic force. Note the likeness in technical detail between the engines, with pistons moving up and down in cylindrical coils even in the electric motor.*

Schönberg. The discrete steps are giant. However, considering the music by Bach's sons and contemporaries of the "gallant" style, makes the jump to Mozart much more understandable. It makes it easier to isolate his real contribution, without subtracting the least from his genius. In the same way intermediate styles fit in between any of the named giants, thus making the whole evolution process for composition styles a much more continuous process.

Basalla takes his starting point in James Watt's invention of the steam engine in 1775, in romanticised popular representation shown as springing out of a dream of a boy conceived at watching a boiling tea kettle. Basalla points at the preexistence of blacksmith Thomas Newcomen's steam engine for pumping water out from mines, invented in 1712 already. Though the principles are quite different, Newcomen's working with single action on vacuum resulting from condensating cooled steam, it is a fact that Watt's invention arouse in direct connection with repair and improvement of one of the Newcomen engines at the University of Glasgow, where he worked as instrument maker.

Basalla also points at the fact that not even Newcomen's invention was out of the blue sky, all the elements, such as piston pumps, mechanical linkages, and steam displacement devices being well known and used in Europe in the 17th Century. As a matter of fact Thomas Savery's invention "Miner's Friend" demonstrated in 1699 even antedates Newcomen's machine.

He also points at links to the later internal combustion engine, as it in 1759 already was proposed to replace steam by hot air in steam engines, and as, in fact, in 1791 an internal combustion engine working on turpentine vapour was patented. Though there still was two way action remaining from the original steam engine, nevertheless the giant leap to Nikolaus Otto's combustion engine is bridged over.

More surprising is that even early electric motors were modelled directly after the steam engine, with pistons moving back and forth in cylindrical coils. The rotary motion we take as a matter of course in the electric motor, though not necessary, by the way, also has its obvious mechanical analog in the steam turbine, which itself, of course, goes back to very old ideas embodied in water wheels in mills and the like.

All this demonstrates the usefulness of the biological analogy. First, there no doubt exists a continuous evolution process in the realm of human artifacts quite as in that of living organisms. Second, there is such an overwhelming richness of "species" that it must have arisen through a process of branching and diversification, rather than by some act of simultaneous "creation", which is the obvious alternative.

7.6 Diversification

So let us try to pin down some facts of the development of human artifacts, keeping in mind the bifurcation idea. Now we may observe something like a curious natural law: Given the state of technology, an implement can be made more efficient the more specific its operation is. The original all-purpose tool of the Stone Age can never become as efficient as a saw for sawing, or a knife for cutting. On the other hand an all-purpose tool is better for sawing than is a perfectly smooth honed knife.

As a consequence, in the process of harvesting increased efficiency by specialization, something in terms of the versatility and efficiency in secondary functions is sacrificed. Only when the different specialized tools are again assembled in a joiner's workshop, or in a modern combination machine, is there on overall improvement of efficiency.

It is very unlikely that such a development would in general ensue according to some premeditated blueprint. Rather we would expect that a more knifelike tool is developed just when efficient cutting is highly needed, and the sawlike tool when sawing is particularly essential (in terms of economics: when the prices for these services are high). The complete workshop or combination machine is likely to be organized first when most of the specialized tools are already at hand.

This will then be the result of recognizing the complementarity property of various specialized tools when they are used in combination.

This too is quite like the case of zoology. The ants and anteaters obviously are complementary from an ecological point of view, even though the individual ant, provided it had a conscious mind, might be reluctant to distinguish the anteater as its natural companion.

Such increased complexity can develop at several levels simultaneously. The joiner's workshop is an example at a relatively low level, the making of furniture in the 18th century, involving a multitude of different workshops, and craftsmen of different specialization, among them the joiner, is at a higher level.

The reader may consult Edward Lucie Smith 1981, *"The Story of Craft - The Craftsman's Role in Society"* or the already mentioned *"Dictionnaire raisonnée des sciences, des arts et des metiers"* by Diderot and d'Alambert about all this.

7.7 Property Space

In mentioning the properties of a tool, exemplified by the ability to cut, to saw, and to scrape, it was implicit that tools, and other human implements, could be regarded as bundles of properties.

To make things more specific we can treat them as measurable efficiencies in various operations, thus making the implements representable as coordinate points in some space of sufficiently many dimensions.

This is just like consumers' goods were once regarded by Lancaster in his seminal contribution of 1971, *"Consumer Demand. A New Approach"*. It seems fairly obvious that the performance of man-made implements, as discussed above, exactly like that of living organisms, for any practical or scientific purpose could be represented by points in a Lancasterian property space of sufficiently many dimensions.

A little caution is needed in defining the dimensions. After all, sawing and cutting are just two ways of splitting up materials, so we might have to resort to even more basic properties such as splitting, shaping, and smoothing.

Given this, it seems to be rather exceptional that the implements are just for one single purpose each, having maximum performance in only one dimension and zero in all the other. The knife, for example, can be used in splitting, shaping, and even smoothing.

Lancaster explicitly states that his theory is not suitable for the analysis of objects having "aesthetic" qualities of "beauty", but the case is not that bad in the opinion of the present author. Some dimensions might be hard to quantify for cultural objects, but the difficulties seem to be far from insurmountable. Critics of art, literature, and music in fact have the habit to discuss the quality aspects of a given product in different dimensions separately before weighing them into a compound evaluation.

Experience shows that such critics are remarkably unanimous when listing and characterizing the important aspects, even if their judgement in their application in individual cases can vary.

Exactly the same holds true in evaluations of scientific work judged in terms of originality, analytical acumen, clarity of presentation, practical usefulness, and the like. This is done constantly in evaluating staff for promotion, or in distributing research funds among applicants.

It is then no worse than in many other scientific procedures to introduce some scale for measuring the score in each dimension. This is, in fact, done by every teacher grading exams.

As the next step then we would place the Darwinian development tree in a Lancasterian property space. This is a new setting for the development tree, the branching tree structure remains, but is placed in a multidimensional vector space.

The dimensions of the space in which the biologists usually draw the development tree do not make such mathematical sense, it is just a two-dimensional picture of a set of three-dimensional animals. In this respect our use of the analogy is different, though it probably with profit could be used in the same more precise sense in Biology as well.

The essential characteristic of the development tree is its combination of continuous development and its branching structure. By the branchings or bifurcations we can best understand the nature of the emergence of new implements with more specialized function. Later we will focus on mathematical descriptions of such branching structure.

7.8 Paretian Ordering

Let us turn to the issue of evaluation. Within the setting of Lancasterian property space, economics offers just one way of defining uncontroversial progress: the Paretian.

Whenever one tool performs better in at least one dimension, without performing worse in any of the other, for instance being better as a knife, without being worse as a saw or a scraper, then we would say that it is better in a Paretian sense.

As indicated above, natural limits to a certain extent seem to favour efficiency in a specialized tool. Therefore, in the strict Paretian meaning just defined, we very seldom encounter a case of real progress. As was said above, most changes in history rather represent improvements in some dimensions at the expense of others.

The chance for such Paretian comparability of two objects, chosen at random in a group, increases with the number of objects in the group, and decreases with the dimension of the Lancasterian space in which they have to be represented.

We can even present a simple formal argument for the latter fact: In order to retain a certain degree of Paretian comparability, the number of objects has to increase geometrically when the dimension of the space increases arithmetically. The reason is that a point in n-dimensional property space

divides the space into 2^n orthants, among which only 2 are comparable in Paretian terms. Consequently, incomparability increases very fast with the dimension of the Lancasterian property space.

Very complex mass-produced goods, of which there are many examples in our high-tech society, may also need a property space of many dimensions for their representation, and comparisons of the different brands have basically the same characteristics as comparisons of different objects of art. Nevertheless, as long as there are many copies of each design it still makes some sense to define one dimension for each brand and to focus analysis on their numbers. In the case of artwork this is not meaningful, as there may be just one copy of each design.

In practice we expect the number of implements of every special group to more or less equal the number of dimensions in the property space. This is due to the possibility of combining them, just like the tools in a joiner's workshop. If the efficiency of combined performance were linear, we would even expect a strict equality to hold.

Too many tools would then imply that some of them are redundant, being dominated by a convex combination of the remaining ones, too few would only make it possible to span a subspace of the space of operations.

We can, of course, not expect things to be as simple as that. In particular, we have to consider that we are dealing with capital goods with long physical lifetimes, so at any moment we should expect to see vintages of tools which do not belong to the latest state of the technology.

7.9 Prices and Progress

Thinking in terms of economics we could, however, always get a step further by evaluating heterogeneous bundles of properties with the help of a pricing system. The question is how we are to obtain such prices. A natural way to proceed would be to calculate the imputed prices for the various properties from the actual market values of the commodities possessing them to various degrees.

We could then calculate the values of a given tool in different designs. According to the theory of production we would expect a change of design to occur whenever prices change, and the value would then be higher for the new design as compared to the old at every transition, because otherwise it would not have occurred.

It would also be understandable that major changes in design need not be the results of inventions and discoveries, they may just result from changing evaluations, reflecting changing needs, tastes, habits, and whims. History can even return to an old solution as was illustrated for the case of music.

Paradoxically, the value of an object in the course of changing design, always calculated at current prices, would show up as constantly increasing, even when the development was circular, returning to an earlier design.

Economic index theory warns us that there is a problem here. One can evaluate each single actual design change in the history of a certain human implement in terms of the momentary set of prices, and report an increase in value, but one cannot just accept a continuous increase of value when new prices are applied at each transition. This, however, is exactly what historians reporting constant progress do.

It is interesting to note that historians of science, art, and music of various ages usually report continuous progress until their own times when some recent transition renders a state of final perfection. Some later observer may report yet another development and a new state of perfection, but he often accepts the previous chronicles.

This is very like the attitude of biologists who regard the development of living organisms as a unidirectional way to higher levels of performance, whether the reason is ascribed to divine guidance or to natural selection.

Our claim is that something is always sacrificed in the apparently constant process of "improvement" of single implements. According to what was said above, improvements in certain dimensions are often bought at the expense of poorer performance in other.

7.10 Branching Points

We understand that a new direction in the design of implements is most often due to changes of needs and tastes. Such changes on the demand side must be complemented by corresponding design changes on the supply side. Design ideas occur quite frequently and even erratically over time. Some of them become successful, some are skipped from the beginning.

There are two issues involved. First, the innovation must be transformed from a blueprint idea to a material implement, and second, it must remain at the stage as useful over its lifetime and even be reproduced when it is worn out.

Again, taking the development tree analogy as support, we would say that they arise like mutations in biology. Exactly like mutations they most often do not remain permanent. Only when there is a macro environment with a suitable niche for them, do they appear and remain. The two stages are the same too. First, the genetic change in a chromosome must result in an individual organism that can at all live. Second, it must survive in terms of being propagated to further generations.

Such a permanence for implements can result from the recognition of the complementarity of specialized tools, and from the potential overall productivity increase in using them in combination.

The rise of such a suitable macro environment is thus responsible for the actual emergence of new implements. The economic identification of such an environment can always be expressed in terms of prices.

The emergence of new implements is also a matter of transgressing certain critical threshold values, and the nature of the branching points, as sudden dramatic events contrasted to smooth continuous evolution becomes understandable.

For instance, it is well known that the aeroplane was invented many times, but became a reality only when the aerofoil wing could be combined with an engine of a sufficient power and a trunk of sufficient strength in respect to weight.

Likewise the computer of any capacity was a possibility ever since the days of Pascal. If space required for the machine, the cost of materials needed, and the time for computation were not constrained, the supercomputer of any capacity (though admittedly very slow by our standards), could have became reality long ago.

The case of the computer represents an issue of economic feasibility, the case of the aircraft one of technical feasibility, but in essence they are like.

Modern systems theory provides tools for analysing branching in terms of the vanishing, emergence, fusion, and splitting of attracting points for such systems. Such methods are found under the headings of catastrophe theory, bifurcation theory, synergetics, self-organisation, and complexity theory.

Drastic vanishing of previous implements from the stage are not difficult to find, either from the arts, nor from the sciences. The same holds true for entire systems, the medieval guild system disappearing quite as the world of the dinosaurs.

Fig. 7.3: *A Hupfeld automatic piano with violin trio from 1900. In this normal piano, which can be played the usual way, we see the opening just above the keys where the punched paper scroll containing the recorded music is located. When the automatic mechanism runs, the tangents are automatically moved and the piano is playing. In the opening further up we see three violins fixed to a central vertical axis. The round structure is a constantly turning resined circular bow. According to the instructions on the paper scroll, the violins are thrown towards the bow, first being rotated so that the right strings come in contact with the bow. We can also see the outline of the mechanical "fingers" to stop the strings at the right place, and their pneumatic tubing.*

7.11 Music Automata

As an example of how a group of implements can disappear we take the case of music making automata. They have a surprisingly old history. An automatic virginal (a small keyboard instrument with plucking action like the harpsichord) was for instance listed in the inventory of Henry VIII upon his death 1547. Henry, by the way, was himself a fine musician who even left a few compositions.

This type of instruments stayed until around 1930, when it suddenly vanished form the stage. Automatic operation was applied to keyboard, wind, and string instruments. The recording of the pieces was first made on expensive brass cylinders with pegs, which were later replaced by punched metal discs, and eventually by paper scrolls. The last technology made live recordings possible quite far back in history, and several fine composers, including Händel and Mozart, produced music for automata.

There exist punched paper scrolls, supposed to be recorded by Georg Friedrich Händel's own hands (and feet), produced for automatic organs. Knowing the speed of the feeding machines, they are useful for determining Händel's own tempi. It is not surprising that Händel, being a cunning businessman all his life, would have tried this way of earning some money too.

The determination of tempi is not without interest, because historical records indicate that his own performance of the "Messiah" took 45 minutes less than the shortest existent recording today.

Mozart, during his period of financial difficulties the last years of his life, also tried composing for mechanical instruments. In a letter to his wife in 1791 he complains about difficulties of finishing a piece commissioned by a Viennese clock maker as the task was not sufficiently challenging.

Such automatic pianos and organs existed until their niche disappeared due to the advances in the gramophone industry. The most fantastic pieces, produced just before the collapse of the whole branch, are those machines where the automatic piano had a cupboard above it, containing several violins mounted within the circle of a constantly turning resined bow.

While the piano is played by an invisible pianist, the violins are thrown towards the circular bow, one by one, or several at once, under any of four different angles to have the right string touched, while the strings in various positions are pressed by mechanical fingers, operated by orders given through pneumatic tubes.

It is hard to find any more impressive token of human ingenuity, if not certain scientific instruments. From approximately the same period date the

frames, looking like those simple pantographs which children used to en-
large drawings, though provided with some complicated gears. By letting
the point traverse any closed plane curve, however complicated, its three
dials computed the perimeter, the area enclosed, and the moment of inertia
with respect to any given point fixed to the table in one single step.

The mathematical instruments in fact included a variety of tools for spe-
cific purposes in engineering and physics, for practical application in indus-
try or ballistics, but also general purpose instruments, such as the Bush (1928)
and Weiss (1944) integrators for differential equations and the mechanical
harmonic analyser due to Lord Kelvin (1878).

Of course, the expenditures for these implements being considerable, they
disappeared from the stage, as they could not compete with the CD record
or with modern PC software for calculus.

The author of these lines once invented a nomogram for the calculation of
internal rates of interest for bonds from nominal rates, prices and durations.
Compared to the enormous tables then used in the banks, the cost was re-
duced to a vanishing tiny fraction, but, alas! In a few years every pocket
calculator was supplied with a program for financial computations, so there
was no money in it. This was a mutation that did not even survive infancy.

7.12 Bifurcations

Let us now turn to the mathematical tools for the analysis of bifurcations in
the development tree we have in mind. Earlier models for dynamical sys-
tems were focused on smooth movement only. In our days sudden transi-
tions have been focused more and more.

René Thom in his 1972 monograph *"Stabilité structurelle et morphogenèse"*
opened up what came to be called Catastrophe Theory. His intention was to
formulate a method by which structural change such as the development of
a bud into a leave or into a flower could be mathematically modelled. For a
while this was a most active research area in applied mathematics, and all
sorts of phenomena, such as stock market crashes, attacking dogs, riot
outbursts, and Anorexia-Bulimia Nervosa, were discussed by these means.
Somewhat later more general theories of "non equilibrium phase transitions"
and "synergetic self-organisation" were created on this basis through the
double foci of Ilya Prigogine in Brussels and Hermann Haken in Stuttgart.
Today, catastrophe theory is subsumed under the more general topic of bi-

furcation theory, which is a subject of intense study in connection with non-linear dynamical systems and deterministic chaos, and which was discussed above from an entirely different angle.

Bifurcation is a more general term than catastrophe. The latter applies to gradient systems, i.e., such systems that behave as if they optimise something, whereas the former applies to dynamical systems in general, whether they optimise anything or not.

If we assume that economic development is the result of some kind of optimization, subject to a changing macro environment in terms of changing prices and general know-how, we can restrict our interest to catastrophe theory.

This theory has in fact reached very far in terms of classifying the kinds of bifurcation phenomena that can occur in dynamical systems, depending on the dimension of their state space, and on the number of parameters involved.

In our case the state space would be the Lancasterian property space, and the parameters would be represented by such things as innovations changing the state of technological knowledge, and above all, the imputed prices that reflect the current tastes.

Under certain parameter changes a previously stable optimum, which for a long time might have moved smoothly in concordance with changing parameters, could suddenly lose stability and rush to any of the new optima into which the previous one bifurcates. Assuming that several agents operate in the same system they may together recover several or all of the new stable optima, and thus create a branching tree. This explains bifurcations of the type we have been talking about.

A natural question would be whether bifurcations (i. e. successive splitting in two) could account for the very large number of human artifacts actually produced. The process of "splitting in two" however is an exponential one, and it easily leads to huge numbers. We mentioned the number of US patents, no less than 4,700,000 in the period 1790 to 1980. However $2^{22} = 4,194,304$, so supposing there was only one implement in 1790, we would need no more than around one bifurcation per decade in order to arrive at the required order of magnitude.

Two words of warning are in place if we want to make an explicit model. First, we assumed that the Lancasterian property space would need to have a considerable number of state variables, whereas all catastrophe theory attained was a classification of systems with one or two state variables and with no more than five parameters.

Second, even though the mathematical proofs, that all possible phenomena

can be modelled in terms of the "canonical forms" of the catastrophes and their "universal unfoldings", are safe, it is extremely hard to actually transfer substantial models into these canonical forms. This is why there were so many trivial catastrophe models created.

7.13 Synergetics

As for the first argument, concerning the multitude of variables, the Synergetics school of Haken provides a good argument why those low-dimensional models are not so bad after all.

In reality, despite the multitude of variables involved, the probability that more than very few of them are involved in actual phase transitions is small. The stability of a certain variable is measured by its so called "eigenvalue", obtained through linearising the system in the neighbourhood of an equilibrium state.

An eigenvalue can be zero, negative, or positive. Positive eigenvalues signify instability, and they can hence not exist for more than short periods, otherwise the system will blow up. Negative eigenvalues mean stability, and in the perspective of what eigenvalues close to zero can cause, they can be regarded as momentarily damped out to equilibrium, and hence trivial. The interesting things, catastrophes and bifurcations, in any system are triggered by those few eigenvalues that are very close to zero and that for a while can become positive.

By probability considerations it is very unlikely that more than a few ones among the negative eigenvalues are close to zero. The philosophical argument is that ascribing all drastic changes to the very few "slow" variables is the reason why we find relatively much order and relatively few phase transitions in reality. As a result, low-dimensional models may still be useful for high-dimensional systems.

However, again we need a word of warning: There is no guarantee whatever that those variables associated with the eigenvalues are variables we measure in reality or use in our modelling. They may well represent abstract dimensions constructed at the mathematical normalization process. We can hence not expect to come across fast and slow variables among those "natural" ones which we use in modelling.

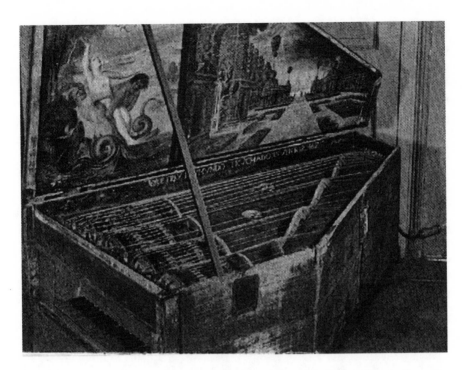

Fig. 7.4: *"Geigenwerk" from 1625. This is essentially a harpsichord where the strings are not plucked, but played with a resined bow, or rather a number of such. The strings are mounted in semicircularly arranged groups, and brought in contact with a resined turning wheel when a key is depressed. At the far end an assistant operates a crank which puts all these wheels in rotation This illustrates how even the bowed strings can be operated from a keyboard, just as plucked strings in the normal harpsichord, and wind instruments in the organ.*

7.14 Viable Alternatives

Seeing development this way, as a branching process resulting from more or less erratic mutation-like innovations that, if viable, result in a branching of the development tree, means that the actual state of the world and the road there by no means are the unique possible outcomes.

It is quite possible that development could have taken another course so that we might have been equipped with quite different sets of implements, constituting quite different macro-environments.

Basalla mentions the interesting fact that all Oriental hand tools, be it saws or planes, operate on the motion of drawing the tool towards you rather than on the motion pushing it away from you like in the Occident. According to Basalla the Oriental way is the more efficient than the opposite. The interesting thing, however, is that both work, when all operates in the same way, and when the labour force is accustomed to that.

Brian Arthur of the Santa Fe Institute has focused such issues as how, for instance, the original QWERTY layout of typewriters became established through people just becoming accustomed to a certain layout and wanting to have it retained. The situation may thus be locked for a long time, though there are no compelling reasons of absolute advantage for such a system. On the contrary he claims that the layout was devised in 1873 to the end of actually slowing typists down, in order avoid jamming on the old mechanical slow typewriters. Yet the QWERTY is still there on my computer keypad this very moment, without any real reason for it.

So, there definitely are alternative development histories for the human implements, quite as there are for living organisms.

7.15 A "Genesis" of Musical Instruments

Let us finish with an example from real life of a development towards increasing specialisation, again turning to the emergence of the modern musical instruments. They are very easily systematized, because they involve few principles for sound production, combined with few methods of operation.

Almost all musical sound is either produced in vibrating air columns or in vibrating strings. Strings and air columns both share the character of being virtually one dimensional media.

A homogeneous one dimensional medium, put in vibration, is essential for the production of musical sound, because this is almost the only instance where the series of ascending eigenvalues corresponds to the natural harmonic overtones of some basic pitch.

The only exception is provided by solid shells, blocks, and air cavities, but those means of sound production are only responsible for a tiny fraction of all musical sounds, being used mainly for special effects in the percussion section of the orchestra,

In dimension higher than one the eigenvalues are no longer harmonic, and they become more closely packed, which is good in its way too, because a soundboard (two dimensional) or an air cavity (three dimensional) can thus amplify sounds produced by for instance a string, which is hardly audible by itself. But they can as a rule not by themselves produce musical sound.

A string can be put in vibration in two ways: by an initial impact, i.e., through striking or plucking, or by bowing. The basic difference is that in the first case the initial impact energy just dissipates over time, and the note becomes progressively weaker. Bowing supplies the system with a constant inflow of energy, and can hence produce a sustained note.

To the first category belong guitars, mandolines, lutes, harps, and harpsichords, which are plucked, the modern grand, the dulcimer, and the clavichord, which are struck.

To the second belong all the members of the modern violin family, those of the once competing viol family, and all their common ancestors, such as rebecs and fiddles. Like other (modern European) instruments they go back to medieval Arabic-Jewish origins in Spain, which is testified even by etymology, by words such as "el oud" for "lute".

Even the bowed string instrument, operated by keyboard, did exist under the name of "Geigenwerk". The strings were organized on semicircular bridges with a set of resined disks beneath, put in rotation by an assistant operating a crank. The strings sounded once they were pulled down in contact with a disk by the keys, a technique that was also employed in the "hurdy-gurdy". It may not even surprise us that Leonardo da Vinci produced a drawing of the principles for the "Geigenwerk".

It is interesting to note that the plucked and bowed string instruments fuse back in history, the names for a plectrum and bow even becoming identical. Some tutors from the 17th Century, such as Thomas Mace, *"Musick's Monument"* dating from 1676, used to teach lute and viol at the same time, and the pizzicato way of playing bowed strings has remained to our day.

As for wind, the column of air is put in vibration by the lips and air from the lungs (the organ being an exception as it uses the mechanical device of a magazine of air under pressure). In brass just the lips are used, in woodwind either a labium, as in recorders and flutes, or a reed, as in clarinets, oboes, and bassoons.

In some cases, as for the historical trumpet, just the natural harmonics are used, the basic pitch being selected by the pressure provided by the lips and lungs. Otherwise, in flutes, oboes, and bassoons, there are finger holes to define the length of the air column, sometimes, especially in modern instru-

ments, operated by levers and valves, or else by adjustable slides to the same end, as in the sackbut.

Like the bowed strings, all the wind instruments are constantly supplied with energy, and hence produce a sustained tone.

An organ is essentially a set of woodwind instruments, both of the reed type and of the labium type, mounted on a wind chest and operated from a keyboard.

It is not difficult to see that, far back in history, the wind instruments fuse to a simple kind of whistle, just like the case of string instruments.

Strings and wind alike used to be built in entire families of different sizes. As a rule linear dimensions are reciprocal to pitch, so the volume and weight of a base instrument, sounding one and a half octave below the treble, would have to be increased by a factor of 27!

The usual sizes are the soprano, alto, tenor, and bass. Occasionally there is one above the soprano, such as a sopranino, piccolo, or pardessus, and one below, such as the violone, double base or contra bassoon.

The normal pitch difference between the family members is a fourth or fifth, so together they used to cover the whole musically interesting range of pitches.

The compass for each instrument is usually very well defined, and outside the basic range, the notes are extremely hard to produce so that they do not sound just awkward. A modern recorder tutor by Hans Martin Linde, when instructing the students to play the top notes of the one and a half to two octave compass, introduces the exercises as follows:

"Until now the student has been able to practice at ease without taking note of neighbours or family members. Now is the time, however, to close all doors and windows."

The instance of the French base viol, which had a compass of near four octaves, was quite an exception but it could not compete in loudness with either the cello or the viola in their proper more restricted ranges.

This already is a partial answer to the natural query: Why not just make one size of instrument of each kind? There are basic physical principles for the diversity. Length, surface area, and volume all are relevant for note production. The two latter increase with the square and cube of the length dimension respectively; so if all three factors matter we can expect well defined sizes to be associated with various pitches. Length is reciprocal to pitch, and hence it is impossible to produce a low note on a small instrument. Increasing surface area and volume of the cavity, however decrease structural strength, and therefore big instruments have to be more robust than small. There is then a necessary loss in suppleness, so, even if a high

violin note may be played on a double bass, the quality of sound is much better on the violin. Note that the reverse is not even possible.

All this provides instances of increasing specialization, combined with joint use to enhanced overall performance. Only together do the instruments of a family cover the entire audible range for the human ear restricted to the subset of musically interesting pitches. As mentioned, an individual instrument compass seldom covers more than a few octaves, whereas the range for a modern grand, which is supposed to represent all the musically interesting sounds, is 7 octaves with frequencies from about 20 to about 2500 Hz.

In particular the appearance of families holds for recorders and viols, which were played in consorts in the period when homogeneous sound was appreciated.

Besides jointly covering the entire range, the use in consorts made polyphony available. For wind instruments this is the only possibility for polyphonic music.

The case is different for strings. As almost all stringed instruments are provided with several strings, there is also a possibility of making them sound simultaneously. The purpose shows up in the way the instruments are tuned, those intended for melody, for instance violins and celli, tuned in fifths, those intended for harmony, for instance viols and lutes, usually tuned in fourths and thirds. The latter type usually also have more strings and frets to make the chords sound.

In some instances the use remained ambiguous. The viols were used for melody in consorts, but the bases were also used for solo purposes or for accompanying voice. The names for the various types, consort basses versus division basses, indicate the differences in use. There still remains one type of consort music: The string quartet.

The Baroque introduced a new focus on the "broken consort", using different types instruments together for their different timbres.

A harmony instrument, such as a harpsichord, theorbo or chitarrone (large base lute), together with a base melody instrument, such as a cello, base viol, or bassoon, provided the foundation for the entire construction. Over it various treble instruments, violins, recorders, flutes, oboes, or the human voices, provided the soli. In this way sonatas and trio sonatas, but also cantatas and concertos were born.

This is a track on which we still are, except that the base fundament, the "basso continuo" lost its role by the end of the 18th Century.

This simple taxonomy for musical instruments is inspired by D'Arcy Wentworth Thompson's *"On Growth and Form"*, where the forms of living organisms are discussed against the background of surprisingly few physical principles concerning structural strength, diffusion, surface tension, and overcoming friction to locomotion,

René Thom in his *"Stabilité structurelle et morphogenèse"* (1972), mentioned above, took Thompson's outlook as a start for studying structural change in living organisms, and in recent studies of the locomotion of animals, such issues as the "gear" shifts from walk to trot to gallop for horses extend this "physicalistic" outlook to pure dynamics. See Ian Stewart, *"Fearful Symmetry"* (1992).

In fact, if we take not only the instruments themselves, but also their use, in consideration, then the "gear shift" idea is highly relevant for music making. Anybody playing a bowed string instrument knows how to use the whole arm in slow movements and only the hand in fast ones, thus setting up an undulating movement of the three joints.

This, of course, is nothing but using a pendulum of varying length as appropriate for the desired period of oscillation. The system of three coupled pendula is mathematically quite complex, and may result in chaotic as well as periodic motion.

A closer mathematical study of the natural frequencies of such a coupled system might in fact yield interesting information concerning tempi in fast and slow movements, because most composers worked with, rather than against, nature. In the case of woodwind, double-tongue, and triple-tongue techniques serve the same purpose as the different movement gears of the arm. All this, in combination with the Darwinian development idea, would provide an excellent paragon to shape a development theory after.

7.16 Summary

Let us now summarize what we have concluded up to now for the development process seen from a qualitative point of view.

PROPOSITION 1. *Economic development, along with its characteristic of growth is in the direction of increasing specialisation of function of its elements. The internal complexity of these elements in a more complex whole also increases with the specialisation of their function.*

PROPOSITION 2. *In any given state of technology an implement can be made more efficient the more specialised its use is. Varying prices for the specialized operations call forth all, or at least most, of the specialized implements. This explains the increase towards specialisation.*

PROPOSITION 3. *The complementarity property of a set of specialised implements when they are used in combination, enhances overall efficiency and explains the development towards increasing structural complexity.*

PROPOSITION 4. *The performance of the implements can be represented as a point in a Lancasterian property space of sufficiently many dimensions.*

PROPOSITION 5. *The development of implements can be understood by the branching structure of a Darwinian development tree put in the strict framework of a Lancasterian property space.*

PROPOSITION 6. *In a Lancasterian property space, Paretian comparability is very unlikely to occur, especially if the space has many dimensions. Therefore we seldom see indubitable progress in culture.*

PROPOSITION 7. *The preferences of the economy are reflected in the imputed prices for the various performance dimensions of the Lancasterian property space. When commentators speak of progress they mean increasing value in terms of the imputed prices ruling at that moment.*

PROPOSITION 8. *Innovations come like mutations at a constant but erratic rate. They result in technological change when a niche is opened up for them by a suitable macro environment, reflected by favourable imputed prices.*

PROPOSITION 9. *Mathematically the branching points in the development tree can be analysed by bifurcation or catastrophe theory.*

PROPOSITION 10. *Ideas developed by Haken's synergetics school explain how the structural change in the branching tree can be low dimensional even though the whole system obviously is high dimensional.*

References

Classics (before 1800)

d'Alambert J. le Rond, Diderot D (1751) Encyclopédie ou Dictionnaire raisonné des science, des arts et des métiers

Alberti LB (1436) Della pittura

Bach CPhE (1752) Versuch über die wahre Art Klavier zu spielen

le Blanc H (1740) Défense de la basse de viole contre les Entreprises du violon et les Prétentions du violoncel

de Brosses C (1739) Voyage en Italie

Castiglione B (1513) Il Cortegiano

Cellini B (1565) Vita

Descartes R (1649) Traité des passions de l'âme

Dürer A (1533) Institutionem geometricam

Dürer A (1557) De symmetria partium humanorum corporum

Gibbon E (1776) Decline and Fall of the Roman Empire

von Goethe JW (1786) Italienische Reise

Lilly W (1647) Christian Astrology modestly treated in three books

Mace T (1676) Musick's Monument

Mattheson J (1739) Der vollkommene Kapellmeister

Mozart L (1756) Gründliche Violinschule

Mozart WA (1763-1791) Letters, various editions, Gesamtausgabe. Hrsg. von Mozarteum Salzburg, Bärenreiter

Quantz JJ (1752) Versuch einer Anweisung die Flute Traversière zu spielen

Smith A (1776) An Inquiry into the Nature and Causes of the Wealth of Nations

du Tillet T (1732) Le Parnasse Francois

Vasari G (1568) Le vite de'più eccellenti Architetti, Pittori, et Scultori Italiani

Modern (1800 to our days)

Abraham R, Shaw R (1992) Dynamics, Addison-Wesley

Arthur B (1990) Positive feedbacks in the economy, Scientific American, February, pp. 92-99

Banchoff TF (1990) Beyond the Third Dimension, Freeman

Bailly A (1968) La serenissima repubblica di Venzia, dall'Oglio

Basalla G (1988) The Evolution of Technology, Cambridge University Press

Berenson B (1957) Italian Pictures of the Reanaissance, Phaidon

Beyle MH, Ps. Stendhal (1827) Promenades dans Rome

Bol H (1973) La basse de viole au temps de Marin Marais et d'Antoine Forqueray, Creychton

von Böhm-Bawerk E (1889) Kapital und Kapitalzins, Innsbruck, Wagner

Böttger D (2003) Wolfgang Amadeus Mozart, München, DTV

Carcopino J (1961) La vie quotidienne a Rome à l'apogée de l'empire, Hachette

Dart T (1954) The Interpretation of Music, Hutchinson & Co

Devaney R (1989) Film and video as a tool in mathematical research, The Mathematical Intelligencer 11:33

Davis PJ, Hersch R (1981) The Mathematical Experience, Birkhäuser

Deppisch W (1968) Richard Strauss, Rowolth

Ernst B (1978) Der Zauberspiegel des M.C. Escher, Taco

Field M, Golubitsky M (1992) Symmetry in Chaos, Oxford University Press

Frazer Sir J (1890) The Golden Bough, London

Fletcher NH, Rossig TD (1991) The Physics of Musical Instruments, Springer-Verlag

Forkel JN (1802) Über Johann Sebastian Bach - Leben, Kunst und Kunstwerke, Leipzig

Frances G (1987) Topological Picturebook, Springer-Verlag

Frey BS (2000) Arts & Economics, Springer-Verlag

Gombrich EH (1950) The Story of Art, Phaidon

Gombrich EH (1960) Art and Illusion - A Study in the Psychology of Pictorial Representation, Phaidon

Goodstein DL, Goodstein JR (1997) Feyneman's Lost Lecture, Vintage Books

Haken H (1983) Advanced Synergetics, Springer-Verlag

Harnoncourt N (1982) Musik als Klangrede, Salzburg, Residenz-Verlag

Harnoncourt N (1984) Der Musikalische Dialog, Salzburg, Residenz-Verlag

Haskell E (1988) The Early Music Revival, Thames and Hudson

Heron-Allen E (1885) Violin Making as It Was and Is, Ward Lock reprint 1976

Hockney D (2001) Secret Knowledge: Rediscovering the Lost Techniques of the Old Masters, New York, Viking Studio

Hofstaedter D (1980) Gödel, Esher, Bach - an Eternal Golden Braid, Vintage Books

Hubbard F (1967) Three Centuries of Harpsichord Making, Harverd University Press

Janik H, Toulmin S (1973) Wittgenstein's Vienna, Touchstone

Jaquier P (1991) Rediscovery of a portrait of Jean-Baptiste Forqueray - Discovery of some elements of the represented basse de viole (Proceedings of the Viola da Gamba Symposium Utrecht), STIMU Publications

Jeans J (1937) Science and Music, Cambridge University Press

Kirkpatrick R (1953) Domenico Scarlatti, Princeton University Press

Kirkpatrick R (1983) Fifty years of harpsichord playing, Early Music 11:31

Kolneder W (1965) Antonio Vivaldi, Breitkopf und Härtel

Kuhn T (1962) The Structure of Scientific Revolutions, University of Chicago Press

Laidler KJ (2004) The Harmonious Universe: The Beauty and Unity of Scientific Understanding, Prometheus Books

Lancaster K (1971) Consumer Demand - A New Approach, Columbia University Press

Lucie-Smith E (1981) The Story of Craft - the Craftsman's Role in Society, Phaidon

Mandelbrot BB (1977) The Fractal Geometry of Nature, Freeman

Mossetto G (1992) The economics of a city of art: A tale of two cities, Ricerche Economiche 46:121

Mossetto G (1993) Aesthetics and Economics, Kluwer Academic

Mumford D, Series C, Wright D (2002) Indra's Pearls - The Vision of Felix Klein, Cambridge University Press

Parry H (1886) Studies of the Great Composers, London

Penrose R (1969) The Emperor's New Mind, Oxford University Press

Peitgen HO, Richter PH (1986) The Beauty of Fractals, Springer-Verlag

Pickover CA (1990) Computers, Pattern, Chaos, and Beauty, Alan Sutton

Popper KR (1959) The Logic of Scientific Discovery, Huchinson

Poston T, Stewart I (1978) Catastrophe Theory, Pitman

Savart F (1819) Mémoire sur les instruments à musique aux cordes et à l'archet, Deterville

Schorske K (1961) Fin-de-siècle Vienna, Knopf

Schumpeter J (1954) History of Economic Analysis, Allen and Unwin

Singh S (1997) Fermat's Last Theorem, Fourth Estate

Stewart I (1989) Does God Play Dice?, Blackwell

Stewart I,Golubitsky M (1993) Fearful Symmetry, Penguin

Taine H (1866) Voyage en Italie

Tromba A (1984) Mathematics and Optimal Form, Scientific American Books

Weissenberger R (1984) Wien 1890-1920, Wien, Überreuter

Wentworth-Thompson D'Arcy (1917) On Growth and Form, Cambridge University Press

Wölfflin H (1948) Kunstgeschichtliche Grundbegriffe - Das Problem der Stilentwicklung in der Neueren Kunst, Basel, Benno Schwabe & Co.

Wölfflin H (1952) Classic Art, an Introduction to the Italian Renaissance, Phaidon

Zuckermann WJ (1969) The Modern Harpsichord, Peter Owen

Figures

Chapter 2

Fig. 2.1 (p.11) Caricature drawing of Antonio Vivaldi by Leone Ghazzi. Original in the Vatican Library, Rome.

Fig. 2.2 (p.12) Francesco Guardi, "Galakonzert". Alte Pinakothek München.

Fig. 2.3 (p.14) The Mandelbrot set. Computer graphics using the Fractint software.

Fig. 2.4 (p.15) Piazza Navona, engraving by Giovanni Battista Piranesi 1773. Original engraving in the possession of the author.

Fig. 2.5 (p.16) Canaletto, Piazza and Piazzetta San Marco, National Gallery of Art, Washington, DC.

Fig. 2.6 (p.18) Illustrations from an article by Christian Gut, "Les Archives de Paris" from "Sauvegarde et Mise en valeur de Paris historique", Bulletin d'information, Numéro spécial - Juin 1972.

Fig. 2.7 (p.19) Early 20th Century postcard of Ringstrasse in Vienna.

Fig. 2.8 (p.21) Piazza San Pietro in Rome. Engraving by Giovanni Battista Piranesi.

Fig. 2.9 (p.27) The Antikythera mechanism. Original in the Adler Planetarium, Illinois.

Chapter 3

Fig. 3.1 (p.38) Publicity photo of Salzburg.

Fig. 3.2 (p.39) The Ducal Palace Mantova, gallery of the mirrors. Published in Heinrich Decker, "The Renaissance in Italy" (Thames and Hudson/ Verlag Anton Schroll, Wien, 1967).

Fig. 3.3 (p.40) Fernando, Maria Barbara, and the Spanish Court. After a painting 1752 by Jacopo Amiconi. Etching by Joseph Filipart, Calcografia Nacional, Madrid.

Chapter 4

Fig. 4.1 (p.47) Painting by Giovanni Paolo Panini, "Concert in Rome to celebrate the birth of Dauphin". Musée de Louvre, Paris.

Fig. 4.2 (p.51) Portrait of Mme Henriette de France playing basse de viole, painted 1754 by Jean-Marie Nattier. Musée de Versailles et Trianon.

Fig. 4.3 (p.55) Photo 1860 of Heinrich Schliemann. Published in Ernst Meyer, "Schliemann, Briefwechsel I" (Berlin 1953).

Fig. 4.4 (p.58) Photo of Florence, showing Santa Maria del Fiore, including Brunelleschi's dome and Giotto's bell tower, as well as Palazzo Vecchio to the right.

Fig. 4.5 (p.59) Cappella del Cardinale di Portogallo, San Miniato al Monte, Florence. Scanned from colour brochure published by the Church in the series "Tesori dell'arte Cristiana" (3rd Ed. 1966). Officine grafiche Poligrafici. Il Resto del Carlino, Bologna.

Fig. 4.6 (p.60) Screw jack after a design by Leonardo da Vinci. From exhibition catalogue "Renaissance engineers from Brunelleschi to Leonardo da Vinci" in Palazzo Strozzi Florence 1996. Model in Museo della storia di scienza in Florence. Photo: Fernando Ciagola.

Fig. 4.7 (p.64) Dining room in Palais Stoclet, Brussels, by Josef Hoffmann and Gustav Klimt. Picture published in Eduard Sekler, "Das architektonishe Werk", picture 111 (Salzburg u. Wien 1982).

Fig. 4.8 (p.65) Self-portrait by Arnold Schönberg, published in Janik and Toulmin, Wittgenstein's Vienna".

Fig. 4.9 (p.67) Fouquet jewellery shop at 6, rue Royal, Paris around 1900 by Alfons Mucha. Scrapped in 1923, and reassembled for Musée Carnavalet. Presently in Musée d'Orsay, Paris.

Fig. 4.10 (p.74) Jacopo Sansovino's courtyard of the university of Padova. Photo Agenzia Alinari, Florence, reproduced in Heinrich Decker, "The Renaissance in Italy" (Thames and Hudson/ Verlag Anton Schroll, Wien, 1967).

Chapter 5

Fig. 5.1 (p.79) Boyle's and Van der Waals's laws.

Fig. 5.2 (p.91) Computer experiment with the restricted three-body problem, using software from J.C. Sprott, Chaos Demonstrations.

Fig. 5.3 (p.94) Computer graphics of the Lorenz attractor using software from H.E. Nusse and J.A. Yorke, Dynamics. Numerical Explorations.

Fig. 5.4 (p.96) Drawing of Lithocubus Geometricus from D'Arcy Wentworth Thompson, "On Growth and Form", 1917.

Fig. 5.5 (p.97) Drawing of Maupertuis in polar expedition outfit. Reproduced in Hidebrandt and Tromba, "Panoptimum" (Spektrum der Wissenschaft, Heidelberg 1984).

Fig. 5.6 (p.101) From Kepler's "Mysterium Cosmographicum" 1596. Published in Goodstein and Goodstein, "Feyneman's Lost Lecture".

Fig. 5.7 (p.103) Computer graphics producing a symmetric "icon", according to a recipe in M. Field and M. Golubitsky, "Symmetry in Chaos".

Fig. 5.8 (p.110) The Beluosov-Zhabotinsky reaction. From Winfree, "Rotary chemical reactions" 1974, Scientific American 230(6), p.82. Photo by Fritz Goro.

Chapter 6

Fig. 6.1 (p.120) Andrea Verrocchio "Bust of a Lady". In Museo Nazionale ("Bargello"), Florence.

Fig. 6.2 (p.121) Lorenzo Bernini, portrait bust of Constance Buonarelli. In Museo Nazionale ("Bargello"), Florence.

Fig. 6.3 (p.123) Baroque wind instruments in "Musée instrumentale du Conservatoire de Paris", now "Cité de la Musique". Picture published in Larousse "La Musique", Vol. 1 (1965).

Fig. 6.4 (p.126) Albrecht Dürer, Engraving from "Unterweisung der Messung" (Nürnberg 1525). Reproduced in E.H. Gombrich, "Art and Illusion" (Phaidon 1960, London). Original to the photograph in New York Public Library Print Collection.

Fig. 6.5 (p.128) Central panel "Adoration of the Lamb" from Hubert and Jan van Eyck, the "Ghent Altar", 1420. Reproduced in D. Hockney, "Secret Knowledge".

Fig. 6.6 (p.129) Left: Detail from a portrait of J.-B.A. Forqueray by J.-M. Frédou. Painting "in private possession". Reproduced in Pierre Jaquier, "A Rediscovery of a portrait of J.B. Forqueray", Proceedings of the Viola da Gamba symposium Utrecht 1991 (STIMU, Utrecht). Right: "Cordier" from the collections of "Musée des arts decoratifs", Paris.

Fig. 6.7 (p.130) Full portrait of J.B.A. Forqueray by J.-M. Frédou around 1737.

Fig. 6.8 (p.131) Michelangelo da Caravaggio, "The Lute Player". In the Hermitage, S:t Petersburg. Reproduced in Goldberg Magazine Vol. 1:1.

Fig. 6.9 (p.134) Base Viol by Martin Voigt, Hamburg. In Victoria and Albert Museum, London. Published in one of their catalogues.

Fig. 6.10 (p.135) Beginning of "La Régente", Pièces de violes by Antoine Forqueray. Original published in Paris 1747. From a facsimile edition, "performer's facsimiles", 1985 in the author's possession.

Fig. 6.11 (p.137) "Loves Galliard" by Captain Tobias Hume, "The first part of airs" printed 1605 in London. From a modern facsimile edition in the possession of the author.

Fig. 6.12 (p.138) Beginning of sonata XI from the "Rosary" or "Mystery" sonatas by H.I.F. von Biber. Original in Bayerische Staatsbibliothek, München. Picture scanned form facsimile score.

Fig. 6.13 (p.142) Harpsichord from Sperrhake factory, Passau. Publicity photo, reproduced in W.J. Zuckermann, "The Modern Harpsichord" (Peter Owen, London 1970).

Fig. 6.14 (p.143) Publicity photo of a copy of a Taskin harpsichord built by Hubbard & Dowd, reproduced in W.J. Zuckermann, "The Modern Harpsichord" (Peter Owen, London 1970).

Fig. 6.15 (p.146) Left: Delft porcelain violin in Rijksmuseum, Amsterdam. Right: Experimental violin, probably 19th Century, from the collections of the museum of musical instruments, Stockholm.

Fig. 6.16 (p.147) Interior of a Luthérie, illustration from Diderot, D'Alambert, "Encyclopédie...". Scanned from a facsimile edition of the "Recueil de planches sur les sciences, les arts libéraux, et les arts méchaniques/Lut-hérie" by "Inter-livres.

Fig. 6.17 (p.149) Picture of Arnold Dolmetsch and his family in Heslemere, published in H. Haskell, "The Early Music Revival - A History" (Thames & Hudson 1988).

Fig. 6.18 (p.151) "La Primavera" by Sandro Botticelli, in Galleria delle Uffici, Florence.

Fig. 6.19 (p.153) Engraving by Albrecht Dürer, "Melancholia". One original in the Royal Library, Stockholm.

Fig. 6.20 (p.154) M.C. Escher drawing published in Bruno Ernst, "Der Zauberspiegel des M.C. Escher" (TACO, Berlin 1986).

Chapter 7

Fig. 7.1 (p.161) The development tree, by the author. Previously published in my "Attractors, Bifurcation, and Chaos" (Springer 2003).

Fig. 7.2 (p.164) Picture of James Watt's steam engine, and drawing of electric motor, both publishe in George Basalla, "The evolution of Technology" (Cambridge University Press 1988).

Fig. 7.3 (p.172) Orchestrion, picture from the catalogue of Nationaal Museum van Speelklok tot Pierement Utrecht.

Fig. 7.4 (p.177) "Geigenwerk" by Raymondo Truchador in the Museum of Musical Instruments of the Conservatoire, Brussels. Picture from official catalogue.